A Short Course in Photography

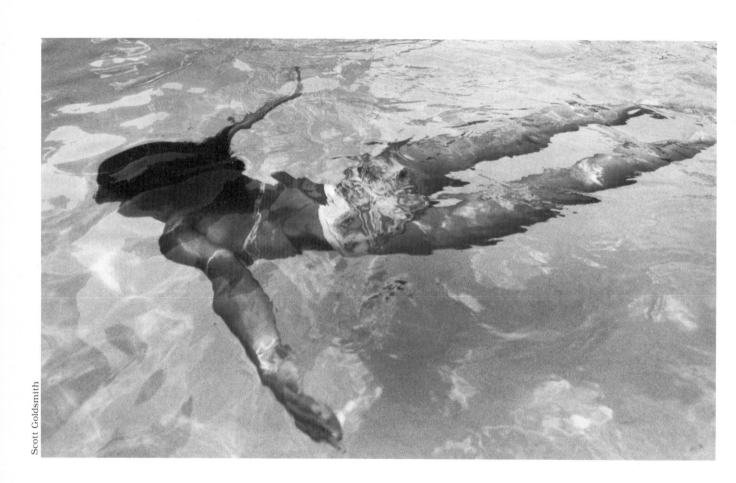

A Short Course in Photography

Second Edition

An Introduction to Black-and-White
Photographic Technique

Barbara London

HarperCollins*Publishers*

Still—for all the relatives and friends who are my family.

Sponsoring Editor: Melissa A. Rosati
Project Coordination: Nancy Benjamin
Text and Cover Design: Dianne Schaeffer
Cover Photo: Ellen Land-Weber
Production: Michael Weinstein
Compositor: DEKR Corporation
Printer and Binder: Courier Book Companies/Murray
Cover Printer: New England Book Components

Acknowledgments

Thanks to those organizations who granted us permission to repro-
duce photographs on the following pages: Berkey Marketing Compa-
nies, 5 (left); Bethlehem Steel, 53, 151 (bottom); Boston Public Library,
Herald file, 65; EPA — Documerica, 7 (top), 25, 29 (top), 138, 151
(top); Library of Congress American Folklife Center, 10, 11, 147, 159
(top); National Park Service, 8, 28, 34, 54 (top), 57, 67 (top); *The Sac-
ramento Bee*, 32, 117, 118, 121; U.S. Department of Agriculture, 22,
42, 45, 50, 59, 60 (top), 66 (bottom), 68, 119 (top), 144, 149, 152, 155
(top); *The Virginian Pilot*, 116.

A Short Course in Photography, Second Edition

Library of Congress Cataloging-in-Publication Data
London, Barbara
 A short course in photography : an introduction to black-and-white
photographic technique / Barbara London. — 2nd ed.
 p. cm.
 Includes bibliographical references and index.
 ISBN 0-673-52121-4
 1. Photography. I. Title.
TR146.L618 1991 90-47149
771—dc20 CIP

 93 9 8 7 6 5

Contents

7 **Lighting / 116**

8 **Special Techniques / 134**

9 Seeing Like a Camera / 144

Preface

If you don't know anything about photography and would like to learn, or if you want to make better pictures than the ones you make now, *A Short Course in Photography* will help you. It presents in depth the basic techniques for black-and-white photography:

• how to get a good exposure

• how to adjust the focus, shutter speed, and aperture (the size of the lens opening) to produce the results you want

• how to develop film and make prints

Today's cameras are becoming increasingly automatic, but that doesn't mean that they automatically produce the results you want. Special attention is given to:

• automatic focus and automatic exposure—what they do and, particularly, how to override them when it is better to adjust the camera manually

The book covers other essential topics as well:

• types of lenses

• types of film

• lighting, including a new spread on portrait lighting

• filters

Photography is a subjective and personal undertaking. *A Short Course in Photography* emphasizes your choices in picture making with:

• how to look at a scene in terms of the way the camera can record it

• how to select the shutter speed, point of view, or other elements that can make the difference between an ordinary snapshot and an exciting photograph

Chapter 9, Seeing Like a Camera, makes suggestions on:

• how to choose what is in a photograph (by selecting the image frame and background)

• how to adjust the image (by selecting the perspective, depth of field, or representation of motion)

• how to photograph subjects such as people and landscapes

• how to respond to photographs—a new spread on looking at your own and other people's work

The book is designed to make learning these subjects as easy as possible:

• every two facing pages completes a single topic

• detailed step-by-step instructions clarify each stage of extended procedures (such as negative development and printing)

• boldfaced headings make subtopics easy to spot

• numerous photographs and drawings illustrate each topic

Many people gave generously of their time and effort in the production of this book. Rick Steadry reviewed the entire manuscript and made many valuable suggestions. Ken Kobre had special insights to offer as the author of a photography textbook himself. At HarperCollins, Melissa Rosati provided editorial support, Glenn Campbell handled a host of editorial details, and Michael Weinstein coordinated production. Nancy Benjamin supervised production of the book from manuscript to printer. Once more, I was lucky to have her experience and help in making the thousand and one decisions that every book entails.

If, as you read the book or use it in your class, you have suggestions to make, please send them to Melissa Rosati, Communications Editor, HarperCollins, 10 E. 53rd St., New York, NY 10022. They will be welcome.

Barbara London

1 Camera

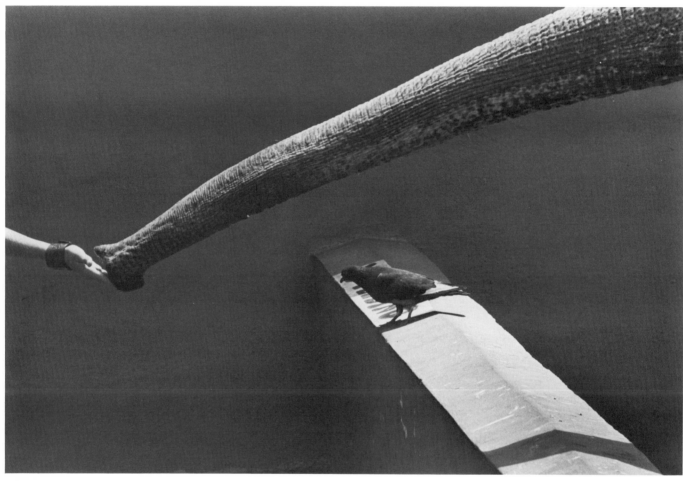

Fredrik D. Bodin

This chapter describes your camera's most important controls and how you can take charge of them, instead of always having them control you. Cameras have become increasingly automatic in recent years; today, a new 35mm camera is often equipped with automatic exposure, automatic focus, and automatic flash. If you are interested in making better pictures, however, you should know how your camera works, even if it is an automatic model. You will want to override your camera's automatic decisions from time to time and make your own choices.

• You may want to set a slow shutter speed to blur the motion of a moving subject, or use a fast shutter speed to freeze motion. Page 11 tells how.

• You may want to set your lens aperture (its adjustable opening) very wide so that the background is out of focus. Page 13 tells how.

• You may need to override your camera's automatic focus mechanism so that the right part of a scene is sharp. Page 31 tells when and how to do so.

• You may decide to underexpose a scene to silhouette a subject against a bright background, or give more exposure than your metering system recommends so that you *don't* end up with a silhouette. See pages 62–63.

Professional photographers learn how a camera operates manually as well as automatically so they can choose which is best for a particular situation. You will want to do the same, because the more you know about how your camera operates, the better you will be able to get the results you want.

Fredrik D. Bodin

Cropping is one of the basic controls you have in making a photograph (see this page and opposite). Horizontal or vertical? The whole scene or only a part of it? More about cropping on pages 107 and 146–147.

Types of Cameras

What kind of a camera is best for you? For occasional snapshots of family and friends, an inexpensive, completely automatic, nonadjustable camera that you just point and shoot will probably be satisfactory. But if you have become interested enough in photography to take a class or buy a book, you will want an adjustable camera, like one of those described here, because it will give you greater creative control. If you buy a camera with automatic features, make sure that you can manually override them when you want to make exposure and focus choices yourself.

Single-lens reflex cameras (SLRs) show you a scene directly through the lens, and so preview what will be recorded on the film. You can see what the lens is focused on; with some cameras you can check the depth of field, how much of the scene from foreground to background will be sharp. Through-the-lens viewing is a definite advantage for close-ups or any work when you want an exact view of a scene.

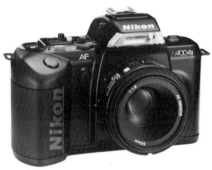
Nikon. Inc.

Interchangeable lenses for SLRs are available in many focal lengths. Automatic exposure is commonly available, as are automatic focus, automatic flash, and automatic film advance and rewind. Most SLRs use 35mm film. Some models are designed for larger film formats, such as 2¼-inch square.

SLRs are very popular, among both professionals, such as photojournalists, and nonprofessionals who want to move beyond snapshots.

Rangefinder cameras show you a scene through a peephole, the viewfinder, which is equipped with its own lens system that approximates the image formed by the lens. The rangefinder, a focusing system coupled to the lens, shows in the viewfinder the point on which the lens is focused, but you cannot assess the depth of field because all parts of the scene look equally sharp.

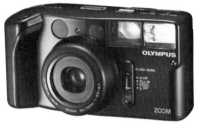
Olympus

Because the viewing system is in a different position from the lens that exposes the film, you do not see exactly what the lens sees. This parallax, or difference between the viewfinder image and the lens image, increases as objects come closer to the camera. Better rangefinder cameras correct for parallax except for objects that are very close.

Interchangeable lenses are made for some rangefinder cameras, although usually not in as many focal lengths as for SLRs. Most use 35mm film, though a few are designed for larger film formats.

Rangefinder cameras are fast, reliable, quiet in operation, and relatively small in size. Better models are in demand among professionals, whereas inexpensive, compact 35mm models are popular for snapshots and less exacting work.

View cameras have a lens in the front, a ground-glass viewing screen in the back, and a flexible, accordion-like bellows in between. The camera's most valuable feature is its adjustability: the camera's parts can be moved in relation to each other, which lets you alter perspective and sharpness to suit each scene. You can change lenses, and even the camera's back; for example, you can attach a back to make Polaroid pictures. Each exposure is made on a separate piece of film, so you can develop each negative individually. Film size is large: 4 x 5 inches and larger, which makes detail crisp and sharp even in a big print.

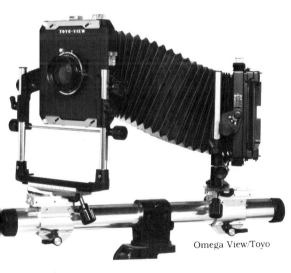

Omega View/Toyo

View cameras are slow and rather inconvenient to use compared to smaller handheld cameras. They are large and heavy, and must be used on a tripod. The image on the viewing screen is upside down and backwards, and is usually so dim that you have to put a focusing cloth over your head and the screen to see the image clearly. Nevertheless, when complete control of an image is desired, such as for architectural or product photography or for personal work, the view camera's advantages outweigh its inconveniences.

Twin-lens reflex (TLR) cameras have two lenses: one for viewing the scene and another just below it that exposes the film. A relatively large format (2¼-inch square) and a moderate cost are the

Mamiya

TLR's advantages. Its disadvantages are parallax (because the viewing lens is in a different position from the taking lens) and a viewfinder image that is reversed left to right. Only a few models have interchangeable lenses. TLRs have been largely displaced by single-lens-reflex cameras, but used ones are still available, as are a few new models.

Some cameras fill a specialized need.
Instant cameras produce a print within a few seconds, if not instantly. Polaroid makes films for its own cameras, as well as for view cameras and 35mm cameras. *Underwater cameras,* such as the Nikonos, are not only for use underwater, but for any situation in which a camera is likely to get wet. Some cameras are water resistant, rather than usable underwater. *Panoramic cameras* rotate either the lens or the camera from side to side. Their long, narrow format can be interesting, for example, for landscapes. *Stereo cameras* take two pictures at the same time through two side-by-side lenses. The result, a stereograph, gives the illusion of three dimensions when seen in a stereo viewer.

Basic Camera Controls

Cameras don't quite "see" the way the human eye does, so at first the pictures you get may not be the ones you expected. One of the aims of this book is to help you gain control over the picture-making process by showing you how to see the way the camera does and how to use the camera's controls to make the pictures you want.

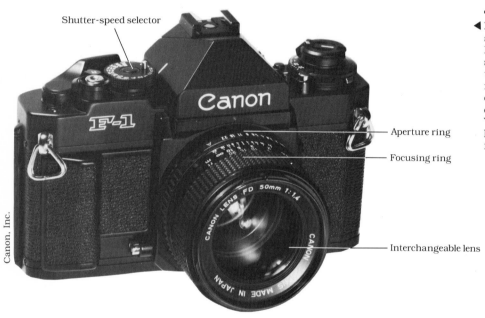

Shutter-speed selector

Aperture ring

Focusing ring

Interchangeable lens

◀ **Basic controls** on this single-lens reflex camera let you select the shutter speed (the length of time the shutter remains open) and the aperture (the size of the opening inside the lens). You can also focus the lens or change one lens for another.

Data panel shows shutter speed and aperture settings

Control keys for manually setting shutter speed and aperture

In automatic operation, pressing the shutter release focuses the lens and sets shutter speed and aperture

On some automatic models, push-button controls replace adjustable knobs and rings. When you press the shutter release, this camera automatically focuses the lens and sets the shutter speed and aperture. When you want to choose camera settings yourself, you can override the automatic functions.

Interchangeable lens

Ring for manual focusing

Focusing. Through the viewfinder window you see the scene that will be exposed on the film, including the sharpest part of the scene, the part on which the camera is focused. A particular part of a scene can be focused sharply by manually turning the focusing ring on the lens, or by letting an autofocus camera adjust the lens automatically. More about focusing and sharpness appears on pages 14–15 and 30–35.

Shutter-speed control. Moving objects can be shown dead sharp and frozen in mid-motion or blurred, either a little bit or a lot. The faster the shutter speed, the sharper that motion will be. Turn to pages 10–11 for information about shutter speeds, motion, and blur.

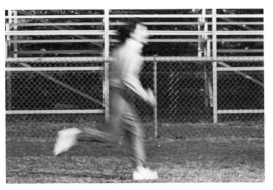 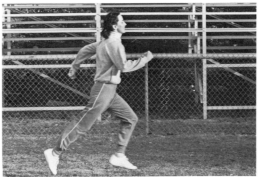

Aperture control. Do you want part of the picture sharp and part out of focus, or do you want the whole picture sharp from foreground to background? Changing the size of the aperture (the lens opening) is one way to control sharpness. The smaller the aperture, the sharper the picture will be. See pages 12–13.

 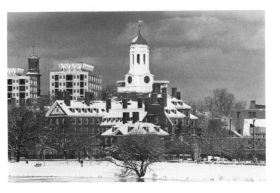

Lens focal length. Your lens's focal length controls the size of objects in a scene and how much of that scene is shown. The longer the focal length, the larger the objects will appear. See pages 20–28 for more about focal length.

More About Camera Controls

Automatic exposure is a basic feature on many 35mm single-lens reflex cameras. The camera makes a light reading of the scene and then sets shutter speed, aperture (lens opening), or both in order to let the right amount of light reach the film so the resulting image is neither too light nor too dark. As you become more experienced, you will want to set the exposure manually in certain cases, instead of always relying on the camera. More about exposure in Chapter 4, pages 50–67.

You have a choice of exposure modes with many cameras. Read your camera's instruction book to find out which exposure features your model has and how they work. If you don't have an instruction book, ask your instructor or someone familiar with cameras.

With programmed automatic exposure, the camera selects both the shutter speed and the aperture based on a program built into the camera by the manufacturer. This automatic operation can be useful in rapidly changing situations be-

cause it allows you simply to focus and shoot.

In shutter-priority mode, you set the shutter speed and the camera automatically sets the correct aperture. This mode is useful when the motion of subjects is important, as at sporting events, because the shutter speed determines whether moving objects will be sharp or blurred.

In aperture-priority mode, you set the lens opening and the camera automatically sets the shutter speed. This mode is useful when you want to control the depth of field or sharpness of the image from foreground to background, because the size of the lens opening is a major factor affecting sharpness.

Manual exposure is also a choice with many automatic cameras. You set both the lens opening and shutter speed yourself using, if you wish, the camera's built-in light meter to measure the brightness of the light.

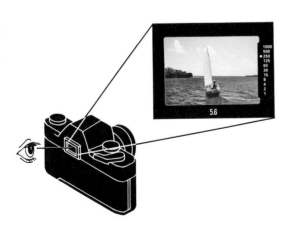

Exposure information appears in the viewfinder of many cameras. This viewfinder shows the shutter speed (here, 1/250 sec.) and aperture (f/5.6). Displays show you when the flash is ready to fire and give you warnings of under- or overexposure.

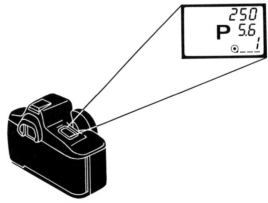

Some cameras have a data panel on the top of the camera that shows information such as shutter speed (here, 1/250 sec.) and aperture (f/5.6). This model also shows the mode of exposure operation (P, for programmed automatic) and the frame number (number 1).

Inside a single-lens reflex camera

A. Body. The light-tight box that contains the camera's mechanisms and protects the film from light until you are ready to make an exposure.

B. Lens. Focuses an image in the viewfinder and on the film.

C. Lens elements. The optical glass lens components that produce the image.

D. Focusing ring. Turning the ring focuses the image by adjusting the distance of the lens from the film plane. Some cameras focus automatically.

E. Lens diaphragm. A circle of overlapping leaves that opens up to increase (or closes down to decrease) the amount of light reaching the film.

F. Aperture ring or button. Setting the ring or button determines the size of the diaphragm inside the lens.

G. Mirror. During viewing, the mirror reflects light from the lens upwards onto the viewing screen. During an exposure, the mirror swings out of the way so light can pass straight ahead to the film.

H. Viewing screen. A ground-glass (or similar) surface on which the focused image appears.

I. Pentaprism. A five-sided optical device that reflects the image from the viewing screen into the viewfinder.

J. Metering cell. Measures the brightness of the scene being photographed.

K. Viewfinder eyepiece. A window in which the image from the pentaprism is visible to the photographer.

L. Shutter. Keeps light from the film until you are ready to take a picture. Pressing the shutter release opens and closes the shutter to let a measured amount of light reach the film.

M. Film. The light-sensitive material that records the image. The film speed (the rating of a particular film's sensitiv-

ity) is set into the camera by turning a dial, or, on some cameras, is set automatically when you load the film.

N. Film advance. A lever that advances an unexposed segment of film. Some cameras advance film automatically.

O. Shutter-speed dial or button. Selects the shutter speed, the length of time the shutter remains open. On some models, it also sets the mode of automatic exposure operation.

P. Shutter release. A button that activates the exposure sequence in which the aperture adjusts, the mirror rises, the shutter opens, and film is exposed.

Q. Hot shoe. A bracket that attaches a flash unit to the camera and with suitable units provides the electrical linking that synchronizes camera and flash.

R. Rewind mechanism. A crank that rewinds the film into its cassette after the roll of film has been exposed. Some cameras rewind the film automatically.

S. Film cassette. The light-tight container in which 35mm film is packaged.

All cameras have the same basic features:
• A light-tight box to hold the camera parts and film
• A viewing system that lets you point the camera accurately
• A lens to form an image and a mechanism to focus it sharply
• An adjustable shutter and lens aperture to control the amount of light that reaches the film
• A means to hold and advance the film

Below, a simplified look inside a single-lens reflex 35mm camera (designs vary in different models). The camera takes its name from its single lens (another kind of reflex camera has two lenses) and from its reflection of light upwards for viewing the image.

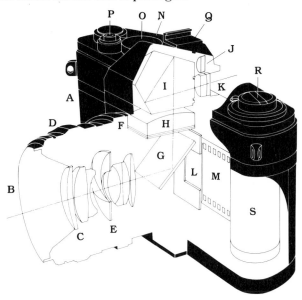

Shutter Speed: Affects light and motion

Light and the shutter speed. To expose film correctly, so that your picture is neither too light nor too dark, you need to control the amount of light that reaches the film. The shutter speed (the amount of time the shutter remains open) is one control your camera has. The aperture size (page 12) is the other. In automatic operation, the camera sets the shutter speed or aperture, or both. In manual operation, you choose the settings. The shutter-speed dial (a push button on some cameras) sets the shutter so that it opens for a given fraction of a second after the shutter release has been pressed. The B or bulb setting keeps the shutter open as long as the shutter release is held down.

Motion and the shutter speed. In addition to controlling the amount of light that enters the camera, the shutter speed also affects the way that moving objects are shown. A fast shutter speed can freeze motion—1/250 sec. is more than fast enough for most scenes. A very slow shutter speed can record even a slow-moving object as a blur. The important factor is how much the image actually

moves across the film. The more of the film it crosses while the shutter is open, the more the image will be blurred. The shutter speed needed to freeze motion depends in part on the direction in which the subject is moving in relation to the camera (see opposite).

The focal length of the lens and the distance of the subject from the camera also affect the size of the image on the film and thus how much it will blur. A subject will be enlarged if it is photographed with a long-focal-length lens or if it is close to the camera; it has to move only a little before its image crosses enough of the film to be blurred.

Obviously, the speed of the motion is also important: all other things being equal, a darting swallow needs a faster shutter speed than does a hovering hawk. Even a fast-moving subject, however, may have a peak in its movement, when the motion shows just before it reverses. A gymnast at the height of a jump, for instance, or a motorcycle negotiating a sharp curve is moving slower than at other times and so can be sharply photographed at a relatively slow shutter speed.

A focal-plane shutter is located just in front of the film, near the focal or film plane. During exposure, the shutter opens to form a slit that moves across the film. The size of the slit is adjustable; the wider the slit, the longer the exposure time and the more light that reaches the film. Focal-plane shutters are found on single-lens reflex cameras and on some rangefinder cameras.

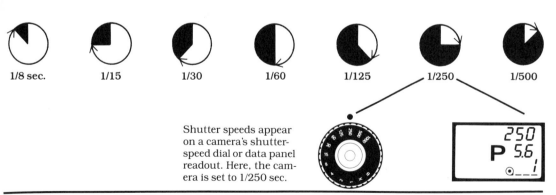

1/8 sec. 1/15 1/30 1/60 1/125 1/250 1/500

Shutter speeds appear on a camera's shutter-speed dial or data panel readout. Here, the camera is set to 1/250 sec.

250
P 5.6

Shutter-speed settings are in seconds or fractions of a second: 1 sec., 1/2 sec., 1/4, 1/8, 1/15, 1/30, 1/60, 1/125, 1/250, 1/500, 1/1000, and sometimes 1/2000, 1/4000, and 1/8000. Only the bottom part of the fraction appears on camera dials or readout. Each setting lets in twice as much light as the next faster setting, half as much as the next slower set-

ting: 1/250 sec. lets in twice as much light as 1/500 sec., half as much as 1/125 sec. In automatic operation, shutter speeds are often "stepless," the camera can set the shutter to 1/225 sec., 1/200 sec., or whatever speed it calculates will produce a correct exposure.

A leaf shutter is usually built into the lens. The shutter consists of overlapping leaves that open during the exposure, then close again. The longer the shutter stays open, the more light reaches the film. Leaf shutters are found on most rangefinder cameras, view camera lenses, large-format single-lens reflex cameras, and twin-lens reflex cameras.

Blurring to show motion. Freezing motion is one way of representing it, but not the only way. In fact, freezing motion sometimes eliminates movement altogether so that the subject seems to be at rest. Allowing the subject to blur can be a graphic means of showing that it is moving.

1/30 sec.

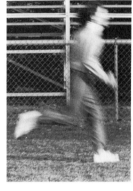

Slow shutter speed, subject blurred. The direction a subject is moving in relation to the camera can affect the sharpness of the picture. At a slow shutter speed, a jogger moving from left to right is not sharp.

1/30 sec.

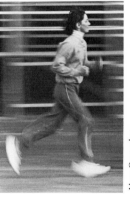

Slow shutter speed, subject sharp. Here the jogger is sharp even though photographed at the slow shutter speed that recorded blur in the first picture. Because she was moving directly toward the camera, her image did not cross enough of the film to blur.

Panning to show motion. Panning the camera—moving it in the same direction as the subject's movement during the exposure—is another way of showing motion (bottom right). The background will be blurred, but the subject will be sharper than it would if the camera was held steady.

1/125 sec.

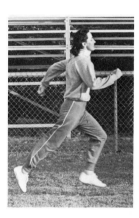

Fast shutter speed, subject sharp. Photographed at a faster shutter speed, the same jogger moving in the same direction is sharp. During the shorter exposure her image did not cross enough of the film to blur.

1/30 sec.

Alan Oransky

Panning with the jogger is another way to keep her relatively sharp. During the exposure the photographer moved the camera in the same direction that the jogger was moving.

Aperture: Affects light and depth of field

Light and the aperture. The aperture, or lens opening, is another control that you can use in addition to shutter speed to adjust the amount of light that reaches the film. Turning a ring on the outside of the lens (pushing a button on some cameras) changes the size of the aperture diaphragm, a ring of overlapping metal leaves inside the lens. (In automatic operation, the camera can do this for you.) Like the iris of your eye, the diaphragm can get larger (open up) to let more light in; it can get smaller (stop down) to decrease the amount of light.

Aperture affects amount of light

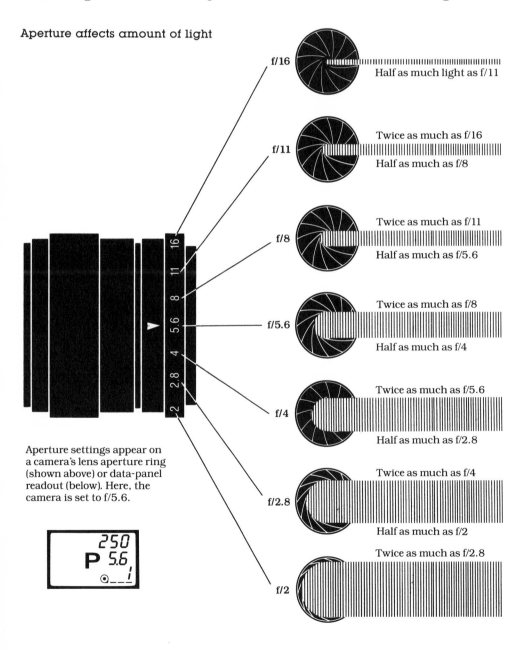

f/16 Half as much light as f/11

f/11 Twice as much as f/16
 Half as much as f/8

f/8 Twice as much as f/11
 Half as much as f/5.6

f/5.6 Twice as much as f/8
 Half as much as f/4

f/4 Twice as much as f/5.6
 Half as much as f/2.8

f/2.8 Twice as much as f/4
 Half as much as f/2

f/2 Twice as much as f/2.8

Aperture settings appear on a camera's lens aperture ring (shown above) or data-panel readout (below). Here, the camera is set to f/5.6.

Light and the aperture. The size of the lens opening—the aperture or f-stop—controls the amount of light that passes through the lens. Each aperture is one "stop" from the next; that is, each lets in twice as much light as the next smaller opening, half as much light as the next larger opening. Notice that the lower the f-stop number, the wider the lens opening. F/8 is a wider opening than f/11, which is wider than f/16, and so on.

Aperture settings (f-stops). Aperture settings, from larger lens openings to smaller ones, are f/1, f/1.4, f/2, f/2.8, f/4, f/5.6, f/8, f/11, f/16, f/22, f/32, f/45. Settings smaller than f/45 are seldom found except on some view camera lenses.

The lower the f-stop number, the wider the lens opening; each setting lets in twice as much light as the next f-stop number up the scale, half as much light as the next number down the scale. F/11 lets in double the light of f/16, half as much as f/8.

Referring to a "stop" is a shorthand way of stating this half-or-double relationship. You can give one stop more (twice as much) exposure by setting the aperture to its next wider opening, one stop less (half as much) exposure by stopping down the aperture to its next smaller opening.

No lens has the entire range of f/stops. A 50mm lens may range from f/2 at its widest opening to f/16 at its smallest, a 200mm lens may range from f/4 to f/22. Some cameras can set intermediate f-stops, for example, f/13, part way between f/11 and f/16.

Depth of field and the aperture. The size of the aperture setting also affects the relative sharpness of objects in the image, known as depth of field. In theory, only one distance from the lens, the plane of critical focus, can be sharply focused at one time. However, in practice, part of the scene near the plane of critical focus also appears acceptably sharp. As the aperture opening gets smaller, the depth of field increases and more of the scene from near to far appears sharp in the photograph. (See photos, right, and pages 32–35.)

Small aperture, more depth of field

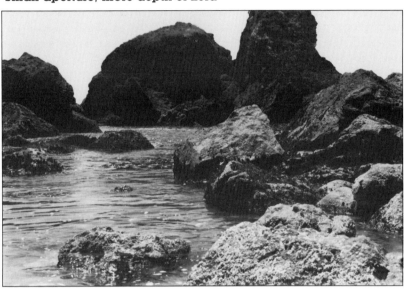

Large aperture, less depth of field

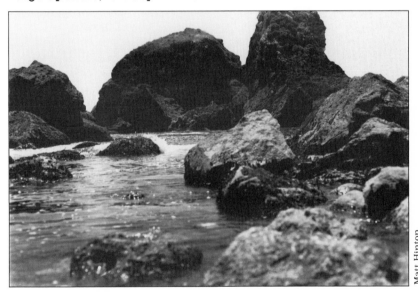

Matt Hinton

Depth of field and the aperture. The smaller the aperture opening, the greater the depth of field. At f/16 (above), the entire depth in the scene from foreground to background appears sharp. At a much larger aperture, f/2 (below), there is less depth of field and the rocks in the foreground are out of focus.

Shutter Speed and Aperture: Blur vs. depth of field

Controlling the exposure. Both shutter speed and aperture affect the amount of light reaching the film. To get a correctly exposed negative, one that is neither too light nor too dark, you need to find a combination of shutter speed and aperture that will let in the right amount of light for a particular scene and film. (Chapter 4, Exposure, pages 50–67, explains how to do this.)

Equivalent exposures. Once you know a correct combination of shutter speed and aperture, you can change one setting and still keep the exposure the same as long as you change the other setting in the opposite direction. If you want to use a smaller aperture (which lets in less light), you can keep the exposure the same by using a slower shutter speed (which lets in more light), and vice versa.

A stop of exposure change. Each f-stop setting of the aperture lets in half (or double) the amount of light as the adjoining setting, a 1-stop difference. Each shutter speed setting does the same. The term *stop* is used whether the aperture or shutter speed is changed. The exposure stays constant if, for example, a move to the next faster shutter speed (1 stop less exposure) is matched by a move to the next larger aperture (1 stop more exposure).

Which combination do you choose? Any of several combinations of shutter speed and aperture could expose the film correctly, but the effect on the sharpness of the image will be different. Shutter speed affects the sharpness of moving objects, aperture size affects depth of field (the sharpness of a scene from near to far).

You can decide for each picture whether stopped motion or depth of field is more important. More depth of field and near-to-far sharpness with a smaller aperture means you would be using a slower shutter speed, and so risking that motion would blur. Using a faster shutter speed to freeze motion means you would be using a larger aperture, with less of the scene sharp near to far. Depending on the situation, you may have to compromise on a moderate amount of depth of field with some possibility of blur.

Shutter speed and aperture combinations. Both the shutter speed and the aperture size control the amount of light that strikes the film. Each setting lets in half (or double) the amount of light as the adjacent setting—a 1-stop difference.

If you decrease the amount of light 1 stop by moving to the next smaller aperture setting, you can keep the exposure constant by also moving to the next slower shutter speed. In automatic operation, the camera makes these changes for you.

Each combination of aperture and shutter speed shown at left lets in the same amount of light; but see the photographs opposite: the combinations change the sharpness of the picture in different ways.

	Slower shutter speed: More light reaches film More chance of motion blurring			Faster shutter speed: Less light reaches film Less chance of motion blurring		

Shutter speed	1/8 sec.	1/15	1/30	1/60	1/125	1/250	1/500

Aperture	f/16	f/11	f/8	f/5.6	f/4	f/2.8	f/2

	Smaller aperture: Less light reaches film More depth of field			Larger aperture: More light reaches film Less depth of field		

Shutter speed and aperture combinations. [Each of] the combinations for this scene lets in the same total amount of light, so the overall exposure stayed the same. But the motion of the swing is blurred with a slow shutter speed, sharp with a fast shutter speed. The depth of field (overall sharpness of near to far objects) extends farther with a small aperture, less far with a larger aperture.

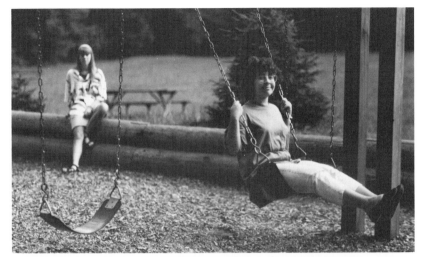

Fast shutter speed (1/500 sec.): the moving swing is sharp. **Wide aperture** (f/2): the trees and woman in the background are out of focus.

Shutter speed

sec.	1/8	1/15	1/30	1/60	1/125	1/250	1/500
	f/16	f/11	f/8	f/5.6	f/4	f/2.8	f/2

Aperture

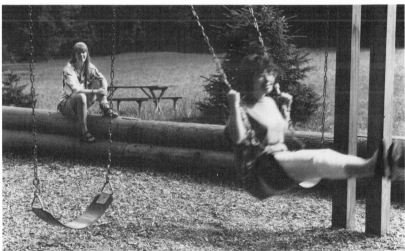

Medium-fast shutter speed (1/60 sec.): the moving swing shows some blur. **Medium-wide aperture** (f/5.6): the background is mostly sharp.

Shutter speed

sec.	1/8	1/15	1/30	1/60	1/125	1/250	1/500
	f/16	f/11	f/8	f/5.6	f/4	f/2.8	f/2

Aperture

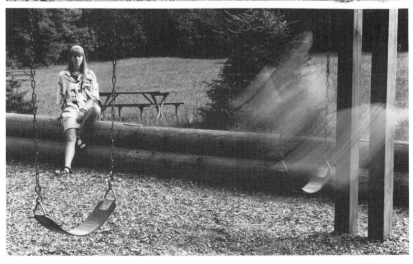

Slow shutter speed (1/8 sec.): the moving swing is completely blurred. **Small aperture** (f/16): the background is completely sharp.

Shutter speed

sec.	1/8	1/15	1/30	1/60	1/125	1/250	1/500
	f/16	f/11	f/8	f/5.6	f/4	f/2.8	f/2

Aperture

John Becker

Care of Camera and Lens

Cameras are remarkably sturdy instruments considering the precision mechanisms that they contain, but a reasonable amount of care in handling and maintaining a camera will more than repay you with longer, trouble-free life and better performance.

To protect a camera in use, use a neck strap, either worn around your neck or wound around your wrist. It keeps the camera handy and makes you less likely to drop it. Eveready cases enclose the camera and have a front that folds down for picture-taking. They provide protection but can be tedious to take off and put on. Gadget bags are good for carrying extra items. Lenses can be kept in lens cases or plastic bags to protect them from dust, with lens caps both back and front for additional protection of lens surfaces. Aluminum cases with fitted foam compartments provide the best protection against jolts and jars; their disadvantage is that they are heavy and not conveniently carried on a shoulder strap. In high-theft areas, some photographers prefer a case that doesn't look like a camera case—for example, a sports bag or a small backpack. A beat-up case that looks as though it contains sneakers and a sweatsuit is less likely to be stolen than one that shouts "cameras."

Battery power is essential to the functioning of most cameras. If your viewfinder display or other data display begins to act erratically, the batteries may be getting weak. Many cameras have a battery check that will let you test battery strength. It's a good idea to check batteries before beginning a day's shooting or a vacation outing and to carry spares in your camera bag. If you don't have spares and the batteries fail, try cleaning the ends of the batteries and the battery contacts in the camera with a pencil eraser or cloth; the problem may just be poor electrical contact. Warming the batteries in the palm of your hand might also bring them back to life temporarily.

Cameras and film in transit should be protected from excessive heat; for example, avoid putting them in a glove compartment on a hot day. Excessive heat not only damages the quality of film, it can also soften the oil lubricant in the camera, causing the oil to run out and cause mischief such as jamming lens diaphragm blades. At very low temperatures, meter batteries and other mechanisms may be sluggish, so on a cold day it is a good idea to keep the camera warm by carrying it under your coat until you're ready to take a picture. On the beach, protection from salt spray and sand is vital.

If a camera will not be used for a while, push the shutter release button so that the shutter is not cocked, turn off any on/off switches, and store the camera away from excessive heat, humidity, and dust. Operate the shutter occasionally, because it can become balky if not used. For long-term storage, remove batteries because they can corrode and leak.

Protecting a camera from dust and dirt is the primary purpose of ordinary camera care. Load and unload film or change lenses in a dust-free place if you possibly can. When changing film, blow or brush around the camera's film-winding mechanism and along the film path. This will remove dust as well as tiny bits of film that can break off and work into the camera's mechanisms. Be careful of the shutter curtain when doing this; it is delicate and should be touched only with extreme care. You may want to blow occasional dust off the focusing mirror or screen, but a competent camera technician should do any work beyond this. Use the right equipment for the job: to blow, a

rubber squeeze bulb, like an ear syringe; to brush, a soft brush designed for photo use. A can of compressed gas produces more force than a rubber squeeze bulb, but contains ozone-damaging chlorofluorocarbon (CFC). If you still decide to use it, at least buy a type like Dust-Off Plus that has a reduced level of CFC. Never lubricate any part of the camera yourself.

The lens surface must be clean for best performance, but keeping dirt off it in the first place is much better than too-frequent cleaning, which can damage the delicate lens coating. Particularly avoid touching the lens surface with your fingers, because they can leave oily prints that may corrode the coating. Keep a lens cap on the front of the lens when it is not in use and on the back of the lens as well if the lens is removed from the camera. During use, a lens hood helps protect the lens surface in addition to shielding the lens from stray light that may degrade the image. UV (ultraviolet) and 1A filters are designed for use with color film, but have no adverse effect on black-and-white film, so some photographers leave one on the lens all the time for protection against dirt and accidental damage.

To clean the lens you will need a rubber squeeze bulb, a soft brush, lens tissue, and lens cleaning fluid. Avoid using cleaning products made for eyeglasses; they are too harsh for lens surfaces. A clean cloth or paper tissue is usable in an emergency, but lens tissue is much better.

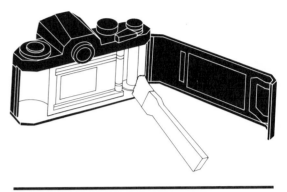

Cleaning inside the camera. When you blow or dust inside the camera, tip the camera so the dust falls out and isn't pushed farther into the mechanism. Do not touch the delicate shutter curtain unless absolutely necessary.

Cleaning the lens. First, blow or brush any visible dust off the lens surface. Holding the lens upside down helps the dust fall off the surface instead of just circulating on it.

Using lens cleaning fluid. Dampen a wadded piece of tissue with the fluid and gently wipe the lens with a circular motion. Don't put lens fluid directly on the lens because it can run to the edge and soak into the barrel. Finish with a gentle, circular wipe using a dry tissue.

2 Lens

Lois Bernstein

Forming an image. Although a good lens is essential for making crisp, sharp photographs, you don't actually need one to take pictures. A primitive camera can be constructed from little more than a shoebox with a tiny pinhole at one end and a piece of film at the other. A pinhole won't do as well as a lens, but it does form an image of objects in front of it.

A simple lens, such as a magnifying glass, will also form an image—one that is brighter and sharper than an image formed by a pinhole. But a simple lens has many optical defects or aberrations that prevent it from forming an image that is sharp and accurate. A modern compound lens eliminates these aberrations by combining several lens elements made of different kinds of glass and ground to different thicknesses and curvatures so that in effect they cancel out each other's aberrations.

The main function of lenses is to project a sharp image onto the film. Lenses vary in design; different types perform some jobs better than others. The two major differences are speed and focal length.

Lens speed is not the same as shutter speed; it is the widest aperture to which the lens diaphragm can be opened. A lens that is "faster" than another opens to a wider aperture and admits more light; it can be used in dimmer light or at a faster shutter speed.

Lens focal length is the most important characteristic of a lens. One of the prime advantages of a single-lens reflex camera or a view camera is the interchangeability of its lenses; the reason photographers own more than one lens is so that they can change lens focal length. More about focal length on the following pages.

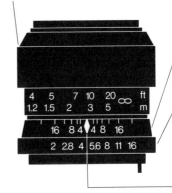

Focusing ring rotates to bring different parts of the scene into focus.

Depth-of-field scale shows how much of the scene will be sharp at a given aperture (explained in detail on page 34).

Aperture-control ring selects the f-stop or size of the lens opening.

Distance marker indicates on the **distance scale** the distance in feet and meters on which the lens is focused.

On the lens barrel (top) are controls such as a ring that focuses the lens. Cameras and lenses vary in design, so check the features of your own camera. For example, some cameras have push-button controls on the camera body instead of an aperture-control ring on the lens. Engraved around the front of the lens (bottom) are its focal length and other information.

Focal length. The shorter the focal length, the wider the view of a scene. The longer the focal length, the narrower the view and the more the subject is magnified.

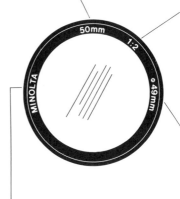

Maximum aperture. The lens's widest opening or speed. Appears as a ratio, 1:2. The maximum aperture is the last part of the ratio, f/2.

Filter size. The diameter in mm of the lens, and so the filter size needed to fit the lens.

Manufacturer.

Lens Focal Length: The basic difference between lenses

Photographers generally describe lenses in terms of their focal length; they refer to a normal, long, or short lens, a 100mm lens, a 75-150mm zoom lens, and so on. Focal length affects the image formed on the film in two important and related ways: the amount of the scene shown (the angle of view) and thus the size of objects (their magnification).

How focal length affects an image. The shorter the focal length of a lens, the more of a scene the lens takes in and the smaller it makes each object in the scene appear in the image. You can demonstrate this by looking through a circle formed by your thumb and forefinger. The shorter the distance between your hand (the lens) and your eye (the film), the more of the scene you will see (the greater the angle of view). The more objects that are shown on the same size negative, the smaller all of them will have to be (the less magnification). This is similar to filling a negative either with an image of one person's head or with a group of twenty people. In the group portrait, each person's head is smaller.

Interchangeable lenses are convenient. The amount of the scene shown and the size of objects can also be changed by moving the camera closer to or farther from the subject, but the additional option of changing lens focal length gives you much more flexibility and control. Sometimes it is impossible to get closer to your subject—for example, if you are standing on shore photographing a boat on a lake. Sometimes it is difficult to get far enough away, as when you are photographing a large group of people in a small room.

With a camera that accepts different lenses, such as a single-lens reflex camera, you can remove one lens and put on another when you want to change focal length. Interchangeable lenses range from super-wide-angle fisheye lenses to extralong telephotos. A zoom lens is a single lens with adjustable focal lengths.

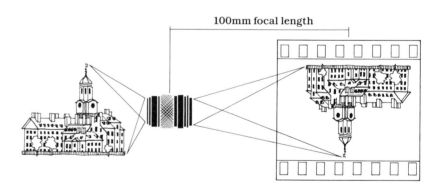

100mm focal length

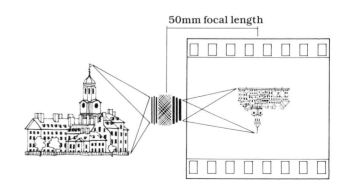

50mm focal length

Focal length is measured from an optical point in a lens to the image it forms on the film. It is measured when the lens is sharply focused on an object in the far distance (technically known as infinity). Magnification, the size of an object in an image, is directly related to focal length. As the focal length increases, the size of the object increases. A 100mm lens produces an image twice as large as one produced by a 50mm lens.

24mm
focal
length

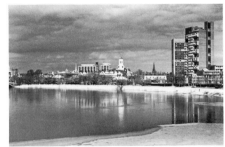

50mm
focal length

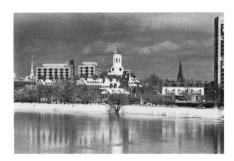

100mm
focal length

84°
angle of view

47°
angle of view

24°
angle of view

Alan Oransky

200mm
focal length

500mm
focal length

1000mm
focal length

12°
angle of view

5°
angle of view

2.5°
angle of view

What happens when you change lens focal length?
With a given size of film, the amount of a scene in-
cluded in the image (angle of view) and the size of
objects (magnification) are changed if the focal
length of the lens is changed. To make this se-
quence, the photographer changed only the focal
length of the lenses, while the distance from lens to
subject remained the same. As the focal length in-
creased, for example, from 24mm to 50mm, the an-
gle of view narrowed and the size of objects in-
creased.

Normal Focal Length: The most like human vision

A lens of normal focal length, as you might expect from the name, produces an image on film that seems normal when compared with human vision. The image includes about the same angle of view as the human eye sees clearly when looking straight ahead, and the relative size and spacing of near and far objects appear normal. For 35mm cameras, this effect is produced by a lens of about 50mm focal length; 35mm single-lens reflex cameras typically are fitted by manufacturers with lenses of that length.

The size of the film used in a particular camera determines what focal length is normal for that camera; cameras that use film sizes larger than 35mm have proportionately longer focal lengths for their normal lenses. Normal focal length for a film format of 2¼ x 2¼ inches is 80mm. Normal for a view camera with 4 x 5-inch film is 150mm.

Normal lenses have many advantages. Compared with those of much shorter or much longer focal length, normal lenses are generally faster: they can be designed with wider maximum apertures to admit the maximum amount of light. Therefore, they are convenient for use in relatively dim light, especially where action is involved, as in theater or indoor sports scenes or in low light levels outdoors. They are a good choice if the camera is to be hand held because a wide maximum aperture permits a shutter speed fast enough to prevent blur caused by camera movement during exposure. Generally, the normal lens is more compact and lighter in weight, as well as somewhat less expensive, than lenses of much longer or much shorter focal length.

Choice of focal length is a matter of personal preference. Many photographers with 35mm cameras use a lens with a focal length of 35mm rather than 50mm as their normal lens because they like its wider view and greater depth of field. Some photographers use an 85mm lens because they prefer its narrower view, which can concentrate the image on the central objects of interest in the scene.

Walter Palmer

◄ **A lens of normal focal length** produces an image that appears similar to that of normal human vision. The amount of the scene included in the image and the relative size and placement of near and far objects are what you would expect to see if you were standing next to the camera. The scene does not appear exaggerated in depth, as it might with a short-focal-length lens, nor do the objects seem compressed and too close together, as sometimes happens with a long-focal-length lens.

Long Focal Length: Telephoto lenses

A lens of long focal length seems to bring things closer, just as a telescope does. As the focal length gets longer, less of the scene is shown (the angle of view narrows), but what is shown is enlarged (the magnification increases). This is useful when you are so far from the subject that a lens of normal focal length produces an image that is too small. Sometimes you can't get really close—at a sports event, for example; sometimes it is better to stay at a distance, as in nature photography. An intercepted pass, the President descending from Air Force One, and an erupting volcano are all possible subjects for which you might want a long lens.

A long lens has relatively little depth of field. When you use long lenses, you'll also notice that as the focal length increases, depth of field decreases so that less of the scene is in focus at any given f-stop. For example, a 200mm lens at f/8 has less depth of field than a 100mm lens at f/8. Sometimes this is inconvenient—for example, if you want objects to be sharp both in the foreground of a scene and in the background. But it can also work to your advantage by permitting you to minimize unimportant details or a busy background by photographing them out of focus.

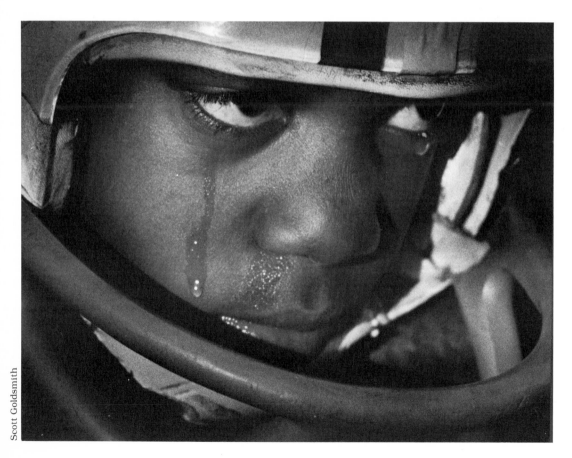

Scott Goldsmith

A long lens enlarges a distant subject. Photographer Scott Goldsmith was standing on the sidelines at the moment that a 6th grade football player on the field realized that his team was too far behind to win the city championship. Goldsmith's 180mm lens on his 35mm camera brought the boy's face close.

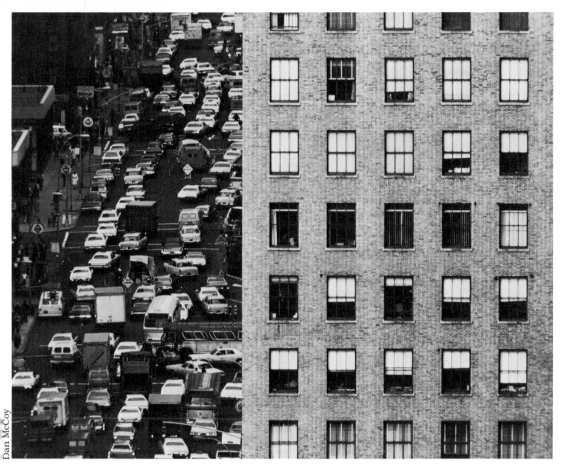

Dan McCoy

A long lens can seem to compress space. Though traffic was heavy in New York on the day this picture was taken, a long-focal-length lens made the scene look even more crowded than it was. When do you get this effect, and why? See pages 36–37 to find out.

How long is a long lens? A popular medium-long lens for a 35mm camera is 105mm; this focal length magnifies your view significantly, but not so much that the lens's usefulness is limited to special situations. A lens of 150mm has a comparably long focal length for a camera with a 2¼-inch format, 300mm for a 4 x 5 view camera. The difference between a medium-long lens and an extremely long one (for example, a 500mm lens with a 35mm camera) is rather like that between a pair of binoculars and a high-power telescope. You may want a telescope occasionally, but wouldn't need, or even want, one for general use.

A medium-long lens is particularly useful for portraits because the photographer can be relatively far from the subject and still fill the image frame. Many people feel more at ease when photographed if the camera is not too close. Also, a moderate distance between camera and subject prevents the distortion of facial features closest to the camera that occurs when a lens is used very close. A good working distance for a head-and-shoulders portrait is 6-8 ft. (2-2.5 m), easy to do with a medium-long lens of from 85-135mm focal length with a 35mm camera.

A long lens, compared with one of normal focal length, is larger, heavier, and somewhat more expensive. Its largest aperture is relatively small; f/4 or f/5.6 is common. It must be focused carefully because with its shallow depth of field there will be a distinct difference between objects that are sharply focused and those that are not. A faster shutter speed is needed to hand hold the camera or a tripod should be used for support because the enlarged image magnifies the effect of even a slight movement of the lens during exposure. These disadvantages increase as the focal length increases, but so do the long lens's unique image-forming characteristics.

Short Focal Length: Wide-angle lenses

Lenses of short focal length are also called wide-angle or sometimes wide-field lenses, which describes their most important feature—they view a wider angle of a scene than normal. A lens of normal focal length records what you see when you look at a scene with eyes fixed in one position. A wide-angle lens records what you see when you move your vision from side to side. A 35mm focal length records the 63° angle of view that you see if you move your eyes slightly from side to side. A 7.5mm fisheye lens records the 180° angle you see if you turn your whole head to look over your left shoulder and then over your right shoulder.

A popular short focal length for a 35mm camera is 28mm. Comparable focal lengths are 55mm for a camera with 2¼-inch format, 90mm for a 4 x 5 view camera.

A short lens can have great depth of field. The shorter the focal length of a lens, the more of a scene will be sharp (if the f-stop and distance from the subject remain unchanged). A 28mm lens, for example, stopped down to f/8 can be sharp from less than 6.5 ft. (2 m) to infinity (as far as the eye or lens can see), which often will eliminate the need for further focusing as long as the subject is within the range of distances that will be sharp.

Wide-angle "distortion." A wide-angle lens can seem to distort an image and produce strange perspective effects. Sometimes these effects are actually caused by the lens, as with a fisheye lens (page 29). But, more often, what seems to be distortion in an image made with a wide-angle lens is caused by the photographer shooting very close to the subject.

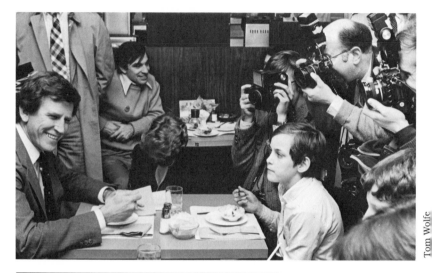

Tom Wolfe

Short lenses are popular with photojournalists, feature photographers, and others who shoot in fast-moving and sometimes crowded situations. For example, many photojournalists with 35mm cameras regularly use 35mm or 28mm lenses instead of 50mm lenses. These medium-short lenses give a wider angle of view than a 50mm lens, which makes it easier to photograph in close quarters. Medium-short lenses also have more depth of field, which can let a photographer focus the lens approximately instead of having to fine-focus every shot. Here, a political candidate on the campaign trail enjoys a dish of ice cream with a somewhat doubtful young constituent and several press photographers, who are all using wide-angle lenses.

A 28mm lens, for example, will focus as close as 1 ft. (0.3 m), and shorter lenses even closer. Any object seen from close up appears larger than an object of the same size that is at a distance. While you are at a scene, your brain knows whether you are very close to an object, and ordinarily you would not notice any visual exaggeration. In a photograph, however, you notice size comparisons immediately. See photographs at right.

Short lenses show a wide view. Short-focal-length lenses are useful for including a wide view of an area. They have great depth of field so that objects both close to the lens and far from it will be in focus, even at a relatively large aperture.

Objects up close appear larger. A short lens can produce strange perspective effects. Since it can be focused at very close range, it can make objects in the foreground large in relation to those in the background. With the lens close to the statue, it looks larger relative to the buildings behind it than it does in the photograph above.

Fredrik D. Bodin

Zoom, Macro, and Fisheye Lenses

In addition to the usual range of short-, normal-, and long-focal-length lenses, other lenses can view a scene in a new way or solve certain problems with ease.

Zoom lenses are popular because they combine a range of focal lengths into one lens (see below). The glass elements of the lens can be moved in relation to each other; thus infinitely variable focal lengths are available within the limits of the zooming range. Using a 50-135mm zoom, for example, is like having a 50mm, 85mm, and 135mm lens instantly available, plus any focal length in between. Compared to fixed-focal-length lenses, zooms are somewhat more expensive, bulkier, and heavier, but one of them will replace two or more fixed-focal-length lenses. Zoom lenses are best used where light is ample because they have a relatively small maximum aperture. New designs produce a much sharper image than earlier zoom lenses, which were significantly less sharp than fixed-focal-length lenses.

Macro lenses are used for close-up photography (opposite, top). Their optical design corrects for the lens aberrations that cause problems at very short focusing distances, but they can also be used at normal distances. Their main disadvantage is relatively small maximum aperture, often about f/3.5 for a 50mm lens. (More about close-up photography on pages 136–139.)

Macro-zoom lenses combine both macro and zoom features. They focus relatively close, though usually not as close as a fixed-focal-length macro lens, and give you a range of focal length choices in one lens.

Fisheye lenses have a very wide angle of view—up to 180°—and they exaggerate to an extreme degree differences in size between objects that are close to the camera and those that are farther away. They actually distort the image by bending straight lines at the edges of the picture (opposite, bottom).

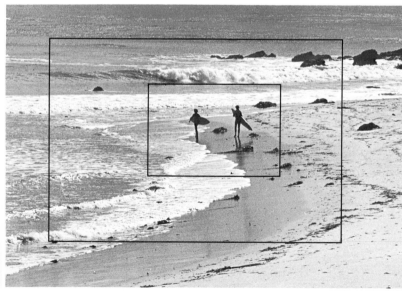

Richard Frear

A zoom lens gives you a choice of different focal lengths within the same lens. The rectangles overlaid on the picture show some of the ways you could have made this photograph by zooming in to shoot at a long focal length or zooming back to shoot at a shorter one.

A macro lens enabled the photographer to move in very close to this denizen of the Florida Everglades without having to use supplemental close-up attachments such as extension tubes.

Fred Ward

A fisheye lens bent the buildings in this city scene into a round globe shape. Objects at the edge of the fisheye's image circle are distorted more than they are at the center.

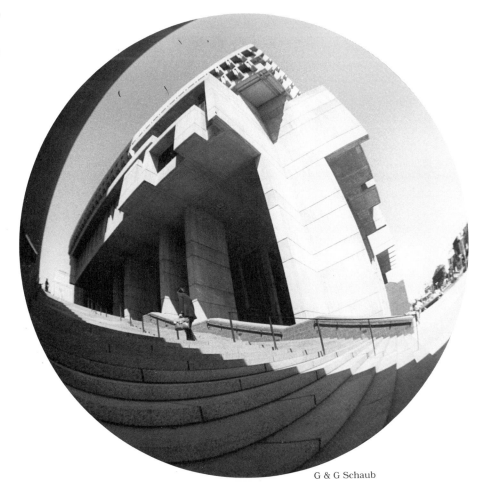

G & G Schaub

Focus and Depth of Field

Sharp focus attracts the eye. Sharp focus acts as a signal to pay attention to a particular part of a photograph, especially if other parts of the image are not as sharp. If part of a picture is sharp and part is out of focus, it is natural to look first at the sharply focused area (see photographs, page 153). When you are photographing, it is also natural to focus the camera sharply on the most important area. You can select and, to a certain extent, control which parts of a scene will be sharp.

When you focus a camera on an object, the distance between lens and film is adjusted by rotating the lens barrel until the object appears sharp on the viewing screen. You focus manually by turning the focusing ring on the lens barrel. If you are using an automatic-focus camera, you focus by partially depressing the shutter-release button.

Depth of field. In theory a lens can only focus on one single distance at a time (the plane of critical focus) and objects at all other distances will be less sharp. But in most cases part of the scene will be acceptably sharp both in front of and behind the most sharply focused plane. Objects will gradually become more and more out of focus the farther they are from the sharply focused area. This depth within which objects appear acceptably sharp in the image—the depth of field—can be increased or decreased (see pages 32–33).

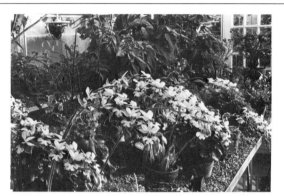

Alan Oransky

Depth of field is the part of a scene that appears acceptably sharp in a photograph. Depth of field can be deep, with everything sharp from near to far. Here it extends from the flowers in the foreground to the greenhouse windows in the background. The photographer actually focused on some flowers in the third row of pots.

For another picture the photographer wanted shallow depth of field, with only some of the scene sharp. Here the only sharp part of the picture is the flower on which the lens was focused.

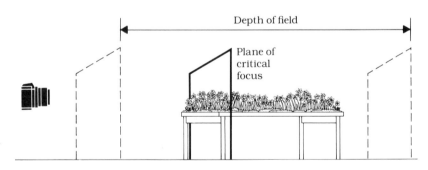

Imagine the plane of critical focus (the distance on which you focus the lens) to be something like a pane of glass stretched from one side of the scene to the other. Objects that lie along that plane will be sharp. In front of and behind the plane of critical focus lies the depth of field, the area that will appear acceptably sharp. The farther that objects are from the plane of critical focus in a particular photograph, either toward the camera or away from it, the less sharp they will be.

Notice that the depth of field extends about one-third in front of the plane of critical focus, two-thirds behind it. This is true at normal focusing distances, but when focusing very close to a subject, the depth of field is more evenly divided, about half in front, half behind the plane of critical focus.

Automatic Focus

Automatic focus can mean out of focus when a scene has a main subject (or subjects) off to one side and at a different distance from whatever object is at the center. The camera focuses on the object at the center of the frame, here within the small bracketed area.

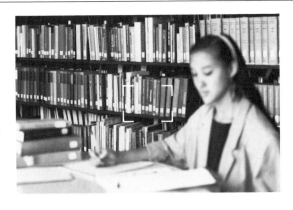

To correct this, first focus by placing the auto-focus brackets on the main subject and partially pressing down the shutter-release button. Lock the focus by keeping partial pressure on the shutter release.

Reframe your picture while keeping partial pressure on the shutter release. Push the shutter button all the way down to make the exposure.

Thomas E. Forsyth

Automatic focus used to be found only on point-and-shoot snapshot cameras. But increasingly it is standard equipment on new 35mm single-lens reflex cameras. When you push down the shutter-release button part way, the camera adjusts the lens to focus sharply on whatever object is at the center of the viewing screen.

Sometimes you will want to focus the camera manually. Just as with automatic exposure, there will be times when you will want to override the automatic mechanism and focus the camera yourself. Almost all 35mm single-lens reflex cameras with automatic focus will also let you focus manually.

The most common problem occurs when your subject is at the side of the frame, not at the center (see illustrations, left). A camera may also have problems focusing if a subject has very low contrast, is in very dim light, or consists of a repetitive pattern.

Moving subjects can also cause problems. It takes a second or two for the autofocus mechanism to adjust the lens, and that can be long enough for a fast-moving subject, such as a race car, to move out of range. The lens may "hunt" back and forth, unable to focus at all or maybe making an exposure with the subject out of focus.

Some cameras have more sophisticated electronics to deal with these problems better. See the instructions for your camera.

Take a moment to evaluate each situation. Override the automatic system when it is better to do so, rather than assume that the right part of the picture will be sharp simply because you are set for automatic focus.

Depth of Field: Controlling sharpness in a photograph

Depth of field. Dead sharp from foreground to background, totally out of focus except for a shallow zone, or sharp to any extent in between—you can choose how much of your image will be sharp. When you make a picture you can manipulate three factors that affect the depth of field, the distance in a scene between the nearest and farthest points that appear sharp in a photograph (illustrations opposite). Notice that doing so can change the image in other ways.

Aperture size. Stopping down the lens to a smaller aperture, for example, from f/2 to f/16, increases the depth of field. As the aperture gets smaller, more of the scene will be sharp in the print.

Focal length. Using a shorter-focal-length lens also increases the depth of field at any given f-number. For example, more of a scene will be sharp when photographed with a 50mm lens at f/8 than with a 200mm lens at f/8.

Lens-to-subject distance. Moving farther away from the subject increases the depth of field most of all, particularly if you started out very close to the subject.

Lois Bernstein

With the main subject sharply focused and the background out of focus, the player and umpire in the foreground are distinctly separated from the jumble of people on the sidelines in the background. When depth of field is shallow, only a narrow band of objects across the photograph appears sharp. Here, the photographer was using a long-focal-length lens at a wide aperture, both of which contribute to shallow depth of field. The lens was focused on the player and umpire in the foreground, while the background was far enough away to be out of focus.

Large aperture

Fredrik D. Bodin

Small aperture

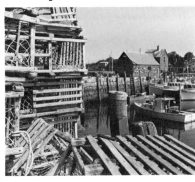

The smaller the aperture (with a given lens), the greater the depth of field. Using a smaller aperture for the picture on the right increased the depth of field and made the image much sharper overall. With the smaller aperture, the amount of light reaching the film decreased, so a slower shutter speed had to be used to keep the total exposure the same.

Long lens

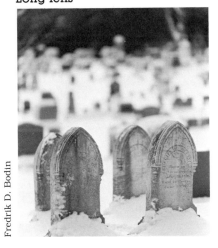

Fredrik D. Bodin

Short lens

The shorter the focal length of the lens, the greater the depth of field. Notice that changing to a shorter focal length for the picture on the right not only increased the depth of field but also changed the angle of view (the amount of the scene shown) and the magnification of objects in the scene.

Up close

Fredrik D. Bodin

Farther back

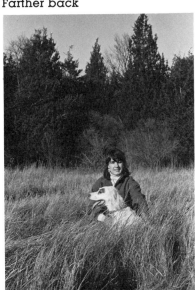

The farther you are from a subject, the greater the depth of field. The photographer stepped back to take the picture on the right. If you focus on an object far enough away, the lens will form a sharp image of all objects from that point out to infinity.

Lens　**33**

More About Depth of Field: How to preview it

When photographing a scene, you will often want to know the extent of the depth of field—how much of the scene from near to far will be sharp. You may want to be sure that certain objects are sharp. Or you may want something deliberately out of focus, such as a distracting background. To control what is sharp, it is useful to have some way of gauging the depth of field.

Checking the depth of field. With a single-lens reflex camera, you view the scene through the lens. The lens aperture is ordinarily wide open for viewing to make the viewfinder image as bright as can be, so you see the scene with the depth of field at its shallowest. When you press the shutter release, the lens automatically stops down to the taking aperture and the depth of field increases. Some single-lens reflex cameras have a previewing mechanism so that, if you wish, you can stop down the lens to view the scene at the taking aperture and see how much will be sharp.

However, if the lens is set to a very small aperture, the stopped-down image on the viewing screen may be too dark to be seen clearly. If so, you may be able to read the nearest and farthest limits of the depth of field on a depth-of-field scale on the lens barrel (this page, bottom). Manufacturers sometimes provide printed tables showing the depth of field for different lenses at various focusing distances and f-stops.

Depth of field with a view camera, which also views through the lens, can be seen on the ground-glass viewing screen when the lens is stopped down to the taking aperture. A rangefinder camera shows you the scene through a viewfinder, a small window in the camera body through which all objects look equally sharp. A depth-of-field scale on the lens barrel is your best means for estimating depth of field with a rangefinder camera.

Zone focusing for action. Knowing the depth of field in advance is useful when you want to preset the lens to be ready for an action shot without last-minute focusing. Zone focusing uses the depth-of-field scale on the lens to set the focus and aperture so that the action will be photographed well within the depth of field (see this page).

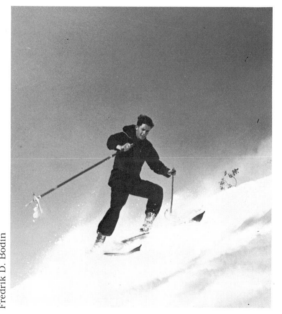

Fredrik D. Bodin

Depth of field

Distance scale lines up opposite the pointer to show the distance from the camera to the most sharply focused object.

Depth-of-field scale lines up opposite the distance scale to show the range of distances that will be sharp at various apertures.

Aperture ring lines up opposite the pointer to show the aperture to which the lens is set.

With zone focusing you can be ready for an action shot by focusing in advance, if you know approximately where the action will take place. Suppose you are on a ski slope and you want to photograph a skier coming down the hill. The nearest point at which you might want to take the picture is 15 ft. (4.5 m) from the action; the farthest is 30 ft. (9 m).

Line up the distance scale so that these two distances are opposite a pair of f-stop indicators on the depth-of-field scale (with the lens shown below, the two distances fall opposite the f/16 indicators). Now, if your aperture is set to f/16 or smaller, everything from 15-30 ft. (4.5-9 m) will be within the depth of field and in focus.

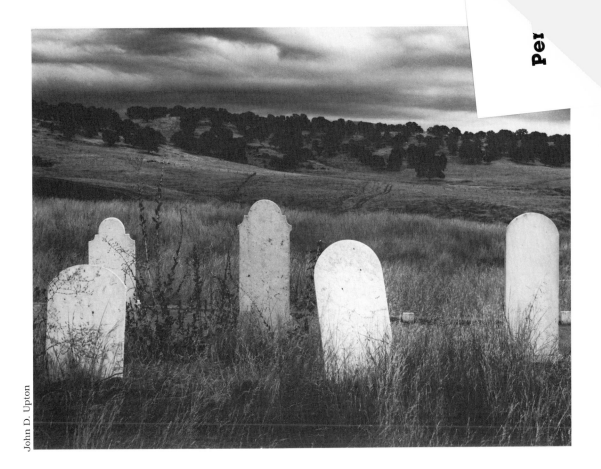

John D. Upton

Depth of field

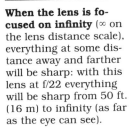

Depth of field

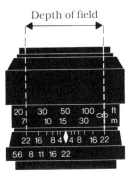

Focusing for the greatest depth of field.
When you are shooting a scene that includes important objects at a long distance as well as some that are closer, you will want maximum depth of field. Shown here is a way of setting the lens to permit as much as possible of the scene to be sharp. Work these examples through on your own lens as you read. You'll need a lens that has a depth-of-field scale.

When the lens is focused on infinity (∞ on the lens distance scale), everything at some distance away and farther will be sharp: with this lens at f/22 everything will be sharp from 50 ft. (16 m) to infinity (as far as the eye can see).

You can increase the depth of field even more if, instead of focusing on infinity, you set the infinity mark ∞ opposite the point on the depth-of-field scale (22) that shows the f-stop you are using (f/22). You are now focused on a distance (50 ft., 16 m) slightly closer than infinity (technically called the hyperfocal distance). Now everything from 23 ft. (7 m) to the far background is within the depth of field and will be sharp in the print.

Perspective: The impression of depth.
Few lenses (except for the fisheye) actually distort the scene they show. The perspective in a photograph—the apparent size and shape of objects and the impression of depth—is what you would see if you were standing at camera position. Why then do some photographs seem to have an exaggerated depth, with the subject appearing stretched and expanded (this page, top), whereas other photographs seem to show a compressed space, with objects crowded very close together (this page, bottom)? The brain judges depth in a photograph mostly by comparing objects in the foreground with those in the background; the greater the size differences perceived, the greater the impression of depth. When viewing an actual scene, the brain has other clues to the distances and it disregards any apparent distortion in sizes. But when looking at a photograph, the brain uses relative sizes as the major clue.

How perspective is controlled in a photograph. Any lens moved in very close to the foreground of a scene increases the impression of depth by increasing the size of foreground objects relative to objects in the background. As shown opposite, perspective is not affected by changing the focal length of the lens if the camera remains at the same distance. However, it does change if the distance from lens to subject is changed.

Perspective can be exaggerated. Perspective effects are exaggerated when changes occur in both focal length and lens-to-subject distance. A short-focal-length lens used close to the subject increases differences in size because it is much closer to foreground objects than to those in the background. This increases the impression of depth. Distances appear expanded and sizes and shapes may appear distorted when scenes are photographed in this way.

The opposite effect occurs with a long-focal-length lens used far from the subject. Differences in sizes are decreased because the lens is relatively far from *all* objects. This decreases the apparent depth and sometimes seems to squeeze objects into a smaller space than they could occupy in reality.

Joe Wrinn

Expanded perspective. A short-focal-length lens used close to a subject stretches distances because it magnifies objects near the lens in relation to those that are far from the lens.

Fredrik D. Bodin

Compressed perspective. A long-focal-length lens used far from a subject compresses space. The lens is relatively far from both foreground and background, so size differences between near and far parts of the scene are minimized, as is the impression of depth.

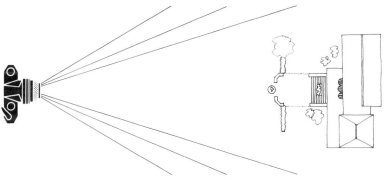

Changing focal length alone does not change perspective—the apparent size or shape of objects or their apparent position in depth. As the focal length was increased for the photographs above, the size of all the objects increased at the same rate. Thus, the impression of depth remained the same.

Alan Oransky

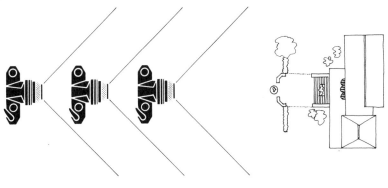

Lens-to-subject distance controls perspective. Perspective is changed when the distance from the lens to objects in the scene is changed. Here, though the focal length remained the same, the impression of depth increased as the camera was brought closer to the nearest part of the subject.

Lens Performance: Getting the most from a lens

Lens motion causes blur. Though some photographers claim to be able to hand hold their cameras steadily at slow shutter speeds—1/15 sec. or even slower—it takes only a slight amount of lens motion during exposure to cause a noticeable blur in an image. If a sharp picture is your aim, using a fast shutter speed or supporting the camera on a tripod is a much safer way to produce an image that will be sharp when enlarged.

Preventing blur due to camera motion. The focal length of the lens you are using determines how fast a shutter speed you need to keep an image acceptably sharp during a hand-held exposure. The longer the focal length, the faster the shutter speed must be, because a long lens magnifies any motion of the lens during the exposure just as it magnifies the size of the objects photographed. As a general rule, the slowest shutter speed that is safe to hand hold can be matched to the focal length of the lens. That is, a 50mm lens should be hand held at a shutter speed of 1/50 sec. or faster, a 100mm lens at 1/100 sec. or faster, and so on. This doesn't mean that the camera can be freely moved during the exposure. At these speeds the camera can be hand held, but with care. At the moment of exposure, hold your breath and squeeze the shutter release smoothly.

A tripod will help you in situations that require a slower shutter speed than is feasible for hand holding, for example, at dusk when the light is dim. A tripod is also useful when you want to compose a picture carefully or do close-up work. It is standard equipment for copy work, such as photographing another photograph or

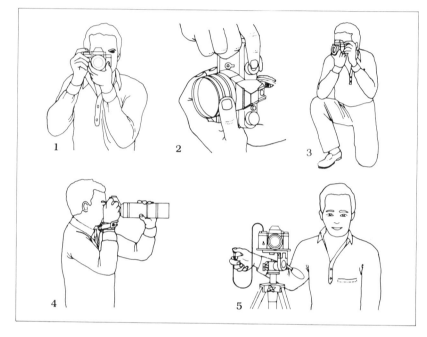

1. To hand hold a camera steadily, keep feet apart and rest the camera lightly against your face. Hold your breath and squeeze the shutter release gently.
2. With the camera in a vertical position, the right hand holds the camera and releases the shutter; the left hand focuses and helps steady the camera.

3. In kneeling position, kneel on one leg and rest your upper arm on the other knee. Leaning against a wall or a steady object will help brace your body.
4. With a long lens on the camera, use one hand to support the weight of the lens.

Winding the camera strap around your wrist helps to steady the camera and to prevent dropping it.
5. A tripod and cable release provide the steadiest support and are essential for slow shutter speeds if you want a sharp image.

something from a book, because hand holding at even a fast shutter speed will not give the critical sharpness that resolves fine details to the maximum degree possible. A cable release also helps by triggering the shutter without your having to touch the camera directly, so the camera stays absolutely still. A view camera is always used on a tripod.

Solving Camera and Lens Problems

From time to time, every photographer encounters negatives or prints that display unexpected problems. This section can help you identify the cause of a problem and how to prevent it in the future. See also Solving Exposure Problems, page 66; Negative Development Problems, page 86; Printing Problems, page 109; and Flash Problems, page 132.

Light streaks. Image area flared or foggy looking overall (darkened in a negative, lightened in a print or slide), with film edges unaffected. The image may also show ghosting or spots in the shape of the lens diaphragm, as in the print at right.

Cause: The sun, a bright bulb, or other light source was within the image, or bright light struck the lens at an angle.

Prevention: Expect some flare if you can see a light source in your viewfinder. The larger or brighter the light, the more flare you will get; distant or dim lights may not produce any flare at all. To prevent stray light from striking the lens, use the correct lens shade for your lens focal length.

Light streaks on film edges, as well as in image area.

Cause: The camera back was accidentally opened with film inside, light leaked into the film cassette, or light in the darkroom struck the film while it was being loaded or developed. Repeated exposure to X-ray screening at airports can fog film overall.

Prevention: Load and unload your camera in the shade, or at least block direct light with your body. Don't let bright light strike the film cassette or roll; put it back into its protective container or box until ready for development. At airports, have film that is in carry-on luggage hand inspected rather than X-rayed.

Vignetting. Image obscured around the edges (clear in a negative, dark in a print or slide).

Cause: A lens shade, filter, or both projected too far forward of the lens and partially blocked the image from reaching the lens.

Prevention: Lens shades are shaped to match different focal length lenses (see right, bottom). Use the correct shade for your lens; too long a lens shade can cause vignetting, but one that is too shallow will not provide adequate protection from flare. Using more than one filter or a filter plus a lens shade can cause vignetting, especially with a short lens.

Double exposures

Cause: If images overlap on entire roll, the film was put through the camera twice. If images overlap on one or a few frames, the film did not advance between exposures.

Prevention: Rewind 35mm film entirely back into the cassette, including the film leader; if you leave the film leader hanging out, you can mistake an exposed roll of film for an unexposed one and put it through the camera again. Accidentally pushing the film rewind button would let you release the shutter without having advanced the film. If double exposures are a repeated problem, have the film advance mechanism checked.

Light streaks

Fredrik D. Bodin

Vignetting

Fredrik D. Bodin

Lens shade

3 Film

Ellen Land-Weber

The light sensitivity of film. The most basic characteristic of film is that it is light-sensitive; it undergoes a chemical change when exposed to light. Light is energy, the visible part of the wavelike energy that extends in a continuum from radio waves through visible light to cosmic rays. These forms of energy differ only in their wavelength, the distance from the crest of one wave to the crest of the next. The visible part of this spectrum, the light that we see, ranges between 400 and 700 nanometers (billionths of a meter) in wavelength.

Not all films respond the same way to light. Silver halides, the light-sensitive part of film, respond primarily to blue and ultraviolet wavelengths, but dyes can be incorporated in the emulsion to increase their range of sensitivity. General-purpose black-and-white films are panchromatic (pan); they are designed to be sensitive to most wavelengths of the visible spectrum so that the image they record is similar to that perceived by the human eye. Some special-purpose films are designed to be sensitive to selected parts of the spectrum. Orthochromatic (ortho) black-and-white films are sensitive primarily to blue and green wavelengths. Infrared films are sensitive to infrared wavelengths that are invisible to the eye (see page 46).

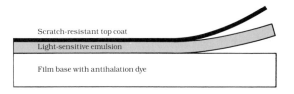

Film cross section. Film is made up of layers of different materials. On top is a tough coating that helps protect the film from scratches during ordinary handling. Next is a layer of gelatin emulsion that contains the light-sensitive part of the film, silver halide crystals—silver chloride, silver bromide, and silver iodide. (Color film has several layers of halides, each sensitive to a different part of the spectrum.) An adhesive bonds the emulsion to the base, a flexible support of either cellulose acetate or polyester. To prevent light rays from bouncing back through the film to add unwanted exposure to the emulsion, the film base contains an antihalation dye that absorbs light.

Light. When certain wavelengths of energy strike the human eye, they are perceived as light. Film is manufactured so that it undergoes changes when struck by this part of the electromagnetic energy spectrum. In addition, film can respond to certain wavelengths that the eye cannot see, such as ultraviolet and infrared light.

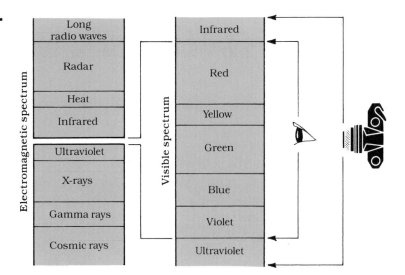

Selecting and Using Film

Buying film. Whatever kind of film you buy (see Selecting Film, opposite), check the expiration date printed on the film package before you make your purchase. The film may still be usable beyond that date but it will steadily deteriorate.

Storing film. Heat accelerates the deterioration of film, so avoid storing it in warm places such as the inside of a glove compartment on a hot day or the top of a radiator on a cold one. Room temperature is fine for short-term storage, but for longer storage a refrigerator or freezer is better. (Don't freeze Polaroid instant-picture film.) Be sure that the film to be chilled is in a moisture-proof wrapping, and when you remove the film from refrigeration, avoid condensation of moisture on the film surface by letting it come to room temperature before opening.

Loading. Light exposes film, and you want only the light that comes through the lens to strike the film. So, load and unload your camera away from strong light to avoid the possibility of stray light leaking into film cassettes and causing streaks of unwanted exposure. Outdoors, at least block direct sun by shading the camera with your body when loading it.

Airport security X-ray devices are supposed to be safe for film, but they can cause fogging of either unexposed or exposed but undeveloped film if the machines are not adjusted correctly or if the same film is subjected to repeated doses. You can ask to have film (and camera, if it is loaded) inspected by hand to reduce the possibility of X-ray damage.

John Running

A medium-speed film, ISO 125, was chosen for this photograph of a forest road. The fine grain and excellent sharpness of the film recorded every detail of the delicate shading on the tree trunks and intricate pattern of leaves. With a slow or medium-speed film, you can make large prints without the image showing significant graininess (see page 44).

A fast film, such as one rated at ISO 400, is good not only for action shots but for any situation in which the light is relatively dim and you want to work with a fast shutter speed or a small aperture.

Selecting film

Camera stores stock a great variety of films, but which one you select depends on only a few basic choices.

Do you want black and white or color? This book primarily covers black-and-white photography, as do most introductory photography courses, but see pages 48–49 for some basic information on color film.

Do you want a black-and-white print? If so, choose a black-and-white *negative film*, which will produce an image on the film in which the tones are the opposite of the original scene: light areas in the scene are dark in the negative, dark areas are light. The negative is then used to make a positive print in which the tones are similar to those in the original scene.

Do you want a transparency? A transparency is usually a positive color image on film. A slide is a transparency mounted in a small frame of cardboard or plastic so that it can be inserted in a projector or viewer. Choose a color *reversal film* if you want a transparency. During processing, the film tones are chemically reversed so that a positive image appears on the film.

Most reversal films are color, but if you want a black-and-white transparency, a few black-and-white films can be given reversal processing, for example, Kodak T-Max 100 processed in the T-Max 100 Direct Positive Film Developing Outfit. Polaroid makes instant films for 35mm black-and-white transparencies and color transparencies.

Do you want a color print? They are usually made from a color negative, but can be made from a color transparency (see page 48).

What film speed do you want? The faster the film speed rating, the less light needed for exposure. Slow films have a film speed of about ISO 50 or less; medium-speed films about ISO 100; fast films about ISO 400; ultra-fast films ISO 1000 or more. See pages 44–45 for more about film speed.

What size film and number of exposures do you want? The film size to buy depends on the format your camera accepts.

35mm film is packaged in cassettes, usually with 12, 24, or 36 exposures per roll, labeled 135-12, 135-24, or 135-36. Some 35mm films can be purchased in 50- or 100-foot rolls and hand loaded into cassettes. This reduces your cost per roll.

Roll film is wrapped around a spool and backed with a strip of opaque paper to protect it from light. (The term *roll* is also used in a general sense to refer to any film that is rolled rather than flat.) 120 roll film makes 12 2¼-inch-square negatives, or in some cameras, 8, 10, or 16 rectangular negatives, depending on the length of the format. Some cameras accept 220 roll film, which produces twice as many exposures per roll.

Sheet film or *cut film*, made in 4 x 5-inch and larger sizes, is used in view cameras. It must be loaded into film holders before use, and produces one exposure per sheet.

Do you want a film for a special purpose? *High contrast film* produces only two tones on the film—black or clear film base. The result is an image of only solid black or pure white tones, instead of the range of gray tones produced by conventional film (see page 46).

Infrared film responds to infrared wavelengths that the human eye cannot see (see pages 46–47).

Film Speed and Grain: The two go together

Film speed ratings. How sensitive a film is to light, that is, how much it reacts to a given quantity of light, is indicated by its film speed number. The more sensitive—or faster—the film, the higher its number in the rating system. (See opposite: Film speed ratings.)

A high film speed is often useful: the faster the film, the less exposure it needs to produce an image. Fast films are often used for photographing in dim light or when a fast shutter speed is important. But along with fast film speed go some other characteristics: most important, an increase in grain, plus some decrease in contrast and loss of sharpness. As the illustrations on this page show, the most detailed image was produced by the slow ISO 25 film. The very fast ISO 3200 film, by comparison, gave a relatively mottled, grainy effect and recorded less detail.

Graininess occurs when the bits of silver that form the image clump together. It is more likely to occur with fast films, which have large and small silver halide crystals, than it is with slower films, which have only small crystals. The effect is more noticeable in big enlargements or if the film is overexposed, if it is not processed at a consistent temperature, or if it is "pushed" to increase its film speed by special development.

What film speed should you use? Theoretically, for maximum sharpness you should choose the slowest film usable in a given situation. For practical purposes, however, most photographers load a medium-speed (ISO 100) film for general use. A higher-speed (ISO 400) film will be their choice for dimly lit subjects or high shutter speeds.

There is nothing necessarily wrong with grain. Some photographers even try to increase the graininess of their pictures

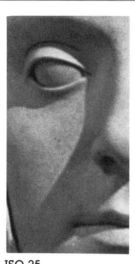 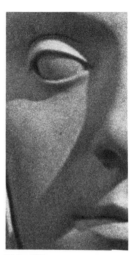 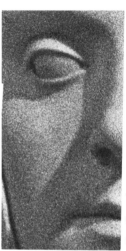

ISO 25 ISO 400 ISO 3200

Alan Oransky

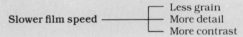

Slower film speed ——— Less grain / More detail / More contrast

because they like the textured look it can give, especially in extreme enlargements. Films like Ilford HP-5 and Kodak Tri-X, which both have a film speed of ISO 400, are relatively fine grained when exposed and developed normally, but increase considerably in grain when pushed. See Push Processing, page 84.

Kodak T-Max films have reduced grain for their speed. The shape of their silver crystals makes them more sensitive to light, but without a corresponding increase in grain. A caution: T-Max processing must be done exactly. Even a slight increase in time, temperature, or agitation during development causes a distinct increase in film contrast. Although Kodak Tri-X (ISO 400) is grainier than T-Max 400 (same film speed), Tri-X and other standard ISO 400 films continue to be used because they are easier to control with ordinary darkroom processing. Similarly, Plus-X Pan and other standard ISO 100 to 125-speed films remain popular, even though T-Max 100 has finer grain.

Film speed and grain. Generally speaking, the slower the film (the lower the ISO number), the finer the grain structure of the film and the more detailed the image the film records. Compare these extreme enlargements. Film speed also affects color film; for example, slower films have more accurate color reproduction.

Film speed ratings

Although there are different rating systems for film speeds, the most important point to remember is that the higher the number in a given system, the faster the film, and, so, the less light needed for a correct exposure.

The most common ratings found in English-speaking countries are **ISO** (International Organization for Standardization), **ASA** (American National Standards Institute), or **EI** (exposure index). All use the same numerical progression: each time the rating doubles, the film speed doubles. An ISO (or ASA or EI) 200 film is twice as fast as an ISO 100 film, half as fast as an ISO 400 film.

Sometimes the ISO rating includes the European **DIN** (Deutsche Industrie Norm) rating, for example, ISO 200/24°. In the DIN system the rating increases by 3 each time the film speed doubles. DIN 24 (equivalent to ISO 200) is twice as fast as DIN 21, half as fast as DIN 27. Except for the unlikely case of using a piece of equipment marked only with DIN numbers, you can ignore the DIN part of an ISO rating.

Larry Rana

▲

A fast film, ISO 400, let the photographer use a shutter speed of 1/500 sec., fast enough to guarantee that action would be sharp in the picture and fast enough to let him shoot freely, hand holding the camera, without fear that camera motion would blur the picture overall. A fast film is particularly important indoors or when light is dim, but was useful even in this scene outdoors where light was bright.

Daniel O. Todd

A medium-speed film, ISO 100, recorded good detail and texture in this forest scene. The image would be crisp and detailed even if enlarged to a much bigger size than shown here.

Special-Purpose Films: High contrast and infrared

Most films are designed to "see" as the human eye does and to respond to light in ways that appear realistic. But some films depart from the reality that we know.

High-contrast black-and-white film does not record a continuous range of tones from black through many shades of gray to white, as films of normal contrast do. Instead it translates each tone in a scene into either black or white (see illustration below). Any film can be processed for higher-than-normal contrast, but some films are specially made for high-contrast photography, such as Kodak Ektagraphic HC Slide Film.

Infrared black-and-white film is sensitized to wavelengths that are invisible to the human eye, the infrared waves that lie between visible red light and wavelengths that are produced by heat. Because the film responds to light that is not visible to the eye, it can be used to

photograph in the dark. The sun is a strong source of infrared radiation; tungsten filament lamps, flash bulbs, and electronic flash can also be used. Unusual and strangely beautiful images are possible because many materials reflect and absorb infrared radiation differently from visible light (see opposite). Grass, leaves, and other vegetation reflect infrared wavelengths very strongly and thus appear very bright, even white. Clouds too are highly reflective of infrared wavelengths, but since the blue sky does not contain them, it appears dark, even black, in a print.

Because infrared wavelengths are invisible, you cannot fully visualize in advance just what the print will look like—sometimes a frustration but sometimes an unexpected pleasure. The correct exposure is also something of a guess; most meters do not measure infrared light accurately. (See Using Infrared Film, opposite.) Infrared color film is also available.

Barbara London

High-contrast film changes the many shades of gray in an ordinary scene into a graphic abstraction of blacks and whites.

Peter Laytin

Infrared film records
leaves and grass as very
light. The result can be
a strangely dreamlike
landscape.

Using infrared film

Storage and loading. Infrared film can be fogged by exposure to heat or even slight exposure to infrared radiation. Do not buy infrared film that is not refrigerated, and once you have it, store it under refrigeration when possible. Load and unload the camera in total darkness, either in a darkroom or with the camera in a changing bag.

Focusing. Most lenses focus infrared wavelengths slightly differently from the way they focus visible light. With black-and-white infrared film, after focusing as usual, rack the lens forward very slightly as if you were focusing on an object closer to you. Some lenses have a red indexing mark on the lens barrel to show the adjustment needed. The difference is very slight, so unless depth of field is very shallow (as when you are photographing close up or at a large aperture), you can usually make do without any correction. No correction is needed for infrared color film.

Filtration. See manufacturer's instructions. Kodak recommends a No. 25 red filter for general use with black-and-white infrared film to enhance the infrared effect by absorbing the blue light to which the film is also sensitive. Kodak recommends a No. 12 minus-blue filter for general use with color infrared film.

Exposure. A general-purpose exposure meter, whether built into the camera or hand held, cannot reliably measure infrared radiation. Kodak recommends the following manually set trial exposures for its films. High-Speed Infrared black-and-white film used with No. 25 filter: distant scenes—1/125 sec. at f/11; nearby scenes—1/30 sec. at f/11. Ektachrome Infrared color film with a No. 12 filter: 1/125 sec. at f/16. Overexposure is better than underexposure; after making the trial exposure, make additional exposures of 1/2 stop and 1 stop more and 1/2 stop less (see Bracketing, page 57).

Color Films

What can you get in color films? Many color films are on the market. They belong basically to two categories: negative films and reversal films. A negative film (often with "–color" in its name, such as Kodacolor or Agfacolor) produces a negative in which the tones and colors are the opposite of those in the original scene. The negative is then printed to make a positive image. A reversal film (often with "–chrome" in its name, such as Kodachrome or Fujichrome) is given special reversal processing to produce a positive transparency or slide.

Color films are balanced for either daylight or tungsten light. The color temperature of light—the mixture of wavelengths of different colors that it contains—varies with different light sources. Daylight, for example, is much bluer than light from an ordinary light bulb, but we tend to ignore any difference in color balance when looking at a scene, seeing either daylight or tungsten light as "white." However, color film must be balanced to match the color temperatures of specific light sources or the color shift will be easily noticed in a photograph.

Daylight-balanced films yield the most natural-looking colors when shot in daylight or other light that is rich in blue wavelengths, such as electronic flash. Tungsten-balanced or indoor films produce the best result when used in more reddish light, such as the light from tungsten bulbs. Most indoor films are designed to be used with light of 3200 K (degrees Kelvin) color temperature; however, they give acceptable results when used with any type of tungsten light. Type A indoor film has a slightly different balance for precise color rendition when used with high-intensity 3400 K photofloods. A colored lens filter can balance the light if it does not match the film you are using. See chart page 141.

Fluorescent light presents a special problem because the color balance does not match either daylight or tungsten films, and varies depending on the type of fluorescent tube and its age. The light often gives an unpleasant greenish cast to pictures. Film manufacturers provide filtration data for different tubes, but, practically speaking, you usually won't know which tube is installed. Try an FL (fluorescent) filter with 1 stop increase in exposure. Daylight film will give a better balance than tungsten film if you use no filter.

Color balance is important with reversal films. Color slides are made from the same film that was in the camera: color balance cannot be corrected later. Reversal film should be shot either in the light for which it was intended or with a filter over the lens to adjust the color balance. If this is not done, the resulting slides will have a distinct color cast.

Color temperature is less critical with some films. Color negative films are somewhat tolerant of different color balances because color balance can be adjusted during printing. Some color negative films, such as Kodacolor VR 1000, minimize color balance differences between light sources even more. Black-and-white film can be shot in light of any color temperature.

You can make prints from either color negatives or color slides. If you know you want to make color prints, load color negative film into your camera. If you want both prints and slides or if you are not sure which you want, use color reversal film. Prints made from slides have brilliant color saturation and are somewhat sharper and less grainy in larger sizes. However, prints from color negatives are less contrasty, more easily processed, and less expensive.

Film	Color temperature	Type of light
	12,000 K and higher	Clear skylight in open shade, snow
	10,000 K	Hazy skylight in open shade
	7000 K	Overcast sky
	6600 K	
	5900–6200 K	Electronic flash
Daylight	5500 K	Midday
	4100 K	
	3750 K	
	3600 K	
	3500 K	
Type A (indoor)	3400 K	Photoflood
Tungsten (indoor)	3200 K	Photolamp
	3100 K	Sunrise, sunset
	3000 K	
	2900 K	100 watt bulb tungsten
	2800 K	
	1900 K	Candlelight, firelight

Bluish light →

← Reddish light

The color temperature of a light source (measured in degrees Kelvin) is a way of describing its color exactly. Color films are made to be used either with daylight, which is relatively blue in color, or with tungsten light, which is more reddish. The lower the color temperature, the more "warm" red wavelengths there are in the light. Higher color temperatures have more "cool" blue wavelengths.

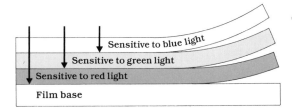

Sensitive to blue light
Sensitive to green light
Sensitive to red light
Film base

Color film consists of three light-sensitive layers, each of which responds to about one-third of the colors in the light spectrum. Each layer is matched to a primary color dye that is built into the emulsion or added during processing. Every color in the spectrum can be produced by mixing varying proportions of these color primaries.

4 Exposure

The exposure of film to light is one area in which a little expertise pays off in much better pictures. Exposing the film correctly (that is, setting the shutter speed and aperture so they let in the correct amount of light for a given film and scene) makes a difference if you want a rich image with realistic tones, dark but detailed shadows, and bright, delicate highlights, instead of a too dark, murky picture or a picture that is barely visible because it is too light.

At the simplest level, you can let your automatic camera set the shutter speed and aperture for you. If your camera has manual settings, you can calculate them by using an exposure meter to make an overall reading of the scene. You can even use the chart of general exposure recommendations that film manufacturers provide with each roll of film. In many cases these standardized procedures will give you a satisfactory exposure. But standard procedures don't work in all situations. If the light source is behind the subject, for example, an overall reading will silhouette the subject against the brighter background. This may not be what you want.

You will have more control over your pictures—and be happier with the results—if you know how to interpret the information your camera or meter provides and how to adjust the recommended exposure to get any variation you choose. You will then be able to select what you want to do in a specific situation rather than exposing at random and hoping for the best.

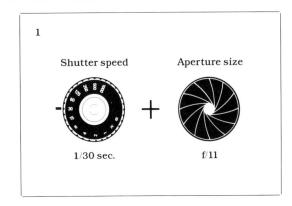

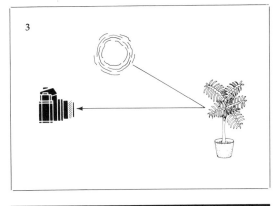

Learning to expose film properly, letting just the right amount of light into the camera, involves understanding just three things:

1. How the shutter speed and the size of the lens opening (the aperture) work together to control light (pages 10–15).

2. The sensitivity of your film to light—the film's speed (pages 44–45).

3. How to measure the amount of light and then set the exposure, either automatically or manually (pages 54–65).

Normal Exposure, Underexposure, and Overexposure

A negative is the image that is produced when film is exposed to light. A negative is the reverse of the original scene: the brightest areas in the scene are the darkest in the negative. How does this happen? When light strikes film, the energy of the light activates light-sensitive silver halide crystals in the film emulsion. The energy rearranges the structure of the crystals so that during development they convert to particles of dark, metallic silver.

The more light that strikes a particular area, the more the light-sensitive crystals are activated and so the denser with silver and darker that part of the negative will be. As a result, a white ship, for example, will be very dark in the negative. If film is exposed to light long enough, it darkens simply by the action of light, but ordinarily it is exposed only long enough to produce a latent or invisible image that is then made visible by chemical development.

A positive print can be made from the negative by shining light through the negative onto a piece of light-sensitive paper. Where the original scene was bright (the white ship), the negative is very dark and dense with many particles of silver. Dense areas in the negative block light from reaching the print; few particles of silver form in those parts of the print so those areas are bright in the final positive image.

The opposite happens with dark areas like the darkest parts of the ships in the original scene: dark areas reflect little light, so only a little silver (or sometimes none) is produced in the negative. When the positive print is made, these thin or clear areas in the negative pass much light to the print and form dark deposits of silver corresponding to the dark areas in the original scene. When a positive transparency like a color slide is made,

the tones in the negative itself are chemically reversed into a positive image.

Exposure determines the lightness or darkness of the image. The exposure you give a negative (the combination of f-stop and shutter speed) determines how much light reaches the film and how dense or dark the negative will be: the more light, the denser the negative, and, in general, the lighter the final image. The "correct" exposure for a given situation depends on how you want the photograph to look. The following pages tell how to adjust the exposure to get the effect you want.

Film and paper have exposure latitude, that is, you can often make a good print from a less-than-perfect negative. Color slides have the least latitude: for best results do not overexpose or underexpose them more than 1/2 stop (1 stop is acceptable for some scenes). Black-and-white or color prints can be made from negatives that vary somewhat more: from about 1 stop underexposure to 2 stops overexposure is usually acceptable. (More about stops and exposure on pages 56–57.)

But with too much variation from the correct exposure, prints and slides begin to look bad. Too much light overexposes a negative; it will be much too dense with silver to pass enough light to the final print, which in turn will be too pale (illustrations, opposite bottom). Conversely, too little exposure produces a negative that is underexposed and too thin, resulting in a print that is too dark (illustrations, opposite top). The results are similar with color slides. Too much exposure produces slides that are too light and that have pale, washed-out colors. Too little exposure produces dark, murky slides with little texture or detail.

Underexposed, thin negative

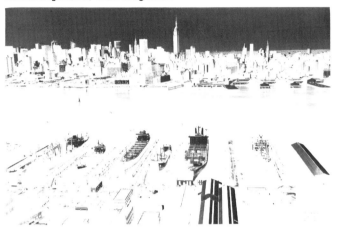

Normal negative

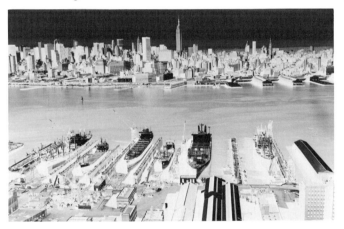

Overexposed, dense negative

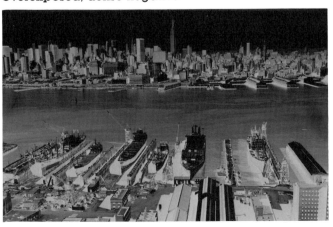

Dark positive

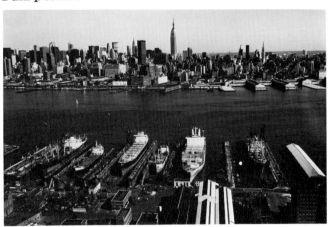

Normal positive

Light positive

Exposure Meters: What different types do

Exposure meters vary in design but they all perform the same basic function. They measure the amount of light; then, for a given film speed, they calculate f-stop and shutter speed combinations that will produce a correct exposure for a scene that has an average distribution of tones.

Meters built into cameras measure reflected light (see opposite, top center). The light-sensitive part of the meter is a photoelectric cell. When the metering system is turned on and the lens of the camera pointed at a subject, the cell measures the light from that subject. With automatic exposure operation, you set either the aperture or the shutter speed and the camera adjusts the other to let in a given amount of light. Some cameras set both the aperture and the shutter speed for you. In manual exposure operation, you adjust the aperture and the shutter speed based on the meter's viewfinder readout.

Hand-held meters measure either reflected or incident light (see opposite, top left and right). When the cell of a hand-held meter (one that is not built into a camera) is exposed to light, it moves a needle across a scale of numbers or activates a digital display. The greater the amount of light, the higher the reading. The meter then calculates and displays recommended f-stop and shutter speed combinations.

Meters are designed to measure middle gray. A reflected-light meter measures only one thing—the amount of light. And it calculates for only one result—an exposure that will reproduce that overall level of light as a medium-gray tone in the final photograph. The assumption is that most scenes, which consist of a variety of tones including very dark, medium gray, and very light, average out to a medium-gray tone. Most, in fact, do. Pages 60–65 tell how to use a meter to measure an average scene, and what to do for scenes that are not average.

The scene visible in the viewfinder

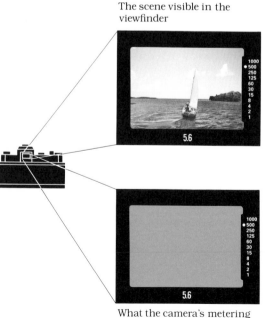

What the camera's metering system "sees"

◀ **A through-the-lens (TTL) meter,** built into a camera, shows in the camera's viewfinder the area that the meter is reading. You can see the details of the scene, but the camera's metering system "sees" only the overall light level. Whether the scene is very light or very dark, the meter always calculates a shutter speed and aperture combination to render that light level as middle gray on the negative.

A TTL meter may be coupled to the camera to set the exposure automatically or it may simply indicate an f-stop and shutter speed combination for you to set. This viewfinder displays the aperture (below) and shutter speed (at side) to which the camera is set. It also warns of under- or overexposure when you choose an aperture or shutter speed for which there is no corresponding setting within the range of those available on your camera.

A hand-held meter is separate from the camera. After measuring the amount of light, the meter's calculator dial or other readout shows recommended f-stop and shutter speed combinations.

Reading reflected light or incident light

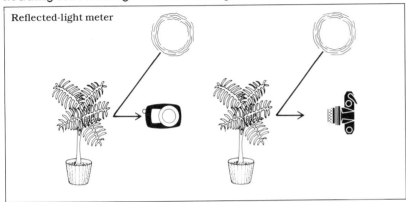

Reflected-light meter

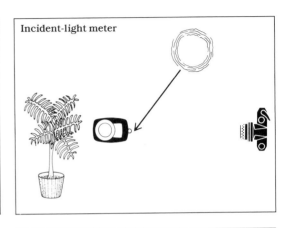

Incident-light meter

A reflected-light meter measures the amount of light reflected from an object. It can be hand held (left) or built into a camera (right). To make a reading, point the meter at the entire scene or at a specific part of it.

An incident-light meter measures the amount of light falling on an object. The meter's light-sensitive cell is pointed at the camera to measure the amount of light falling on the subject as seen from camera position.

Meter weighting

How much of a scene does a reflected-light meter measure?

Averaging meter

An averaging or overall meter reads most of the image area and computes an exposure that is the average of all the tones in the scene. A hand-held meter, like the one shown opposite, typically makes an overall reading.

Center-weighted meter

A center-weighted meter favors the light level of the central area of an image, which is often the most important one to meter. Cameras with built-in meters usually use some form of center weighting.

Spot meter

Multi-segment meter

A spot meter reads only a small part of the image. Very accurate exposures can be calculated with a spot meter, but it is important to select with care the areas to be read. Hand-held spot meters are popular with photographers who want exact measurement and control of individual areas. Some cameras with built-in meters have a spot-metering option.

A multi-segment meter is the most sophisticated of the meters built into a camera. It divides the scene into areas that are metered individually, then analyzed against a series of patterns stored in the camera's memory. The resulting exposure is more likely to avoid problems such as underexposure of a subject against a very bright sky.

Exposure Meters: How to calculate and adjust an exposure manually

How do you calculate and adjust an exposure manually? Even if you have an automatic exposure camera, it will help you to know how to do so. Many automatic cameras do not expose correctly for backlit scenes or other situations where the overall illumination is not "average," and you will need to know how much and in what direction to change the camera's settings to get the results you want.

This page shows the way a hand-held meter works. Once you understand its operation, you will know how any meter functions, whether built into a camera or separate and hand-held. Pages 60–65 tell how to use a meter for different types of scenes.

Exposure = Intensity x Time. Exposure is a combination of the intensity of light that reaches the film (controlled by the size of the aperture) and of the length of time the light strikes the film (controlled by the shutter speed). You can adjust the exposure by changing either the shutter speed, aperture, or both.

Exposure changes are measured in stops, a doubling (or halving) of the exposure. A change from one aperture (f-stop) to the next larger aperture opening, such as from f/5.6 to f/4, doubles the exposure and results in 1 stop more exposure. A change from one shutter speed to the next slower speed, such as from 1/250 sec. to 1/125 sec., also results in 1 stop more exposure. A change to the next smaller aperture or the next faster shutter speed produces 1 stop less exposure.

It is worth your effort to memorize the f-stop and shutter-speed sequences, so that you know which way to move when you are faced with an exposure you want to bracket or otherwise adjust.

Each **light measurement number** records a light level twice as bright as the next lower number —a 1-stop difference. A reading of 11 is twice as high as a reading of 10.

Shutter speeds are 1 stop apart. A shutter speed of 1/125 sec. lets in twice as much light as a shutter speed of 1/250 sec.

F-stop settings are 1 stop apart. F/4 lets in twice as much light as f/5.6. Remember that the lower the f-number, the larger the lens aperture, and so the more light let into the camera.

Film speed ratings double each time the speed of the film doubles. An ISO 400 film is 1 stop faster than an ISO 200 film. It needs only half as much light as the ISO 200 film does.

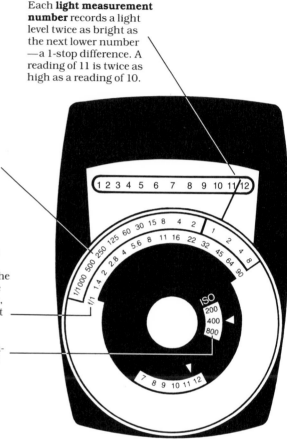

A hand-held exposure meter. Light striking this meter's light-sensitive photoelectric cell moves a needle across a scale that measures the intensity of the light. When you rotate the meter's dials to set in the light measurement reading and the film speed, the meter shows the combinations of f-stops and shutter speeds suggested for a normal exposure. An automatic exposure camera performs the same calculation, but selects the shutter speed and/or aperture for you.

The meter shows the connection of light intensity, film speed, and shutter speed and aperture settings. With a greater amount of light or a faster film speed, the camera can be set to a smaller aperture or a faster shutter speed. See page 175 for a light meter dial to cut out and assemble.

Bracketing helps if you are not sure about the exposure. To bracket, you make several photographs of the same scene, increasing or decreasing the exposure by adjusting the aperture or shutter speed. Among the different exposures, there is likely to be at least one that is correct. It's not just beginners who bracket exposures. Professional photographers probably do it most of all, because they don't want to risk having a whole shooting session turn out to be less than perfectly exposed.

To bracket, first make an exposure with the aperture and shutter speed set by the automatic system or manually set by you at the combination you think is the right one. Then make a second shot with 1 stop more exposure and a third shot with 1 stop less exposure. This is easy to do if you set the exposure manually: for 1 stop more exposure, either set the shutter to the next slower speed or the aperture to the next larger opening (the next smaller f-number); for 1 stop less exposure, either set the shutter to the next faster speed or the aperture to the next smaller opening (the next larger f-number).

How do you bracket with an automatic-exposure camera? In automatic operation, if you change to the next larger aperture, the camera may simply shift to the next faster shutter speed, resulting in the same overall exposure. Instead, you have to override the camera's automatic system. See page 58 for how to do so.

Bracketing produces lighter and darker versions of the same scene. Suppose an exposure for a scene is 1/60 sec. shutter speed at f/5.6 aperture.

Original exposure

1/8 1/15 1/30 1/60 1/125 1/250 1/500 sec.
f/16 f/11 f/8 f/5.6 f/4 f/2.8 f/2

To bracket for 1 stop less exposure, which would darken the scene, keep the shutter speed at 1/60 sec., while changing to the next smaller aperture, f/8. (Or keep the original f/5.6 aperture, while changing to the next faster shutter speed, 1/125 sec.)

Bracketed for 1 stop less exposure

1/8 1/15 1/30 1/60 1/125 1/250 1/500 sec.
f/16 f/11 f/8 f/5.6 f/4 f/2.8 f/2

To bracket for 1 stop more exposure, which would lighten the scene, keep the shutter speed at 1/60 sec. while changing to the next larger aperture, f/4. (Or keep the original f/5.6 aperture, while changing to the next slower shutter speed, 1/30 sec.)

Bracketed for 1 stop more exposure

1/8 1/15 1/30 1/60 1/125 1/250 1/500 sec.
f/16 f/11 f/8 f/5.6 f/4 f/2.8 f/2

Bracketing your exposures is useful when you are not sure if an exposure is correct or if you want to see the results from different exposures of the same scene. Decreasing the exposure several stops for this scene darkened it so that the men were silhouetted against the much brighter sky. With more exposure, the scene would have been lighter, showing more details of the boat and men.

Overriding an Automatic Exposure Camera

Almost all cameras with automatic exposure have some means of overriding the automatic system when you want to increase the exposure to lighten a picture or decrease the exposure to darken it. The change in exposure is measured in "stops." A 1-stop change in exposure will double (or halve) the amount of light reaching the film. Each aperture setting is 1 stop from the next setting. Shutter speeds are also described as being 1 stop apart.

Exposure lock. An exposure lock or memory switch temporarily locks in an exposure, so you can move up close to take a reading of a particular area, lock in the desired setting, step back, and then photograph the entire scene.

Exposure compensation dial. Moving the dial to +1 or +2 increases the exposure and lightens the picture. Moving the dial to −1 or −2 decreases the exposure and darkens the picture.

Backlight button. If a camera does not have an exposure compensation dial, it may have a backlight button. Depressing the button adds a fixed amount of exposure, 1 to 1½ stops, and lightens the picture. It cannot be used to decrease exposure.

Film speed dial. If the film speed is manually set on your camera, you can increase or decrease exposure by changing the setting of the speed dial. The camera then responds as if the film is slower or faster than it really is. Doubling the film speed (for example, from ISO 100 to ISO 200) darkens the picture by decreasing the exposure 1 stop. Halving the film speed (for example, from ISO 400 to ISO 200) lightens the picture by increasing the exposure 1 stop.

Manual mode. In manual mode, you adjust the shutter speed and aperture yourself. You can increase or decrease the exposure, as you wish.

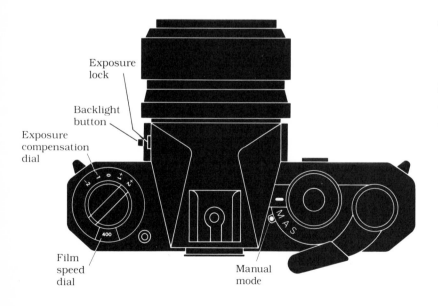

Exposure lock

Backlight button

Exposure compensation dial

Film speed dial

Manual mode

One or more means of changing the exposure are found on most cameras. These features let you override automatic exposure when you want to do so. Don't forget to reset the camera to its normal mode of operation after the picture is made.

You can use manual mode to set the shutter speed and aperture for photographs at night, like this campfire scene. More about exposures for unusual lighting situations on page 65.

Making an Exposure of an Average Scene

What exactly do you need to do to produce a good exposure, one that lets just enough light into the camera so that the film is neither underexposed and too dark nor overexposed and too light? All meters built into cameras (and most hand-held meters) measure reflected light, the lightness or darkness of objects. In many cases, you can simply point the camera at a scene, activate the meter, and set the exposure (or let the camera set it) accordingly.

A reflected-light meter averages the light entering its angle of view. The meter is calibrated on the assumption that in an average scene all the tones—dark, medium, and light—will add up to an average medium gray. So the meter and its accompanying circuitry set, or recommend, an exposure that will record all of the light that it is reading as a middle gray in the photograph.

This works well if you are photographing an "average" scene, one that has an average distribution of light and dark areas, and if the scene is evenly illuminated as viewed from camera position, that is, when the light is coming more or less from behind you or when the light is evenly diffused over the entire scene (see illustrations this page). See opposite for how to meter this type of average or low-contrast scene.

A meter can be fooled, however, if your subject is surrounded by a much lighter area such as a bright sky or by a much darker area such as a large dark shadow. See pages 62–63 for what to do in such cases.

A scene in diffused light photographs well with an overall reading, for example, outdoors in the shade or on an overcast day or indoors when the light is coming from several light sources. Diffused light is indirect and soft. Shadows are not as dark as they would be in direct light, so all parts of the scene are clearly visible.

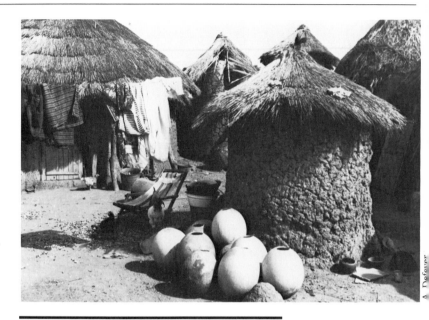

An overall meter reading works well when a directly lit scene is evenly illuminated as seen from camera position. When light is shining directly on a subject, even illumination occurs when the main source of light—here, the sun—is more or less behind you as you face the subject. Shadows are dark but do not obscure important parts of the scene.

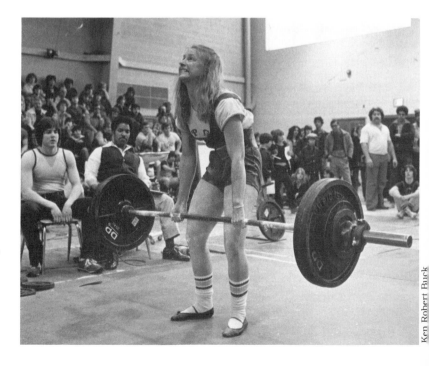

Using a meter built in a camera for an exposure of an average scene

1. Set the film speed into the camera. Some cameras do this automatically when you load the film.

2. Select the exposure mode: automatic (aperture-priority, shutter-priority, or programmed) or manual.

3. Activate the meter as you look at the subject in the viewfinder.

4. *In aperture-priority mode* you select an aperture that gives the desired depth of field. The camera will select a shutter speed; make sure that it is fast enough to prevent blurring of the image caused by camera or subject motion. *In shutter-priority mode,* you select a shutter speed fast enough to prevent blur. The camera will select an aperture; make sure that it gives the desired depth of field. *In programmed mode,* the camera selects both aperture and shutter speed. *In manual mode,* you set both aperture and shutter speed based on the readout shown in the camera's viewfinder.

Calculating exposure of an average scene with a hand-held, reflected-light meter

1. Set the film speed into the meter.

2. Point the meter's photoelectric cell at the subject at the same angle seen by the camera. Activate the meter to measure the amount of light reflected by the subject.

3. Line up the number registered by the indicator needle with the arrow on the meter's calculator dial. (Some meters do this automatically.)

4. Choose one of the combinations of f-stops and shutter speeds shown on the meter and set the camera accordingly. Any combination shown lets the same quantity of light into the camera and produces the same exposure.

Calculating exposure of an average scene with an incident-light meter

1. Set the film speed into the meter.

2. Point the meter's photoelectric cell away from the subject, in the opposite direction from the camera lens. Activate the meter to measure the amount of light falling on the subject. Make sure that the same light that is falling on the subject is falling on the meter. For example, take care not to shade the meter if the subject is brightly lit. Proceed as in steps 3 and 4 for reflected-light meter.

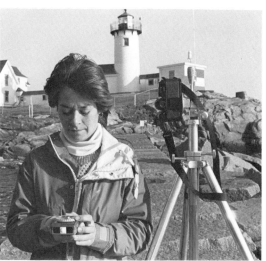

Exposing Scenes with High Contrast

"It came out too dark." Sometimes even experienced photographers complain that they metered a scene carefully but the picture still wasn't properly exposed. All a meter does is measure light. It doesn't know what part of a scene you are interested in or whether a particular object should be light or dark. You have to think for the meter and sometimes change the exposure it recommends, especially with a scene of high contrast, in which the light areas are much lighter than the dark areas.

The most common exposure problem is a backlit subject, one that is against a much lighter background, such as a sunny sky. Because the meter averages all the tonal values—light, medium, and dark—in the scene, it assumes that the entire scene is very bright. It consequently sets an exposure that lets in less light, which makes the entire picture darker and your main subject too dark. Less common is a subject against a very large, much darker background. The meter assumes that the entire scene is very dark, so it lets in more light, which makes the main subject too light.

To expose the main subject correctly in a contrasty scene, measure the light level for that part of the scene only. If you are photographing a person or some other subject against a much darker or lighter background, move in close enough so that you exclude the background from the reading but not so close that you meter your own shadow. If your main subject is a landscape or other scene that includes a very bright sky, tilt the meter or camera down slightly so you exclude most of the sky from the reading.

But suppose a bright sky with interesting clouds is the area in which you want to see detail, and there are much darker land elements silhouetted against it (see page 50). In that case the sky is your

An underexposed (too dark) photograph can result when the light is coming from behind the subject or when the subject is against a much brighter background such as the sky. The problem is that a meter averages all the tonal values that strike its light-sensitive cell. Here the photographer pointed the meter so that it included the much lighter tone of the sky as well as the person. The resulting exposure of 1/250 sec. shutter speed at f/11 aperture produced a correct exposure for an average scene but not a correct exposure for this scene.

Tom Wolfe

A better exposure for contrasty scenes results from moving up close to meter only the main subject, as shown above. This way you take your meter reading from the most important part of the scene—here, the person's face. The resulting exposure of 1/60 sec. at f/11 let in 2 more stops of exposure and made the final picture (right) lighter, especially the important part of it, the person's face.

main subject, the one you should meter to determine your camera settings.

A substitution reading is possible if you can't move in close enough to the important part of a contrasty scene. Look for an object of about the same tone in a similar light and read it instead. For exact exposures, you can meter the light reflected from a gray card, a card of standard middle gray of 18 percent reflectance (meters are designed to calculate exposures for subjects of this tone). The last page of this book is printed to this tone of gray and can be used for substitution readings. You can also meter the light reflected by the palm of your hand (see right).

How do you set your camera after you have metered a high-contrast scene? If your camera has a manual exposure mode, set the shutter speed and aperture to expose the main subject correctly, using the settings from a reading made up close or from a substitution reading. In automatic operation, you must override the automatic circuitry (see page 58). Don't be afraid to do this; only you know the picture you want.

Fredrik D. Bodin

A substitution reading, such as one taken from the palm of your hand or a gray card, will give you an accurate reading if you can't get close enough to a subject. Make sure you are metering just the palm (or the card) and not the sky or other background of a different tone. A hand-held, reflected-light meter is shown here, but you can also use a meter built into a camera.

If you meter from the palm of your hand, try the exposure recommended by the meter if you have very dark skin, but give 1 stop more exposure if you have light skin, as here. If you make a substitution reading from a photographic gray card, use the exposure recommended by the meter.

Move in close to meter a high-contrast scene. With a built-in meter, move in (without blocking the light) until the important area just fills the viewfinder. Set the shutter speed and aperture and move back to your original position to take the picture.

Fredrik D. Bodin

With a hand-held, reflected-light meter, move in close enough to read the subject but not so close as to block the light. A spot meter, which reads light from a very narrow angle of view, is particularly useful for metering high-contrast scenes.

Exposing Scenes that Are Lighter or Darker than Normal

Scenes that are light overall, such as a snow scene, can look too dark in the final photograph if you make just an overall reading or let an automatic camera make one for you. The reason is that the meter will make its usual assumption that it is pointed at a scene consisting of light, medium, and dark tones, and it will expose the film accordingly. But this will underexpose a scene that consists mostly of light tones, resulting in a too-dark final photograph. Try giving 1 or 2 stops extra exposure to a scene that has many very light tones.

Scenes that are dark overall are less common, but can occur. Try reducing the exposure 1 or 2 stops.

In a silhouette, a subject is underexposed against a much lighter background. This can happen unintentionally if the subject is against a bright sky (see page 62). When you want a silhouette against a bright background, try giving several stops less exposure than the meter recommends for the main subject.

You can make some adjustments in tone when you print a negative, but it is easier to start with a negative exposed for the results you want. You can't make adjustments after the fact if you are shooting transparencies because the film in the camera is the final product. Bracket your exposures if you are not sure.

Snow scenes or bright beach scenes are often lighter than average. Adding an extra stop or two of exposure to an overall reading will help keep the final photograph light in tone.

Exposures in Hard-to-Meter Situations

What do you do when you want to make a photograph but can't make a meter reading—photographing fireworks, for instance, or a city skyline at night? Guessing and making a couple of experimental tries is better than nothing, and you might get an image you'll like very much. If you keep a record of the scene and your exposures, you will have at least an idea about how to expose a similar scene.

Bracketing is a good idea: make at least three shots—one at the suggested exposure, a second with 1 or 1½ stops more exposure, and a third with 1 or 1½ stops less exposure. Not only will you probably make one exposure that is acceptable, but each different exposure may be best for a different part of the scene. For instance, at night on downtown city streets a longer exposure may show people best, whereas a shorter exposure will be good for brightly lit shop windows.

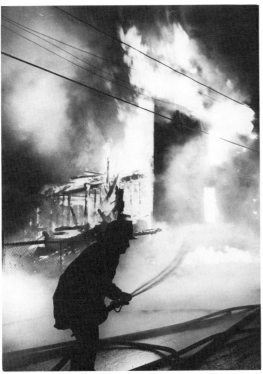

Donald T. Young

Exposures in hard-to-meter situations

	With ISO 400 film	
*Home interiors at night— average light	1/30 sec.	f/2
*Candlelit close-ups	1/15 sec.	f/2
Indoor and outdoor holiday lighting at night, Christmas trees	1/15 sec.	f/2
Brightly lit downtown streets	1/60 sec.	f/2.8
Brightly lit nightclub or theater districts, e.g., Las Vegas	1/60 sec.	f/4
Neon signs and other lit signs	1/125 sec.	f/4
Store windows	1/60 sec.	f/4
Subjects lit by streetlights	1/15 sec.	f/2
Floodlit buildings, fountains	1/15 sec.	f/2
Skyline—distant view of lit buildings at night	1 sec.	f/2.8
Skyline—10 min. after sunset	1/60 sec.	f/5.6
Fairs, amusement parks	1/30 sec.	f/2.8
Amusement-park rides—light patterns	1 sec.	f/16
Fireworks—displays on ground	1/60 sec.	f/4
Fireworks—aerial displays (Keep shutter open for several bursts.)		f/16
Lightning (Keep shutter open for one or two streaks.)		f/11
Burning buildings, campfires, bonfires	1/60 sec.	f/4
Subjects by campfires, bonfires	1/30 sec.	f/2
*Night football, baseball, racetracks	1/125 sec.	f/2.8
Niagara Falls—white lights	4 sec.	f/5.6
Light-colored lights	8 sec.	f/5.6
Dark-colored lights	15 sec.	f/5.6
Moonlit landscapes	8 sec.	f/2
Moonlit snow scenes	4 sec.	f/2
*Basketball, hockey, bowling	1/125 sec.	f/2
*Boxing, wrestling	1/250 sec.	f/2
*Stage shows—average	1/60 sec.	f/2.8
*Circuses—floodlit acts	1/60 sec.	f/2.8
*Ice shows—floodlit acts	1/125 sec.	f/2.8
†Interiors with bright fluorescent light	1/60 sec.	f/4
*School—stage, auditorium	1/30 sec.	f/2
*Hospital nurseries	1/60 sec.	f/2.8
*Church interiors—tungsten light	1/30 sec.	f/2

* Use indoor (tungsten-balanced) film for color pictures

† Use daylight-balanced film for color pictures

© Eastman Kodak Company, 1978

In hard-to-meter situations, try these manually set exposures for films rated at ISO 400. Give twice as much exposure (1 stop more) for films rated at ISO 125 to ISO 200. Give half as much exposure (1 stop less) for films rated at ISO 1000.

Solving Exposure Problems

No picture, frame numbers appear

No picture, no frame numbers

Negative thin

Negative dense

B. W. Muir

See below if your negatives don't look right or are difficult to print. See also Solving Camera and Lens Problems, page 39; Negative Development Problems, page 86; Printing Problems, page 109; Flash Problems, page 132; and Evaluating Your Negatives, page 82.

If you are evaluating a color slide, remember that it is the reverse of a negative. An area that is too dark in a negative will be too light in a slide; both are caused by overexposure, too much light reaching the film. An area that is too light in a negative will be too dark in a slide; the cause is underexposure, not enough light reaching the film.

No picture at all. Image area and negative edges are clear, but film frame numbers are visible.

Cause: If the entire roll is blank, it was not put into the camera; if you are sure that it was, then it did not catch on the film advance sprockets and so did not move through the camera. If only a few frames are blank, the shutter was accidentally released with the lens cap on, the flash failed to fire, the shutter failed to open, or in a single-lens reflex camera, the mirror failed to move up.

Prevention: To make sure film is advancing, check that the camera's rewind lever (if it has one) rotates when you advance the film. In an automated camera without a rewind lever, check that the frame-number counter advances. Have camera checked if film advance or other problems persist.

No picture at all. Image area and negative edges are completely clear, no film frame numbers are visible.

Cause: A film development problem; nothing is wrong with the camera. The film was put into fixer before it was developed.

Prevention: If you developed the film yourself, review film processing, page 79.

Negative thin-looking, too light overall. A too-thin negative will make it difficult to produce a print that is not too dark.

Cause: Most likely the negative was underexposed: the camera's shutter speed was too fast, aperture too small, or both, resulting in not enough light reaching the film. See Evaluating Your Negatives, page 82. Less likely, a film development problem; film received inadequate development.

Prevention: The best prevention for occasional exposure problems is simply to meter scenes more carefully and to make sure you correctly set all camera controls, such as the film speed dial. If your negatives frequently look underexposed, including entire rolls, your meter is probably inaccurate; if your camera permits it, set the film speed dial lower than the rated film speed. For example, with ISO 400 film, set the film speed dial to half that rating, 200, to get 1 stop more exposure.

Negative dense-looking, too dark overall. A too-dense negative will make it difficult to produce a print that is not too light.

Cause: Most likely the negative was overexposed: the camera's shutter speed was too slow, aperture too wide, or both, resulting in too much light reaching the film. See Evaluating Your Negatives, page 82. Less likely, a film development problem; film received too much development.

Prevention: If your negatives frequently look overexposed, including entire rolls, try setting the film speed dial higher than the rated film speed. For example, if you are using ISO 400 film, set the film speed dial to double that rating, 800, to get 1 stop less exposure.

Snow scene too dark

B. W. Muir

Subject too dark against lighter background

Tom Wolfe

Snow scene (or other very bright scene) too dark. Negative appears thin, print or slide too dark.

Cause: The meter averaged all the tones in its angle of view, then computed an exposure for a middle-gray tone. The problem is that the scene was lighter than middle gray, so appears too dark.

Prevention: When photographing scenes that are very light overall, such as snow scenes or sunlit beach scenes, give 1 or 2 stops more exposure than the meter recommends. This will give the scene a realistically light tonality overall. See page 64.

Subject very dark against lighter background.

Cause: Your meter was overly influenced by the bright background and under-exposed the main subject.

Prevention: Don't make an overall reading when a subject is against a bright background. Instead, move in close to meter just the subject, then set your shutter speed and aperture accordingly (see page 62).

Subject very light against darker background.

Cause: Your meter was overly influenced by the dark background and overexposed the main subject.

Prevention: This happens less often than the preceding problem, but can occur if the subject is small and very light against a much larger, very dark background. In such cases, don't make an overall reading. Move in close to meter just the subject, then set your shutter speed and aperture accordingly.

5 Developing the Negative

This chapter describes how to process black-and-white film. The film is immersed in chemicals that transform the invisible image on the film to a permanent, visible one. After you have developed a roll or two of film, you'll find that the procedures are relatively easy.

Familiarize yourself with the steps involved before you develop your first roll, because the process begins in the dark and then proceeds at a brisk pace. Read through the step-by-step instructions on pages 73–78, check the manufacturer's instructions, and make sure you have ready all the materials you'll need. Practice loading the developing reel (steps 4-8) with a junked roll of film; you'll be glad you did when you step into the darkroom with your first roll to load and you turn out the lights.

Consistency and cleanliness pay off. If you want to avoid hard-to-print negatives, mysterious stains, and general aggravation, be sure to follow directions carefully, adjust temperatures exactly, and keep your hands, equipment, and the film clean. Darkrooms generally have a dry side where film is loaded and printing paper is exposed, and a wet side with sinks where chemicals are mixed and handled. Always keep chemicals and moisture away from the dry side and off your hands when you are loading film. (See Avoid Contamination, page 72.)

You get your first chance to see the results of your shooting when you unwind the washed film from the developing reel. But when film is wet, the emulsion is soft and relatively fragile; dust can easily stick to the film, become embedded in the emulsion, and then appear in your print as white specks on the image. Resist the temptation to spend much time looking at the film until it is dry.

Processing Film: Equipment and chemicals you'll need

Equipment to load film

Developing reel holds and separates the film so that chemicals can reach all parts of the emulsion. Choose a reel to match the size of your film, for example, 35mm or the larger size for 120 film. Some plastic reels can be adjusted to different sizes. Stainless steel reels are not adjustable and are somewhat more difficult to learn to load than are plastic reels; however, they are the choice of many photographers because they are durable and easy to clean of residual chemicals.

Developing tank with cover accepts the reel of loaded film. Loading has to be done in the dark, but once the film is inside and the cover in place, processing can continue in room light. A light-tight opening in the center of the cover lets you pour chemicals into and out of the tank without removing the cover. Tanks hold one reel, or two or more for processing more than one reel at a time.

Bottle cap opener pries off the top of a 35mm cassette of film. Special cassette openers are also available.

Scissors trim the front end of 35mm film square, and cut off the spool on which the film was wound.

Optional: **Practice roll of film** lets you get used to loading the developing reel in daylight before trying to load an actual roll of film in the dark. Useful for developing your first roll of film or when loading a different size of film for the first time.

A completely dark room is essential for loading the film on the reel. Even a small amount of light can fog film. If you can see objects in a room after 5 min. with lights out, the room is not dark enough. If you can't find a dark enough room, use a changing bag, a light-tight bag into which fit your hands, the film, reel, tank, cover, opener, and scissors. After the film is in the tank with the cover on, you can take the tank out of the bag into room light.

Equipment to mix and store chemicals

Source of water is needed for mixing solutions, washing film, and cleaning up. A hose connected to a faucet splashes less than using water directly from the faucet.

Photographic thermometer measures the temperature of solutions. An accurate and easy-to-read thermometer is essential because temperatures must be checked often and adjusted critically. You will need a temperature range from about 50° to 120°F (10° to 50°C).

Graduated containers measure liquid solutions. Two useful sizes are 32 oz (1 liter) and 8 oz (250 ml). Graduates can be used for mixing and for holding the working solutions you will need during processing.

Mixing containers hold solutions while you mix them. You can use a graduated container for smaller quantities or storage container with a wide mouth.

Storage containers hold chemical solutions between processing sessions. They should be of dark glass or plastic to keep out light and have caps that close tightly to minimize contact with air. Some plastic bottles can be squeezed when partially full to expel excess air.

Stirring rod mixes chemicals into solution. The rod should not be made of wood, but of an inert material such as hard plastic that will not react with or absorb chemicals.

Optional: **Funnel** simplifies pouring chemicals into storage bottles.

Optional: **Rubber gloves** protect your hands from allergic reactions to processing chemicals.

Equipment to process film

Tri-X film	65°F	**68°F**
	min.	**min.**
HC-110		
(Dilution B)	8½	**7½**
D-76	9	**8**
D-76 (1:1)	11	**10**
Microdol-X	11	**10**
DK-50 (1:1)	7	**6**

Manufacturer's instructions included with film or developer give recommended combinations of development time and developer temperature.

Containers for working solutions must be large enough to contain the quantity of solution needed during processing. Graduates are convenient to use. Have three for the main solutions—developer, stop bath, fixer. It is a good idea to reserve a container for developers only; even a small residue of stop bath or fixer can keep the developer from working properly.

Optional: **Tray** or pan can be used as a water bath for the containers of working solutions to keep them at the correct temperature.

Timer with a bell or buzzer to signal the end of a given period is preferable to a watch or clock that you must remember to consult. An interval timer can be set from 1 sec. to 60 min. and counts down to zero, showing you the amount of time remaining.

Film clips attach washed film to a length of string or wire to hang to dry. Spring-loaded clothespins will do the job. A dust-free place to hang the wet film is essential. A school darkroom usually has a special drying cabinet; at home, a bathroom shower is good.

Optional: **Photo sponge** wipes down wet negatives so that they dry evenly.

Negative envelopes protect the dry film.

Chemicals

There are three essential and two optional (but recommended) solutions that you will need to process black-and-white film. For more information, see Mixing and Handling Chemicals and manufacturer's latest instructions.

Developer converts the latent (still invisible) image in exposed film to a visible image. Choose a developer designed for use with film. For general use and for your first rolls of film, choose an all-purpose developer such as Kodak T-Max or D-76, Ilford ID-11, Ethol TEC or UFG, or Edwal FG7.

Some developers are reusable. The length of time that they can be stored depends on the developer and on storage conditions. Stock solution of Kodak D-76, for example, lasts about 6 months in a full container, 2 months in a half-full container. (See also Replenishing-type Developers and One-shot Developers, page 72.)

Stop bath stops the action of the developer. Many photographers use a plain water rinse. Others prefer a mildly acid bath prepared from about 1 oz of 28 percent acetic acid per quart of water.

If you are using plain water as a stop bath, simply discard it after processing. An acetic acid stop bath is reusable. Working solution lasts about a month if stored in a full, tightly closed bottle, and treats about 20 rolls of film per quart. An indicator stop bath changes color when it is exhausted.

Fixer (also called hypo) makes film no longer sensitive to light, so that when fixing is complete the negative can be viewed in ordinary light. Choose a fixer that contains a hardener, which makes film more resistant to scratching and surface damage. Regular fixer takes 5-10 min. to fix film; rapid fixer takes 2-4 min.

Fixer treats about 25 rolls of film per quart of working-strength solution, and lasts about a month in a full container. The best test of fixer strength is to use an inexpensive testing solution called hypo

check or fixer check. A few drops of the test solution placed in fresh fixer will stay clear; the drops will turn milky white in exhausted fixer.

Optional: **Hypo clearing bath** (also called a hypo neutralizer or washing aid), such as Heico Perma Wash or Kodak Hypo Clearing Agent, followed by washing in running water, clears film of fixer more completely and faster than washing alone. The shortened wash time also reduces swelling and softening of the emulsion and makes the wet film less likely to be damaged.

Different brands vary in capacity and storage; see manufacturer's instructions.

Optional: **Wetting agent,** such as Kodak Photo-Flo, reduces the tendency of water to cling to the surface of the film and helps prevent water spots, especially if you have hard water.

Only a small amount of wetting agent solution treats many rolls of film. Discard the solution periodically.

Mixing and Handling Chemicals

Mixing dry chemicals. Transfer dry chemicals carefully from package to mixing container so that you do not create a cloud of chemical dust that can contaminate nearby surfaces or be inhaled. Mix chemicals with water that is at the temperature suggested by the manufacturer; at a lower temperature, they may not dissolve. Stir the mixture of dry chemical and liquid gently until the chemical dissolves.

Stock and working solutions. Chemicals are often stored as concentrated (stock) solutions. Before use, the stock solution is diluted further to bring it to the correct working strength.

Dilution of a liquid from its concentrated stock solution to its working strength is often given in instructions as a ratio, such as 1:4. The concentrate is listed first, followed by the diluting liquid, usually water. A developer to be diluted 1:4 means add 1 part concentrated stock solution to 4 parts water. Always add concentrate to water rather than water to concentrate so that any splashes will be mostly water.

Replenishing-type developers can be reused if you add chemicals after each developing session to bring the solution back to working strength. To get consistent results, follow the manufacturer's instructions for use, and keep an exact record of the number of rolls processed and the replenishment. Also record the date the developer was mixed, and discard any solution stored longer than recommended. If in doubt about the age or strength of *any* solution—throw it out.

One-shot developers are used once, then discarded. They are often used in school darkrooms so that there is no question about developer replenishment, age, or strength. They are also a good choice if a relatively long time passes between your developing sessions, because stored developer deteriorates with time.

Raising or lowering temperatures will take less time if the solution is in a metal container rather than a glass or plastic one. To heat a solution, run hot water over the sides of the container. To cool a solution, place the container for a short time in a tray of ice water or in a refrigerator. Stir the solution occasionally to mix the heated (or cooled) solution near the outside of the container into the solution at the middle.

Avoid unnecessary oxidation. Contact with oxygen speeds the deterioration of most chemicals, as does prolonged exposure to light and heat. Stir solutions gently to mix them rather than shaking them like a cocktail. Don't let chemicals sit for long periods of time in open tanks or trays. Store in tightly covered, dark-colored containers.

Avoid contamination. Getting chemicals where they don't belong is a common cause of darkroom problems, and an easy one to prevent.

Keep work areas clean and dry. Wipe up spilled chemicals and rinse the area with water. Keep chemicals away from the dry side of the darkroom, where you load film and make prints. Measure and mix chemicals and do all your processing on the wet side of the darkroom.

Chemicals on your fingers can cause spots and stains on film or paper. Rinse your hands well when you get chemicals on them, then dry them on a clean towel.

Rinse tanks, trays, and other equipment well. The remains of one chemical in a tank can affect the next chemical that comes in contact with it. Be particularly careful to keep stop bath and fixer out of the developer.

Wear old clothes or a work apron in the darkroom. Developer splashed on your clothes will darken to a stain that is all but impossible to remove.

Handle chemicals safely. Photographic chemicals, like any chemical, should be handled with care. Note the following precautions and read manufacturer's instructions before using a new chemical.

Mix and handle chemicals only in areas where there is adequate ventilation and a source of running water. Do not inhale vapors or get chemicals in your mouth or eyes. Wash hands carefully before eating.

Some people are allergic to certain chemicals and can develop skin rashes or other symptoms. See a doctor if you suspect this is happening to you. Using rubber gloves and tongs will minimize chemical contact.

Special safety cautions with acids. Follow the basic rule when diluting acids: ALWAYS ADD ACID TO WATER, NOT WATER TO ACID.

Concentrated acids that come in contact with your skin can cause serious burns. Immediately flush well with cold water. Do not scrub. Do not use ointments or other preparations. Cover with dry, sterile cloth until you can get medical help.

For eye contact, immediately flush the eye with running water for at least 15 min. Then get to a doctor immediately.

For internal contact, do not induce vomiting. Drink a neutralizing agent such as milk or milk of magnesia. See a doctor immediately.

Processing Film Step by Step

Setting out materials needed

KODAK TRI-X Pan Film

Kodak Packaged Developers	Small tank—(Agitation at 30-Second Intervals)					Large tank—(Agitation at 1-Minute Intervals)				
	65°F 18.5°C	68°F 20°C	70°F 21°C	72°F 22°C	75°F 24°C	65°F 18.5°C	68°F 20°C	70°F 21°C	72°F 22°C	75°F 24°C
T-Max	6½	5½	5½	5	**5**	—	—	—	—	—
T-Max RS	6½	**5½**	4½	4	3½	9	8	7	6	**5½**
HC-110 (Dilution B)	8½	**7½**	6½	6	5	9½	**8½**	8	7½	6½
D-76	9	**8**	7½	6½	5½	10	**9**	8	7	6
D-76 (1:1)	11	**10**	9½	9	8	13	**12**	11	10	9
Microdol-X	11	**10**	9½	9	8	13	**12**	11	10	9
Microdol-X (1:3)	—	—	15	14	**13**	—	—	17	16	**15**

*Avoid development times of less than 5 minutes if possible, because poor uniformity may result.
Note: Do not use developers containing silver halide solvents.

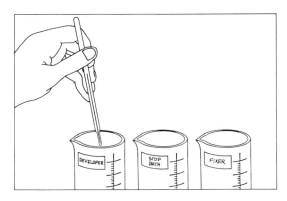

1. Determine the developer time and temperature. The warmer the developer, the less time needed to develop the film. Manufacturers list recommended time-and-temperature combinations in charts in the instructions that come with developers and films. The optimum combination is usually indicated by darker, **boldface** type. If the chart lists different times for large tanks and small tanks (sometimes called reel-type tanks), use the small-tank times. Select a time-and-temperature combination for your film and developer.

2. Mix the solutions and adjust their temperatures. Mix the developer, stop bath, and fixer diluted to working strength recommended by manufacturer. Mix up at least enough solution to completely cover the reel (or reels, if you are developing more than one) in the tank; it's better to have too much solution than too little. Check temperatures (rinse the thermometer between solutions). Adjust the developer temperature exactly, and the stop bath and fixer within 1 to 2 degrees of the developer temperature. In a cold darkroom, put the containers of solutions into a tray of water at the developing temperature so they don't cool down.

3. Arrange materials for loading film. In a dry, clean, light-tight place, set out an exposed roll of black-and-white film, the developing tank and its cover, a reel, a pair of scissors, and a bottle cap opener. Make sure the tank, its cover, and particularly the reel are clean and dry.

If this is your first roll of film, practice steps 4-8 (shown on next pages). Film has to be loaded onto the reel and put into the tank in complete darkness, so if you are developing your first roll of film, practice locating things with your eyes shut. Use a junked roll of film to practice loading the reel.

Each coil of film should be wound into a separate groove. If two or more coils wind onto the same groove or part of a coil jumps its track, different sections of film can come in contact with each other and prevent development at those points.

When you practice, particularly if you are using a stainless-steel reel, see how much of the reel the film fills. A 36-exposure roll of 35mm film will fill a reel completely; a 12- or 24-exposure roll will fill it part way. Knowing how full the reel should be will help you check that it is correctly loaded when you are in the dark.

Preparing the film

Before opening the film, make sure your hands are clean and dry, with no residue from the chemicals that you have been handling. Check that everything you will need is in place (see step 3). Lock the door and turn off the lights. Keep lights off until the film is in the tank with the cover on.

Note: The gray tone over the drawings in this chapter means that the room must be completely dark.

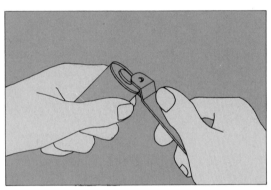

4. Open a 35mm film cassette. Use the rounded end of the bottle cap opener to pry off the flat end of the cassette. Gently push out the film together with the spool on which it is wound.

Opening other types of roll film. With larger sizes of roll film, which are wrapped in paper, break the seal and let the film roll up loosely as you unwind it from the paper. When you reach the end of the film, gently pull it loose from the adhesive strip that attaches it to the paper. To open film that is in a plastic cartridge, twist the cartridge apart and remove the spool of film.

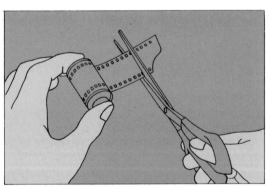

5. Trim 35mm film square. 35mm film has a tongue of film leader at its end. Cut off this tongue to make the end of the film square.

Handle film carefully. Hold the film loosely by its edges. This helps prevent oil from your skin getting on the image area of the film and causing uneven development or fingerprints. Do not unroll film too fast, or rip off an adhesive strip with a quick snap. Doing so can generate a flash of static electricity that may streak the film with light.

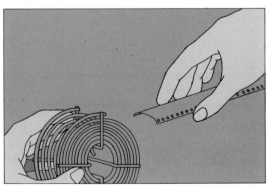

6. Loading a stainless-steel reel. The reel shown here is made of wire spirals running from the core of the reel to the outside. The film loads into the grooves between the spirals.

Hold the reel vertically in your left hand and feel for the blunt ends of the wire on the outermost spirals. Position the reel with the ends on top, pointing toward your right hand. Hold the film in your right hand so that the film unwinds from the top, pointing toward the reel. (If you are left-handed, hold the reel in your right hand, the film in your left hand.)

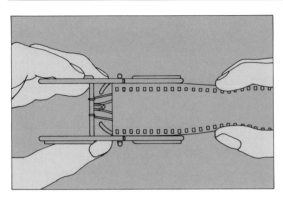

7. Thread the film into the reel. Unwind 2 or 3 inches of film and bow it slightly upward by squeezing the sides gently (extreme flexing can crimp the film and cause marks). Insert the end of the film into the core of the reel. Feed the film in straight so that it goes squarely into the center of the reel. Attach the film to the clip at the center of the reel, if there is one.

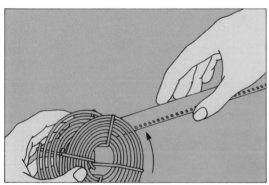

8. Wind the film on the reel. Rest the reel edgewise on a flat surface. Keeping the film bowed slightly upward, rotate the top of the reel away from the film to start the film feeding into the innermost spirals. Hold the film loosely and let it be drawn from your fingers, rather than poking or forcing the film into the reel. If the film kinks, unwind past the kink, then rewind. When all the film is wound, cut the spool free with the scissors.

Check that the film is wound correctly by feeling how full the reel is. If you find more—or fewer—empty grooves than should be there, gently unwind the film from the reel, rolling it up as it comes, and begin again.

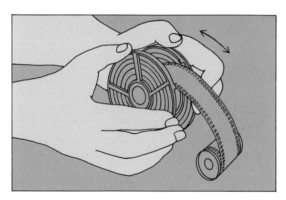

8A. Alternate procedure: Loading a plastic reel. To load this type of plastic reel, first run your finger along the squared-off end of the film to make sure you have cut between the sprocket holes, not through them. The film may snag if the end is not smooth. Hold the film in either hand so it unwinds off the top. Hold the reel vertically in your other hand with the entry flanges at the top, evenly aligned and pointing toward the film. Insert the end of the film just under the entry flanges. Push the film forward about half a turn of the reel. Now hold the reel in both hands (shown at left); turn the two halves of the reel back and forth in opposite directions to draw the film into the reel.

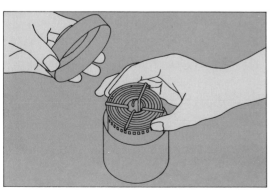

9. Put the reel in the tank and cover it. The cover shields the film from light, so when the loaded reel is in the tank with the cover securely in place you can turn on the room lights or take the tank to the developing area.

Important: Do not remove the entire cover to add or pour out solutions. The tank shown here has a pouring opening at the center of the cover with a small cap that is removed to add or pour out solutions. The cap is put back during agitation so that chemicals do not spill out.

Development

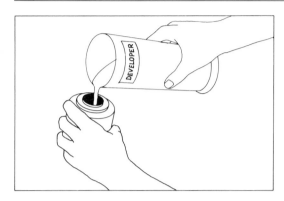

10. Before pouring the developer into the tank, check the developer temperature. If the temperature has changed, readjust it and the other solution temperatures, or select the corresponding development time from the time-and-temperature chart. Set, but don't start, the timer.

Pour the developer into the tank. To do so, remove only the small cap at the center of the lid, not the entire lid. Tilt the tank to help it accept the liquid quickly, and pour in developer until the tank is full.

Start the timer as soon as the tank is filled.

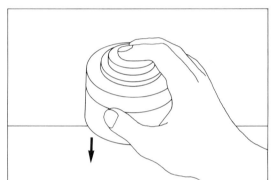

11. Begin agitation immediately. Quickly replace the cap on the tank cover and hold the tank so that its cover and cap won't fall off.

Rap the bottom of the tank once or twice sharply against a solid surface to dislodge any air bubbles that might be clinging to the film surface. Do this only at the start of development.

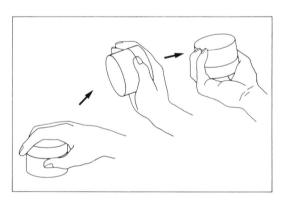

12. Agitate the developer around the tank with a gentle swirling motion, then turn the tank upside down and right side up again. Each complete movement should take about 1 sec. Provide an initial agitation of 5 sec., then repeat the agitation for 5 sec. out of every 30 sec. during the development time. (Check instructions for the developer you are using. Follow manufacturer's recommendations if they differ from these.)

Some plastic tanks have a crank in the lid that rotates the reel to agitate it. Do not invert this type of tank or it will leak.

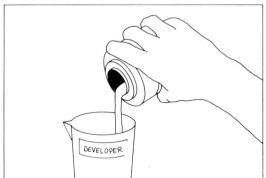

13. Pour out the developer. Shortly before the end of the development time, remove only the small cap from the pouring opening. Do not remove the entire tank cover.

Hold the tank so the cover won't come off. Pour the developer out of the tank, draining it completely. Discard the solution if you are using a one-shot developer; save it if it can be replenished and used again (see page 72).

Stop bath and fixer

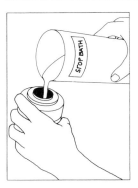
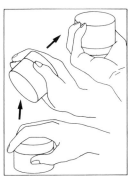

14. Pour the stop bath into the tank. Immediately pour the stop bath through the pouring opening in the tank cover. As before, tilt the tank to help it accept the liquid and fill the tank completely. Replace the small cap over the pouring opening.

Agitate the stop bath. Agitate continuously for about 30 sec. by gently swirling and inverting the tank, holding the tank cover and its cap so they won't fall off.

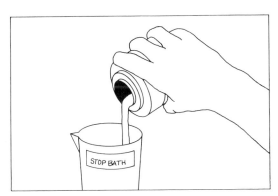

15. Pour out the stop bath. Remove only the small cap from the pouring opening. Do not remove the entire tank cover. Hold the tank so that the cover won't come off and pour out the stop bath, draining the tank completely. Discard a plain water stop bath; save an acetic acid stop bath.

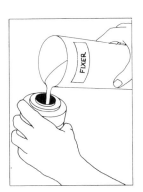
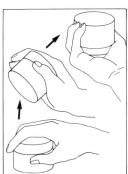

16. Pour the fixer into the tank. Pour the fixer through the pouring opening in the tank cover until the tank is full. Replace the small cap over the pouring opening.

Agitate the fixer. Agitate continuously for the first 30 sec. of the fixing time recommended by the manufacturer, then at 30-sec. intervals. Fixing time will be about 5-10 min. with regular fixer, 2-4 min. with rapid fixer.

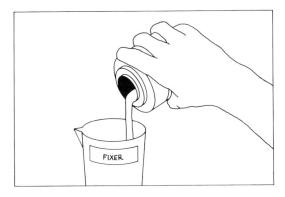

17. Check that the film is clearing. Halfway through the fixing time, lift the tank cover and take a quick look at the film. Film should be fixed for about twice the time it takes to clear of any milky white appearance. If the film still has a milky look after fixing for more than half the maximum time recommended by the manufacturer, the fixer is exhausted and should be discarded. Refix the film in fresh fixer.

Pour out the fixer, saving it for future use. Once the film has been fixed, it is no longer sensitive to light, and the tank cover can be removed.

Processing Film Step by Step (continued)

Washing and drying

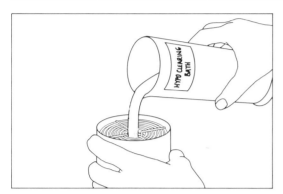

18. Treating the film with a hypo clearing bath is an optional but recommended step that will greatly reduce the washing time. With Kodak Hypo Clearing Agent, first rinse the film in running water for 30 sec. Immerse in the diluted clearing bath, agitating for 30 sec., then at 30-sec. intervals for 1½ min. more. (Check manufacturer's instructions if you are using a different brand.)

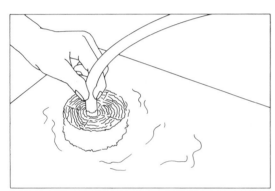

19. Wash the film in running water at about the development temperature. Leave the film on the reel in the tank and, after adjusting the water temperature, insert the hose from the faucet into the core of the reel. Run the wash water fast enough to completely fill the tank several times in 5 min. Also dump the water completely several times. Wash for 5 min. if you have used a hypo clearing bath, 30 min. if you have not.

Treating the film with a wetting agent is optional, but recommended to help prevent spotting as the film dries. Immerse film in diluted solution for 30 sec. without agitation.

20. Hang the film to dry in a dust-free place. Hang a clip or clothespin on the bottom end to keep the film from curling. Handle the film as little as possible and very carefully at this stage; the wet emulsion is soft and easily damaged.

Wiping down the film gently can speed drying and discourage spotting or streaking if that is a problem even though you use a wetting agent. Use only a clean sponge made for photo purposes and dampened with diluted wetting agent. Keep the sponge in good condition by squeezing (not wringing or twisting) out excess moisture. The risk of wiping the film is that you may scratch it; don't wipe it if it dries well without wiping.

21. Clean up. Discard a one-shot developer or save and replenish a developer that can be reused (see page 72). Store solutions that you want to save in tightly closed containers. Rinse well your hands, the reel, tank, containers, and any other equipment that came in contact with chemicals.

When film is completely dry it will curl toward its emulsion, the less shiny side. Cut the film into strips of 5 or 6 frames, depending on the size of the negative envelopes you have. Insert individual strips gently into the envelope sections, handling the film by its edges. Store in a dust-free place, away from extremes of temperature or humidity.

Summary of Film Processing

Step	Time	Procedure
Prepare chemicals	—	Mix the developer, stop bath, and fixer, plus optional hypo clearing bath and wetting agent and dilute to working strength.
		Select a developer time and temperature from the film or developer manufacturer's instructions. Adjust the temperature of all the solutions accordingly.
Load film	—	IN TOTAL DARKNESS, load the film onto the developing reel. Put the loaded reel into the tank and put on the tank's cover. Lights can be turned on when tank is covered.
Development	Varies with film, developer, and temperature	Check the solution temperatures and adjust if necessary. Pour developer into the tank through the pouring opening in the tank cover. DO NOT REMOVE ENTIRE COVER.
		Start timer as soon as tank is filled. Rap tank bottom once or twice on a solid surface. Agitate by swirling and inverting tank for 5 sec. out of every 30 sec. of development time.
		A few seconds before the development time is over, pour out developer through the pouring opening in tank cover. DO NOT REMOVE ENTIRE COVER.
Stop bath	30 sec.	Immediately fill tank through pouring opening with stop bath. Agitate for the entire time. Pour out through pouring opening. DO NOT REMOVE ENTIRE COVER.
Fixer	5-10 min. with regular fixer; 2-4 min. with rapid fixer	Fill tank through pouring opening with fixer. Agitate for 30 sec., then at 30-sec. intervals. Pour out fixer.
Hypo clearing bath (recommended)	30 sec. rinse in running water, then 2 min. in clearing bath	Agitate in the clearing bath for 30 sec., then at 30-sec. intervals for another 1½ min. (Check manufacturer's instructions.)
Wash	5 min. if you used a hypo clearing bath; 30 min. if you did not	Wash water should flow fast enough to fill tank several times in 5 min. Dump water out of the tank several times during wash period.
Wetting agent (recommended)	30 sec.	Immerse in the wetting agent without agitation.
Dry	1 or more hours. Less in a heated film drying cabinet.	Remove film from reel and hang to dry in a dust-free place. When dry, cut into convenient lengths and store strips individually in negative envelopes.

How Chemicals Affect Film

What developer does. Even after film has been exposed to light, the image is latent, not yet visible. Developer chemicals take the film to its next step by converting the exposed crystals of silver halide in the film emulsion to visible metallic silver. The active ingredient in the developer that does this is the reducing agent. Metol and hydroquinone, often used in combination, are two common reducers.

Other chemicals enhance the action of the reducer. Most reducers work only in an alkaline solution. This is provided by the accelerator, an alkaline salt such as borax or sodium carbonate. Some reducers are so active that they can develop the unexposed as well as the exposed parts of the film, fogging the film with unwanted silver. To prevent this from happening, a restrainer, usually potassium bromide, is added to some developers. A preservative, such as sodium sulfite, prevents oxidation and premature deterioration of the developer solution.

Developer time and temperature are critical. The longer the film is in the developer solution at a given temperature or the higher the temperature of the developer for a given time, the more silver halide will be converted to metallic silver and the denser and darker the negative will be. As little as 30 sec. or a few degrees temperature change can make a significant difference in the resulting image. Charts (like the one on page 73) show the combinations of time and temperature for various films and developers.

The stop bath is a simple acid solution (sometimes plain water is used) that stops the action of the developer and, by neutralizing and partially removing the developer, helps preserve the fixer.

Fixer makes the image permanent by dissolving out of the emulsion any unexposed crystals of silver halide. These are still sensitive to light and if exposed would darken the negative overall. This is why the cover must stay on the developing tank until after the fixing stage of development (step 17). Once the fixing is complete, a permanent image of metallic silver remains. Fixer time is not as critical as developer time, but the film should be completely fixed within the time limits set by the manufacturer.

The active fixer chemical is usually sodium thiosulfate. An early name for this chemical was sodium hyposulfite, which is why fixer is still often referred to as hypo. Ammonium thiosulfate is a similar but faster-acting chemical used in rapid fixers. A hardener is also usually part of the fixer formula. It prevents the emulsion from softening and swelling during the washing that follows fixing.

Washing removes chemicals left in the film after fixing, such as sulfur compounds that can damage the image if allowed to remain. Simple immersion in running water will adequately wash the film, but treatment with a hypo clearing bath (also called a hypo neutralizer or washing aid) speeds up the process and does a better job than water alone.

Fresh solutions are vital. Chemicals gradually deteriorate, particularly once they are diluted to working strength with water and exposed to air. Processing film in exhausted chemicals can produce stains, fading images, uneven development, or no image at all. When you store chemical solutions for future use, keep a written record of the date you mixed the solution and how many rolls of film you processed with it. Don't store chemicals longer than the manufacturer recommends or try to use them to process more rolls of film than recommended.

As development begins, the developer solution goes to work first on exposed grains of silver near the surface of the film.

As development continues, the developer solution soaks deeper into the emulsion and the film becomes denser with developed silver.

With even more development, bright highlight areas, which received the most exposure to light in the camera, continue to increase in density at a more rapid rate than dark shadow areas that were exposed to less light.

Tom Wolfe

Developer time and temperature determine how dense a deposit of silver will be created in the film emulsion. The image gradually increases in density during development.

Evaluating Your Negatives

You can make a print from a negative that isn't perfect, for example, one that is overexposed or overdeveloped and so has too much density in the highlights (as in the negatives opposite, far right). But if a negative is correctly exposed and developed, it will be easier to print and you will usually get a better print from it.

Negatives are affected by both exposure and development. An old photographic rule of thumb is: Expose for the shadows, develop for the highlights. You can change the density of bright highlights during development, but you must give adequate exposure to dark shadow areas if you want them to show texture and detail in the print.

Development time controls highlight density. The longer the development time (at a given temperature), the denser and darker a negative will be, but that density does not increase uniformly over the entire negative. During extended development, the density of highlights, such as a sunlit white wall, increases very much. The density of medium tones, such as a gray rock, increases somewhat. The darkest tones, such as a deeply shaded area, change very little. Increasing the time in the developer increases the contrast, the difference between the densities of bright highlight areas and dark shadow areas.

Exposure controls shadow density. Development time has relatively little effect on darker areas, so they must be adequately exposed to begin with if you want them to show texture and detail clearly. If you frequently have trouble getting enough detail in darker parts of your prints, try exposing your negatives more by resetting the film speed dial to a speed lower than that recommended by the film manufacturer.

Follow recommended development times exactly—at first. Ordinarily, you should use the recommended times, but you can change them if you find that roll after roll of your negatives is consistently difficult to print. If your negatives are often high in contrast, so that you print most negatives on a #1 contrast grade of paper (more about contrast grades in Chapter 6, Printing), try decreasing the development time 20 to 30 percent. If your negatives are often low in contrast, so that you have to print most of your negatives on a #4 paper, try increasing the time 20 to 40 percent.

You can change the development for individual scenes. Just as you can adjust the exposure for different scenes, you can change the development time as well. In a very contrasty scene, for example, in a forest on a sunny day, sunlit foliage can meter 6 or more stops brighter than dark shadows. Given normal exposure and development, such a scene will produce a very contrasty, hard-to-print negative. You can decrease the density of highlights and so decrease the contrast in the negative by decreasing the negative development to about three-quarters the normal time.

In a scene with little contrast, perhaps at dusk or on an overcast day, the difference between highlights and shadows may be only 2 or 3 stops. If you think such a scene will be too flat, with too little contrast, try increasing the negative development by 50 percent.

Adjusting the development time for individual scenes is most practical if you are using a view camera, because it accepts individual sheets of film. With roll film, you can't vary the development from one frame to the next, but you can shoot an entire roll under the same conditions and develop it accordingly.

Underexposed. If your negatives are consistently too thin and lack shadow detail, increase the exposure by setting camera to a lower film speed. For 1 stop more exposure, divide the normal film speed by 2.

Overexposed. If many of your negatives are too dense overall with more than adequate detail in darker areas, decrease the exposure by setting camera to a higher film speed. For 1 stop less exposure, multiply the film speed by 2.

A normally exposed, normally developed negative (made of a scene with a normal range of contrast) should have good separation in highlights, mid-tones, and shadows. The negative will make a good print on a normal contrast grade of paper.

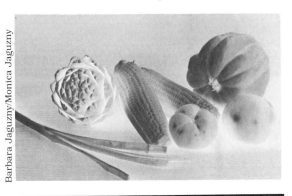

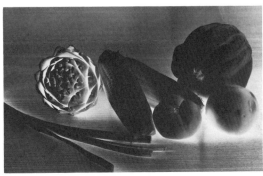

Underdeveloped. If many negatives seem flat, with good shadow detail but not enough brilliance in highlights, increase the development time. Try developing for 50 percent more than the normal time.

Overdeveloped. If negatives are often too contrasty, with good shadow detail but highlights that are overly dense (particularly if you make prints on a condenser enlarger), decrease the development time. Try developing for three-quarters the normal time.

Developing the Negative **83**

Push Processing

Push processing can help you shoot in very dim light. Sometimes the light on a scene is so dim that you cannot use a fast enough shutter speed even at the widest lens aperture. Pushing the film lets you shoot at a film speed higher than the normal rating by, in effect, underexposing the film. For example, if you are using an ISO 400 film, you can reset your film speed dial to ISO 800 or even ISO 1600. This underexposes the film, but lets you shoot at a faster shutter speed. To compensate for the underexposure, you overdevelop the film, either by increasing the development time or by using a special high-energy developer, such as Acufine, Diafine, or Microphen.

To double the film speed, such as from ISO 400 to ISO 800, try increasing your normal development time by about 50 percent. Kodak T-Max films need less increase in development time. See chart at right for manufacturer's instructions. The times of the other processing steps (stop bath, fixer, and wash) stay the same.

Push processing does not actually increase the film speed. It does, however, increase the density of highlight areas enough to produce a usable image, which you might not have if you exposed and developed the film normally. Dark tones, such as shadowed areas, will be darker than in a normally exposed scene because they will be underexposed and the increased development time will not have much effect on them. With push processing, you deliberately sacrifice shadow detail to get a usable highlight image.

Push processing has some side effects. The more you push the film by increasing the working film speed and subsequently overdeveloping, the more that graininess and contrast increase, and sharpness and shadow detail decrease.

Pushing black-and-white films

Film (normal speed ISO 400)	Developer	To push film speed 1 stop to 800	To push film speed 2 stops to 1600
Kodak T-Max 400	Kodak T-Max 75°F (24°C)	develop normally 6 min.	8 min.
	Kodak D-76 68°F (20°C)	develop normally 8 min.	10½ min.
Kodak Tri-X	Kodak T-Max 75°	develop normally 5½ min. [or increase time to 6½–7 min.]	8 min.
	Kodak D-76 68°	develop normally 8 min. [or increase time to 9½–11 min.]	13 min.
Ilford HP5	Ilford Microphen 68°	8 min.	9½–12 min.
Fuji Neopan 400	Kodak T-Max 75°	5¼ min.	8 min.

Film (normal speed ISO 3200)	Developer	To push film speed 1 stop to 6400	To push film speed 2 stops to 12,500
Kodak T-Max P3200	Kodak T-Max 75°	11 min.	12½ min.

Sometimes you don't need to change the development time: you can push film 1 stop by underexposing it and developing normally. Kodak recommends this for a 1-stop push of its T-Max 400 film. Simply expose at ISO 800, instead of the standard ISO 400. Kodak feels that this film has enough exposure latitude to accept 1 stop of underexposure without the need for extra development. Kodak also recommends normal development for a 1-stop push of Tri-X film. However, many photographers still prefer the results they get from increasing the development for a 1-stop push of Tri-X.

Pushing film speed. The chart shows some manufacturers' development recommendations for pushing film. The development times shown are a starting point from which you should experiment to determine your own combinations.

Lois Bernstein

Pushing film, underexposing the film then giving it greater-than-normal development, lets you expose film at a higher-than-normal film speed. It can save the day when the available light isn't bright enough for you to use as fast a shutter speed as you want. Lois Bernstein rated Kodak Tri-X film at ISO 1600 instead of the standard ISO 400, and gave the film special development. This gave her two extra stops of film speed and let her shoot at a 1/500 sec. shutter speed, fast enough to freeze the basketball player and ball as they both bounced out of bounds. The more that film is pushed, the more that grain in the image becomes visible.

Developing the Negative **85**

Solving Negative Development Problems

Patches of undeveloped film

Alan Oransky

Partial development

Alan Oransky

Overdevelopment on edges of film

Jim Stone

Check below if your negatives show spots, stains, or other disorders. The most common problems are described, along with suggestions on how to prevent them from happening again. See also Solving Camera and Lens Problems, page 39; Exposure Problems, page 66; Printing Problems, page 109; Flash Problems, page 132; and Evaluating Your Negatives, page 82.

Patches of undeveloped film. Irregular in shape, usually on more than one frame of film.

Cause: Two loops of film came in contact with each other during processing, either by being wound together onto the same loop of the developing reel or by being squeezed together after reeling. As a result, chemicals did not reach the film emulsion where it was touching. Most often the patches will be totally unprocessed and opaque (light in print). Less likely, but possible if the film comes unstuck during fixing, are clear patches on film (dark in print).

Prevention: Check the positioning of the film as you wind it onto the reel. If it feels wrong, unwind a few loops and start again (see steps 7 and 8, page 75).

Cinch marks. Small, dark marks (light in print), often with the crescent-moon shape and approximate size of a fingernail clipping.

Cause: Film was crimped or creased while it was being loaded onto the reel.

Prevention: Handle film gently during loading, without pinching or crumpling it, especially if you have to unreel and re-reel it. Bow film only slightly to feed it onto the reel.

Partial development. A strip along one edge of entire roll of film is lighter than rest of film (darker in print).

Cause: Developer did not entirely cover reel of film.

Prevention: Check the amount of developer needed to cover reel in tank (or reels, in a tank that accepts more than one reel), or fill tank to overflowing. Mix up a bit more developer than you need, in case you spill some when filling the tank.

Overdevelopment on edges of film. Streaks on edge of film are somewhat darker than surrounding area (lighter in print). Streaks coming from sprocket holes of 35mm film.

Cause: Excessive agitation in developer forced solution along spirals of developing reels and through the sprocket holes of 35mm film, overdeveloping the edges of film.

Prevention: Do not agitate film in developer more than the recommended amount or with excessive vigor; only a gentle motion is needed (see step 12, page 76). If you develop one reel of film in a two-reel tank, put an empty reel on top so the loaded one doesn't bounce back and forth.

Uneven, streaky development, not just at edges.

Cause: Too little agitation in developer let exhausted chemicals accumulate and slide across surface of film, retarding development in those areas.

Prevention: Agitate regularly, as directed.

Reticulation. Image appears crinkled, cracked, or patterned overall.

Cause: Extreme difference between temperatures of processing solutions, for example, taking film from very warm developer and putting it into very cold stop bath. Less extreme changes can cause an increase of graininess in the image.

Prevention: Keep all solutions, from developer to wash water, within a few degrees of each other.

Air bells. Small, round, clear spots on negative (dark in print).

Cause: Small bubbles of air sticking to the surface of film prevented developer from reaching the emulsion.

Prevention: At the start of the development period, rap tank sharply on a solid surface (step 11, page 76). Presoaking the film in plain water for about a minute before development might help if you have persistent problems; increase the development time 10 percent if you presoak. Although presoaking is a common practice, Kodak warns that it can cause uneven development with certain films, such as Technical Pan 2415 film.

Pinholes. Tiny clear specks on negative (dark in print).

Cause: Usually caused by dust on film that keeps light from exposing film or keeps developer away from emulsion. Could be due to acetic acid stop bath solution being mixed too strong.

Prevention: Blow or brush dust out of the inside of camera, and load film onto the developing reel on a dust-free surface. Check that you are mixing stop bath correctly; use a more diluted solution or just plain water instead.

Specks, scratches, fingerprints.

Cause: Rough handling during processing.

Prevention: Handle film gently, by edges as much as possible. Be particularly careful when emulsion is wet and more sensitive to surface damage. Hang film to dry in as dust-free a place as possible, where it will not be jostled or moved around.

Faint, watery-looking marks.

Cause: Uneven drying or water splashed on film during drying.

Prevention: Before drying, treat film in a wetting agent, such as Kodak Photo-Flo, and wipe film gently with photo sponge (step 20, page 78). Don't let water from one roll of film drip onto another roll hanging to dry. Rewashing and redrying the film or cleaning it with a film cleaner may remove the marks.

Cloudy look overall

Cause: Probably due to inadequate fixing, but possibly caused by using old, light-struck, or X-rayed film.

Prevention: Refixing film in fresh fixer may help if due to inadequate fixing; rewash completely.

6 Printing

David A. Pickel

Now comes the fun. Developed negatives in hand, you finally get to examine your pictures closely, first in a contact print that is the same size as the negative, then in enlarged prints.

The negative has the opposite tones of the original scene. Where the scene was bright, such as white clouds, that part of the film received a great deal of exposure and produced an area in the negative that is dense and dark with silver. Where the scene was dark, such as in a shadowed area, the film received little exposure, resulting in a less dense or even clear area in the negative.

When you make a positive print, the tones are reversed again, back to those of the original scene. The densest and darkest parts of the negative will hold back the most light from the paper, producing a light area in the print. Less dense parts of the negative will pass the most light, producing the darkest parts of the print.

Avoid chemical contamination to avoid printing problems. Think of your printing darkroom as having a dry side and a wet side; you will be moving repeatedly from one side to the other. On the dry side you handle negatives, adjust the enlarger, and expose paper. On the wet side you mix chemicals and process paper. It is vital to prevent wet-side procedures from contaminating the dry side. Even a small amount of chemicals straying over to the dry side on your fingertips can leave fingerprints on your next print, permanently damage negatives, and more. See page 72 for how to avoid contamination, mix chemicals, and handle them safely.

Negative

Positive

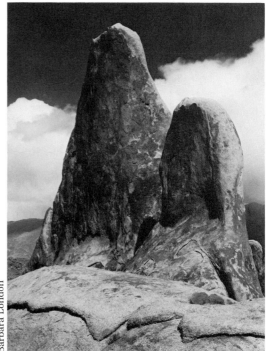

Barbara London

Printing: Equipment and materials you'll need

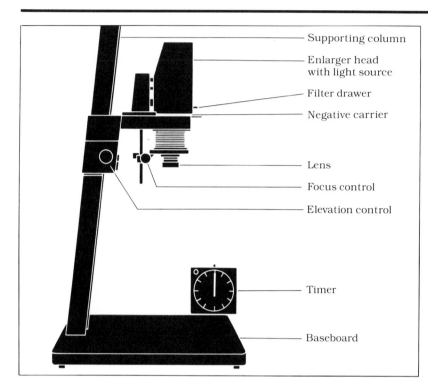

- Supporting column
- Enlarger head with light source
- Filter drawer
- Negative carrier
- Lens
- Focus control
- Elevation control
- Timer
- Baseboard

Dry-side equipment

Enlarger (shown above) projects light through a negative onto photographic paper.

Supporting column holds the enlarger head out over the baseboard.

Enlarger head contains the light source, negative carrier, lens, and other components.

Light source spreads light from a lamp over the negative. A condenser source concentrates light on the negative through a pair of lenses. A dif-

fusion source scatters light onto the negative, producing less contrast. Some designs combine characteristics of these two systems.

Filter drawer holds filters that affect the color of the light source for variable-contrast black-and-white paper or for color printing. A dichroic enlarger head has built-in filters; you simply dial in different colors.

Negative carrier holds the negative flat.

Lens focuses the image from the negative onto the baseboard.

The lens aperture is adjustable to control the brightness of the light passed through the lens. The focal length of the lens is matched to the size of the negative: a 50mm lens is normally used with a 35mm negative, 80mm lens with 2¼-inch-square negative, 150mm lens with 4 x 5-inch negative.

Focus control focuses the image by adjusting the distance from lens to negative.

Elevation control sets the image size by moving the enlarger head up or down on a track on the supporting column.

Baseboard supports enlarger and printing frame or easel.

Enlarger timer activates the enlarger, turning it on, then off when the set time has expired.

Printing frame holds negatives and paper tightly together for contact prints. A sheet of plain glass is a substitute.

Easel holds printing paper flat on the enlarger's baseboard for enlargements. This easel has adjustable slides for cropping the image.

Focusing magnifier enlarges the projected image when making

enlargements so you can focus sharply.

Dodging and burning-in tools let you selectively lighten or darken parts of a print (see page 106).

Miscellaneous: marking pen, scissors. For cleaning negatives use a soft brush, or, if you use compressed gas, buy a type such as Dust-Off Plus, which contains less chlorofluorocarbon than similar products.

Printing paper

Printing paper is coated with a light-sensitive emulsion onto which the image is printed.

Fiber base or resin coated. Resin-coated (RC) papers have a water-resistant coating that lets processing chemicals reach the paper's emulsion, but not its base. RC paper is convenient to use because it does not become saturated with liquid, so less processing time is required for fixing, washing, and drying. Nevertheless, many photographers still prefer conventional fiber-base papers, which are available in a wider range of surfaces, are more permanent, and have what many feel is a better finish.

Graded contrast or variable contrast. To change the contrast of your print, you change the contrast grade of the printing paper. Each grade of a graded-contrast paper produces a single grade of contrast. A variable-contrast paper produces different levels of contrast depending on the filtration of the enlarger's light. See pages 104–105

Surface finish and image tone. Characteristics vary widely, from smooth to rough finishes, glossy to matte (dull) surface sheen, cool blue-black to warm brown-black image color.

Size. Readily available sizes include 8 x 10, 11 x 14, and 16 x 20 inches; some papers are available in additional sizes. The most popular and useful size is 8 x 10.

Weight refers to the thickness of the paper base. Fiber-base papers come in single weight (suitable for contact prints or small-size prints) and double weight (sturdier and easier to mount). RC papers come only in a medium weight that is between single and double weight.

Wet-side equipment

Trays hold solutions during processing. For 8 x 10-inch prints, you'll need three trays that size, plus one larger tray for washing.

Optional: **Tongs** lift prints into and out of solutions, keeping your hands clean so that you don't need to wash and dry your hands so often. You'll need one pair for developer, another for stop bath and fixer.

Timer or clock with sweep-second hand times the processing steps.

Safelight provides dim, filtered light that lets you see what you are doing without fogging the printing paper.

Washing siphon clamps onto a tray. It pumps water into the top of a tray and removes it from the bottom so that clean water circulates around the washing prints. Print washers do the same.

Photo sponge or squeegee wipes down wet prints to remove excess water before drying.

Drying racks or other devices dry prints after processing (see page 96).

Mixing and storing equipment is similar to that used for negative chemicals (page 70): mixing container, thermometer, stirring rod, storage bottles.

Chemicals

Most of the chemical solutions used in paper processing, including stop bath, fixer, and hypo clearing bath, are similar to those used in film processing. Only the developer is a different formulation. Average storage times and capacities are given here; see manufacturer's directions for specifics.

Developer converts, into visible metallic silver those crystals in the paper's emulsion that are exposed to light. Choose a developer made for use with paper.

Stock solution lasts from 6 weeks to 6 months, depending on the developer and how full the storage container is; the more air in the container, the faster the solution deteriorates. Discard working solution after about fifteen to twenty 8 x 10 prints have been developed per quart, or at the end of one working day.

Stop bath halts the action of the developer. A simple stop bath can be prepared from about 1½ oz (46 ml) 28 percent acetic acid to 1 quart (1 liter) of water.

Stop bath stock solution lasts indefinitely. Discard working solution after about a month or after twenty prints have been treated per quart. An indicator stop bath changes color when exhausted.

Fixer removes unexposed and undeveloped silver from the emulsion. A fixer with hardener prevents softening and possible damage to the print emulsion during washing.

Fixer stock solution lasts about 2 months. Working solution lasts about a month in a full container and will process about twenty-five 8 x 10-inch prints before it should be discarded. A testing solution called hypo check (or fixer check) is the best test of fixer strength.

Optional: **Hypo clearing bath** is highly recommended when you are using fiber-base papers. It removes fixer better and faster than washing alone. Capacity and storage time varies depending on the product; see manufacturer's instructions.

Making a Contact Print Step by Step

A contact print is the same size as the negative. A contact sheet of all the negatives on a roll makes it easy for you to examine and compare different frames so you can choose ones to enlarge. Then you can file the contact with the negatives for later reference.

The following method uses an enlarger as the light source and a contact printing frame to hold the negatives and printing paper. See Equipment and Materials You'll Need, pages 90–91, and Processing a Print Step by Step, pages 94–96. A 36-exposure roll of 35mm film (or a roll of 2¼-inch film) will just fit on an 8 x 10-inch sheet of printing paper. Use a grade 2 or normal contrast paper. (Contrast grades are explained on pages 104–105.)

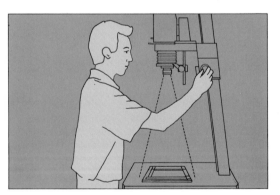

1. Position the enlarger. Close the slot where the negative carrier is inserted in the enlarger head so that light will shine only on the baseboard and is not coming out of the slot. This is particularly important in a school's group darkroom because stray light can fog other people's prints. Switch on the enlarger lamp. Place the printing frame on the enlarger baseboard. Raise the enlarger head until the light covers the entire printing frame.

Note: The gray tone over the drawings in this chapter means that the room lights should be off, darkroom safelights on.

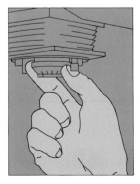

2. Set the lens aperture and the enlarger timer. As a trial exposure, set the enlarger lens aperture to f/8 and the timer to 5 sec. You may want to change these settings after developing and evaluating the print (see step 6, opposite). You can, if you wish, make a test print, giving a range of different exposures to the print as described on page 100.

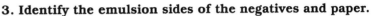

3. Identify the emulsion sides of the negatives and paper.
The emulsion side of the negatives must face the emulsion side of the paper. Film tends to curl toward its emulsion side, which is duller than the back side.

Turn on the darkroom safelights and TURN OFF THE ROOM LIGHTS AND ENLARGER LAMP before opening the package of paper. The emulsion side of paper is shinier and, with glossy papers, smoother than the back side. Fiber-base paper curls toward the emulsion side; RC paper curls much less, but may have a manufacturer's imprint on the back side.

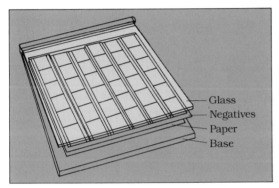

Glass
Negatives
Paper
Base

4. Insert the negatives and one sheet of paper in the printing frame.
The paper goes on the bottom, emulsion side up. The negatives go above the paper, emulsion side down. The glass top of the frame sandwiches the negatives and paper together tightly. If you don't have a printing frame, you can simply put the paper on the enlarger baseboard, the negatives on top of it, and a plain sheet of glass over all.

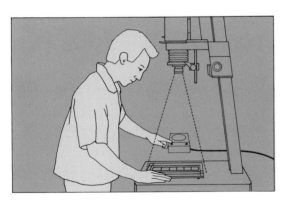

5. Expose and process the print.
With the printing frame in place under the enlarger head, push the timer button to turn the enlarger light on and expose the print.

Process the paper as shown on pages 94–96. After fixing, evaluate the print in room light. If you are the only person using the darkroom, you can simply turn on the lights there. BEFORE YOU TURN ON ROOM LIGHTS make sure the package of unexposed printing paper is closed. If you are in a school darkroom used by several people at the same time, bring the print into another room for evaluation. Put it in an extra tray or on a paper towel so fixer doesn't drip on other surfaces.

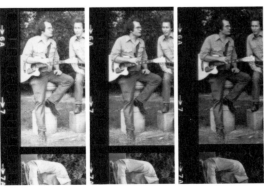

6. Evaluate the print.
Some of the frames will be lighter, others darker, depending on the exposure each received in the camera. To judge print exposure overall, examine the film edges in the print. They should be black, but with the edge numbers legible and, with 35mm film, a very slight difference between the edges and the darker sprocket holes. If the edges of the film look gray, many frames will probably be very light; make another print with the enlarger lens opened to the next larger aperture. If the edges of the film are so dark that you can't see edge numbers or sprocket holes, many frames will probably be very dark; close the enlarger lens to the next smaller aperture.

Processing a Print Step by Step

Development

Processing a print is not unlike processing film: the exposed print is agitated in developer, stop bath, and fixer, then washed and dried. Until the print is fixed, don't expose it to ordinary room light, only to darkroom safelights. They are bright enough so that you can see what you are doing and see the image as it emerges—one of the real pleasures of printing.

See Equipment and Materials You'll Need, pages 90–91. Notice that resin-coated (RC) paper needs less time in the stop bath and fixer, no washing aid, and less washing than fiber-base paper does.

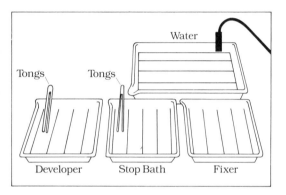

1. Set up the wet-side materials. Set up the processing solutions in four trays (one each for developer, stop bath, and fixer, plus one filled with water to hold prints after fixing until washing).

If you use tongs to lift the paper out of the solutions, reserve one set exclusively for the developer, another for stop bath and fixer. Label them so they are not interchanged.

Solution temperatures are not as critical as for film processing. Most manufacturers recommend temperatures between 65°-75°F (18°-24°C).

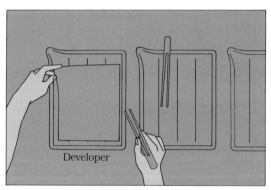

2. Immerse the print in the developer. Slip the exposed paper quickly into the solution, emulsion side up, so the developer covers the entire surface of the print.

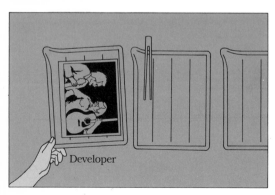

3. Agitate the print in the developer. Agitate continuously for the time recommended by the manufacturer for the particular paper you are using, typically 1-3 min. Agitate by rocking the tray gently. In an oversize tray, as is sometimes used in school darkrooms, you may have to use tongs to agitate the print. If so, touch the surface of the print as little as possible; the tongs can leave marks.

Stop bath and fixer

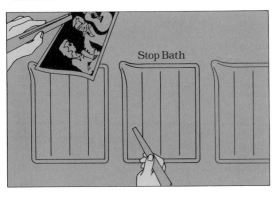

4. Remove the print from the developer. Let it drain for a few seconds into the developer tray so you don't carry too much developer into the stop-bath tray.

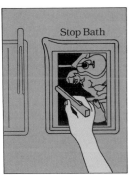
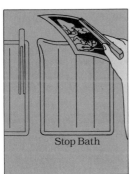

5. Immerse the print in the stop bath. Use only the stop-bath/fixer tongs in this solution, not the developer tongs. Agitate continuously for 15 sec. (10 sec. for RC paper).

Remove the print from the stop bath. Let the print drain for a few seconds into the stop-bath tray. Don't let stop-bath solution splash into the developer.

6. Immerse the print in the fixer. Agitate the print frequently for 5-10 min. (2 min. for RC paper). If several prints are in the fixer, rotate individual prints from the bottom to the top of the tray. Room lights can be turned on after about 2 min.

7. Remove the print from the fixer at the end of the recommended time. Transfer fiber-base paper to a large tray filled with water until the end of your printing session, when you can wash all the prints at once. In the meantime, run water gently into the tray, or dump and refill from time to time. Wash RC paper promptly for best results; ideally, total wet time should not exceed 10 min. to prevent solutions from penetrating the paper at the edges of the print. See Washing and Drying, next page.

Washing and drying

8. Treating prints with a hypo clearing bath is optional for fiber-base paper, but highly recommended. (RC paper should not be treated with a clearing bath; go directly to step 9.)

Rinse fiber-base paper in running water with continuous agitation for 1 min. Then agitate in the clearing bath continuously for 15-30 sec., then occasionally for 2-3 min. more, or as directed by manufacturer. When processing several prints at a time, rotate individual prints from the bottom of the tray to the top during agitation.

9. Wash prints in running water. If fiber-base paper is treated with a hypo clearing bath, wash single-weight paper for 10 min., double-weight paper for 20 min.; if untreated, wash for 1 hour. Wash RC paper for 4 min.

A washing siphon is best if you wash prints in a tray. Run the wash water fast enough to fill the tray several times in 5 min., or dump and refill the tray several times. Rotate individual prints from top to bottom, and keep prints separated so that they circulate freely in the water. Some print washers are designed to keep prints separated; in a tray, do this by hand.

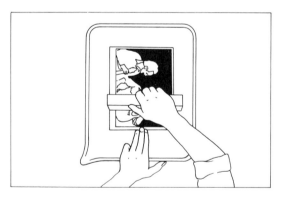

10. Wipe off excess water. Put one print at a time on a clean sheet of plastic or glass. An overturned tray will do if you clean it well and the tray bottom is not ridged. Gently wipe down the front and back of the print with a clean squeegee or photo sponge.

11. Dry prints. You can dry fiber-base prints on racks of fiberglass screens, in a heated dryer, or between photo blotters. RC prints dry well on racks, hung from a line with a clothespin, or face up on a clean surface; do not dry them in a heated dryer.

An improperly washed print will contaminate its drying surface with fixer and cause stains on the next print dried there. If blotters or cloths from heat dryers become tinged with yellow, they are contaminated with fixer. Blotters should be discarded and replaced with new ones; cloths on heat dryers can be washed. Wash off drying rack screens from time to time.

Summary of Print Processing

Step	Time	Procedure
Prepare chemicals	—	Mix developer, stop bath, and fixer, and dilute to working strength. Pour each into a tray; fill a fourth tray with water. Temperatures should be between 65°-75°F (18°-24°C).
Expose the print	—	Expose a piece of printing paper to make a contact print (page 92), test print (page 100), or final print (page 101). Open printing paper package only under darkroom safelight. Do not turn on room lights until print has been fixed.
Development	1-3 min. (2 min. is typical but see manufacturer's instructions)	Agitate continuously for the time recommended by manufacturer. Drain print briefly before putting into stop bath.
Stop bath	15 sec. with fiber-base paper, 10 sec. with RC paper	Agitate continuously. Drain print briefly before putting into fixer.
Fixer	5-10 min. with fiber-base paper, 2 min. with RC paper	Agitate frequently. If more than one print is in tray, rotate each from bottom to top of stack.
Holding until wash	As needed with fiber-base paper	If you have additional prints to make, transfer fiber-base prints into a tray of water until all are ready to wash. Run water gently into tray, or dump and refill occasionally. Wash RC paper promptly (total wet time ideally should be not more than 10 min.).
Hypo clearing bath (recommended for fiber-base paper only)	Water rinse: 1 min. Clearing bath: 2-3 min. (Check manufacturer's instructions.)	Agitate continuously in running water. Agitate continuously for the first 15-30 sec., occasionally thereafter. Do not use with RC paper.
Wash	If hypo clearing bath used with fiber-base paper: 10 min. with single-weight paper, 20 min. with double-weight paper If no clearing bath used with fiber-base paper: 60 min. 4 min. with RC paper	Wash in running water. Keep prints separated. Rotate prints; dump and refill tray several times.
Dry	1 or more hours	Wipe down front and back of print with clean squeegee or photo sponge. Dry fiber-base paper on racks, in heated print dryer, or in photo blotters. Dry RC prints on racks, on a line, or on any clean surface, but not in a heated dryer. Make sure drying surface is free of fixer or other chemical residues.

Making an Enlarged Print Step by Step

Setting up the enlarger

Barbara London

An enlarged print finally gives you a good look at your photograph and the chance to show it to others. Making an enlargement is shown here in three steps: Setting Up the Enlarger (on this page and the one opposite), Exposing a Test Print, page 100, and Exposing the Final Print, page 101.

See Equipment and Materials You'll Need, pages 90–91, and Processing a Print Step by Step, pages 94–96.

1. Select a negative for printing. Examine the contact sheet with a magnifying glass. If you have several shots of the same scene, which has the best light or action or expressions? Evaluate the images technically as well. Is the scene sharp or is it slightly blurred because the camera or subject moved during the exposure? Maybe you have another frame that is sharper. Is the scene overexposed and very light or underexposed and very dark? You can correct minor exposure variations during printing but massive exposure faults will make the negative difficult, if not impossible, to print. Use a white grease pencil to mark the frames on the contact sheet that you want to enlarge.

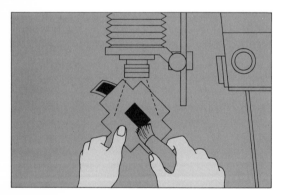

2. Dust the negative and insert it in the negative carrier. Use an antistatic brush or compressed air to dust the negative and the enlarger's negative carrier (usually two metal pieces that hold the negative between them). Look for dust by holding the negative at an angle under the enlarger with the lamp on; it is often easier to see dust with room lights off. Dusting is important because enlargement can make even a tiny speck of dust on the negative big enough in the final print to be visible.

Position the negative in the carrier window so that the (duller) emulsion side faces down in the carrier.

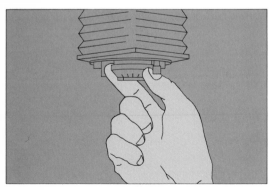

3. Open the enlarger's aperture to its largest f-stop to produce the brightest image for focusing. Turn the enlarger lamp on and the room lights off.

4. Adjust the easel. Insert a piece of plain white paper or the back of an old print in the easel so you can see the focus of the projected image clearly. Adjust the movable sides of the easel to hold the size of paper being used. Position the easel under the projected image.

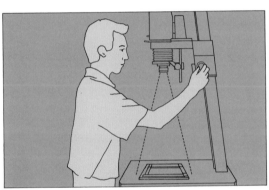

5. Adjust the enlarger head. Raise or lower the enlarger head to get the amount of image enlargement that you want. Re-adjust the position of the easel or the easel blades to crop the image exactly as you want. (More about cropping on page 107.)

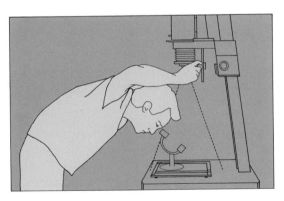

6. Focus the image. Focus by turning the knob that raises or lowers the enlarger lens. A focusing magnifier will help you make the final adjustments of focus. The best focusing magni-fiers enlarge the image enough for you to focus on the grain in the negative.

7. Set the enlarger aperture and timer. Stop down the aper-ture to a setting (you can try f/11 as a start) that is several stops from the widest aperture. This gives good lens perfor-mance plus enough depth of focus to minimize slight errors in focusing the projected image.

Set the enlarger timer to 5 sec. The first print will be a test that receives several different exposures (see next page).

Exposing a test print

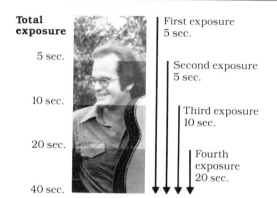

Total exposure

5 sec.

10 sec.

20 sec.

40 sec.

First exposure 5 sec.

Second exposure 5 sec.

Third exposure 10 sec.

Fourth exposure 20 sec.

8. A test print has several exposures of the same print on one piece of paper so that you can determine the best exposure for the final print. The print shown here received four exposures to produce a test with 5-, 10-, 20-, and 40-sec. exposures. Turn on the enlarger and estimate where you will place the strip. It should go across the most important parts of the image.

TURN OFF THE ROOM LIGHTS AND ENLARGER before opening the package of paper. Cut a sheet of 8 x 10-inch paper into four equal strips. Put all but one of the strips back in the paper package and close it.

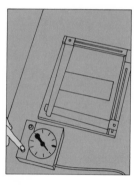
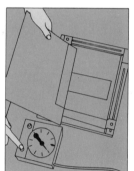

9. Make the first exposure. Put one strip, emulsion side up, on the easel. If you can, secure at least one end of the strip under the easel blades so that the strip will stay in place. Have an opaque piece of cardboard at hand, but don't cover any of the test strip yet. For this test strip, the timer is set for 5 sec. and the enlarger lens aperture set to f/11. Push the timer button.

Make the second exposure. Use the cardboard to cover one quarter of the test strip. Push the timer button again for another 5-sec. exposure. Try not to move the test strip when you move the cardboard.

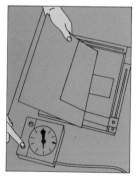

10. Make the third exposure. Reset the timer to 10 sec. Cover one half of the test strip. Push the timer button.

Make the fourth exposure. Reset the timer to 20 sec. Cover all but one quarter of the test strip. Push the timer button.

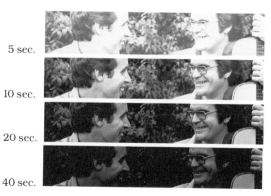

5 sec.

10 sec.

20 sec.

40 sec.

11. An alternate way to test. Instead of one strip with four exposures on it, use four strips, each one exposed in the same position for a single exposure time. This uses more paper but lets you see more of the important areas in the print. Ideally, position the strips to show both highlight and shadow areas.

Remove one strip of paper from the package and expose it for 5 sec. Place each exposed strip in a covered place, so it doesn't get exposed to additional light or mixed up with unexposed strips. Expose the second strip for 10 sec., the third strip for 20 sec., and the fourth strip for 40 sec.

Exposing the final print

12. Process the test. Develop the strip (or strips) for the full time. Do not remove a print from the developer early if it looks too dark, or leave it in longer than the recommended time if it is too light. After fixing, evaluate the test.

Evaluating the test. Always judge prints under room light because they will look much darker under darkroom safelight. If you turn on room lights in the darkroom, make sure the package of unexposed paper is closed. In a school darkroom used by several people at the same time, bring the test into another room. If you do so, put the wet paper in an extra tray or on a paper towel so that you don't drip fixer onto other surfaces.

Judging exposure. If all the test segments are too light, retest using longer times or a larger aperture. One stop wider aperture darkens the print the same as doubling the time. If the test is too dark, use shorter times or a smaller aperture. One stop smaller aperture lightens the same as halving the time.

Judging contrast. Is the test too contrasty, with inky black shadows and overly light highlights? If so, retest using a lower contrast grade of paper. Is the test too flat, with dull gray shadows and muddy highlights? If so, retest with a higher contrast grade of paper. See Evaluating a print, pages 102–103.

13. Expose and process the final print. Recheck the focus. Set the timer to the best exposure time shown on the test (often a midpoint between two of the exposures). Insert a full sheet of paper in the enlarger easel and expose.

Develop for the full time. After fixing for about 2 min., you can evaluate the print under room lights.

14. Evaluate the final print. Don't be disappointed if the final print is not really final, because it will take several trials to get a really good print. Are exposure and contrast about right? You can't always tell from a test print how the full print will look. Also, most prints require some dodging, holding back light from part of the image during the initial exposure, or burning in, exposing an area for extra time (see page 106).

When you are satisfied with a print, complete the fixing, washing, and drying. Make a note of the final aperture and exposure time for reprints.

Evaluating Your Print for Density and Contrast

Now that you have a print, how good is it technically? The goal in most cases is a full-scale print, one that has a full range of tones: rich blacks, brilliant highlights, and good separation in middle tones. Take a look at your print under room light; safelight makes prints appear darker than they really are. You'll be evaluating two elements: density and contrast.

Density is the lightness or darkness of a print. It is controlled by the print exposure—the size of the enlarger lens aperture, plus the length of the exposure time. More exposure makes a print darker, less exposure makes it lighter. A test strip with a series of exposures on it (like the one on page 100) helps you evaluate density and determine the basic exposure for a print, although you may not be able to evaluate density completely until you see an entire print at one exposure.

Contrast is the difference in darkness between light and dark parts of the same print. Contrast is controlled by the contrast grade of the paper or, with variable-contrast paper, by the printing filter used (see pages 104–105).

Adjust density first, then contrast. The photographic rule of thumb for negative exposure and development is: Expose for the shadows, develop for the highlights. The rule for prints is somewhat the opposite: Expose for the highlights, adjust paper contrast for the shadows.

First, examine the highlights, particularly large areas in your print that should be light but that should still show texture and detail, for example, skin or light clothing. (For the moment, ignore areas that should be white or extremely light, such as light sources or their reflections, sunlit snow, or very bright sky.) If light areas seem too dark, make another print giving less exposure; if they are too light, make another print with more exposure. Prints "dry down" slightly in tone, so that a dry print will appear slightly darker overall than a wet one.

When highlight density seems about right, examine the shadow areas. Again, look at larger areas that should have some sense of texture and detail, such as dark clothing or leaves, but not those that should be completely black. If shadows are weak and gray rather than substantial and dark, make another print on the next higher contrast grade of paper. If shadows are extremely dark, so that details that appeared in the negative are obscured in the print, make another print at the next lower contrast grade. Different grades of contrast usually have different printing speeds, so you may have to make another test print for the exposure time.

Last adjustments. When the print looks about right overall, examine it for individual areas that you might want to lighten by dodging or darken by burning in. For example, you can lighten a person's face slightly by dodging it during part of the basic exposure. Sky areas often benefit from burning in because they are often so much brighter than the rest of the scene. (More about dodging and burning on page 106).

If a photograph is important to you, don't be satisfied with a print that only more or less shows the scene. For example, skin tones are important in a portrait, and they should not be pale and washed out or murky dark. Many beginners tend to print too light and too flat, but this will not produce good texture and detail. There will be a big difference in satisfaction between a barely acceptable print and one that conveys a real sense of substance.

Normal density, normal contrast

Barbara London

A full-scale print with normal density and contrast shows good texture and detail in important light highlights and dark areas.

Density: too light too dark

Contrast: too flat too contrasty

Evaluate density by looking at the important lighter parts of the print. If they look too light, make another print with more exposure (longer exposure time or wider aperture). If they look too dark, make another print with less exposure (shorter time or smaller aperture).

Evaluate contrast (after the density of the highlights is about right) by looking at the important darker parts of the print. If they look muddy gray and flat, use a higher contrast grade of paper. If they look too black and contrasty, use a lower contrast grade.

More About Contrast: How to control it in a print

Contrast is the relative lightness and darkness of different parts of a scene. It is different from density (see page 102), which is the darkness of the print overall Most often, you will want a normal range of contrast: deep blacks, brilliant whites, plus a full range of gray tones. But how much contrast is best depends on the scene and how you want to print it. Too little contrast makes most prints look muddy and dull. However, in a scene such as a foggy landscape, low contrast can enhance the impression of soft, luminous fog. Too much contrast, for example in a portrait, can make the photograph—and your subject—look gritty and harsh. However, in a silhouette you want high contrast: dense blacks, bright whites, and few or no middle-gray tones.

You can change contrast during printing. The contrast of your negative is set by the contrast of the scene, the film type, exposure, and processing. But you can change the contrast of a print made from that negative to a considerable extent by changing the contrast of the paper used during printing. You can lower the contrast of a print by using a low-contrast paper. You can increase the contrast by using a high-contrast paper (see opposite).

Other factors also affect print contrast. A condenser enlarger produces about one grade more contrast than a diffusion enlarger. A highly textured paper surface reduces contrast, as do some paper developers, such as Kodak Selectol Soft. However, the contrast grade of the paper is the main method of control.

High contrast dominates this scene shot in India of a child standing by a window. The sunlight on the child was very bright compared to the darkest parts of the room, where objects are just distinguishable. Printing on a lower contrast grade of paper would have made both the lightest and darkest areas less intense, but that is not necessarily the best choice. Here, the high contrast conveys the cavernous darkness of the room, which is lit during the day only through its small openings.

Chris Rainier

Grade 1 paper produced the least contrast

Graded-contrast papers are manufactured in fixed degrees of contrast: grade 0 and 1 (low or soft contrast), grade 2 (medium or normal contrast), grade 3 (often the normal contrast grade for 35mm negatives), and grades 4 and 5 (high or hard contrast). Every paper is not manufactured in every grade. Many photographers prefer to use graded-contrast papers even though it is necessary to purchase each contrast grade separately.

Variable-contrast papers can change their contrast grade, so you have to purchase only one type of paper. Each sheet of paper is coated with two emulsions. One is sensitive to yellow-green light and produces low contrast; the other is sensitive to blue-violet light and produces high contrast. You control the contrast by inserting appropriately colored filters in the enlarger, or with certain enlargers by dialing in the correct filtration. The filters affect the color of the light reaching the paper and so the contrast of the print.

Variable contrast filters are numbered with the contrast grade that they produce: a number 1 filter produces low contrast, 2 and 3 medium contrast, and 4 high contrast. Numbers 1½, 2½, and 3½ filters produce intermediate contrast grades. During printing, if you change from one filter to another darker or lighter one, you may also need to adjust the exposure, because a darker filter passes less light to the print overall. See manufacturer's instructions.

Grade 2 paper produced moderate contrast

Change the contrast grade of the printing paper to change the contrast of the print. Here the same negative was printed on different contrast grades of paper.

Grade 4 paper produced the most contrast

Ellen Land-Weber

Dodging and Burning In

Once the overall density (the lightness or darkness) of a print is right, you will often find smaller areas that could be a little bit lighter or darker. For example, a face might be too dark or the sky too light, even though the rest of the scene looks good. Dodging (holding back light) and burning in (adding light) lets you selectively lighten or darken individual areas. Many prints are both dodged and burned. Whatever manipulation you do, keep it subtle so that the scene looks natural. An obviously dodged or burned-in area is more of a distraction than an improvement.

Burning in darkens part of a print by adding light to an area after the basic exposure (see photos, this page). The edge of a piece of cardboard, a piece of cardboard with a hole in the center, your hands, or any other opaque object can be used as long as it shields light from the rest of the print while you are adding exposure to the part you want darker.

Dodging lightens part of a print by holding back light from that area during some of the basic exposure. You can use a dodging tool, like the one shown at right, your hands, a piece of cardboard, or any other object that casts a shadow of the appropriate size. The longer you hold back the light, the lighter that part of the print will be. However, there is a limit to the amount of dodging that you can do. Too much dodging will make a dodged area look murky gray rather than realistically lighter.

Blend in the edges of the dodged or burned-in area. Keep your dodging or burning tool in smooth, steady motion during the exposure so that the dodged or burned-in area blends into the rest of the print. If you don't move the tool enough, you are likely to print its outline onto the paper.

Before burning in

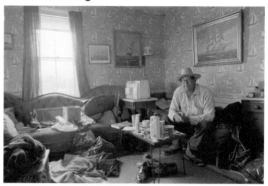

After burning in

Bill Byers

Burn in a print to make part of it darker. After the basic exposure is complete, give more light to the part of the print you want to darken, while shielding the rest of the print from additional exposure. Here, a piece of cardboard with a hole cut in the center was used to give extra exposure to the window while keeping the rest of the print from getting any darker.

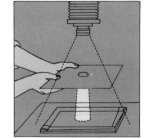

Dodge a print to make part of it lighter. Hold an object (here, a stiff wire attached to a piece of cardboard) underneath the enlarger lens during some of the exposure time to block light from the part of the print that you want to lighten. The closer the object is to the enlarger lens, the larger and more diffuse the shadow it casts.

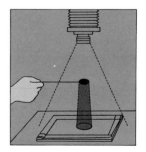

Cropping

Is there something sticking into the corner of an image that you didn't notice when you shot the picture? Is the horizon tilted when you want it straight? You can often improve a print by cropping it, cutting into the image at the edges to remove distracting elements or to focus attention on the most important part of the picture.

The best time to crop is when you take the picture, by composing the viewfinder image until it is the way you want it. You have another chance to crop when you make the print, by adjusting the blades of the printing easel. Be aware, though, that cropping and enlarging a very small part of an image during printing results in considerable enlargement, which can cause some loss of sharpness. When you trim and mount the print, you have a chance to fine-tune the cropping again.

Keep horizon lines straight unless you deliberately want to call attention to the tilt. Even if a horizon line is not visible, an image can look off balance if it is tilted even slightly.

Before cropping

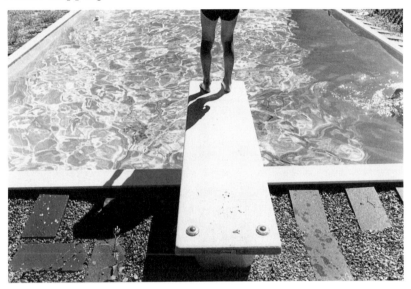

After cropping

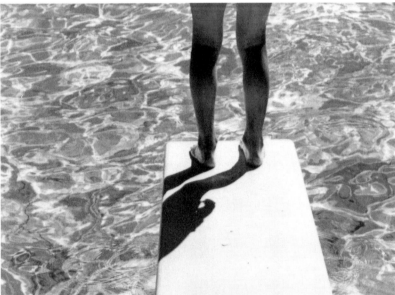

Bill Byers

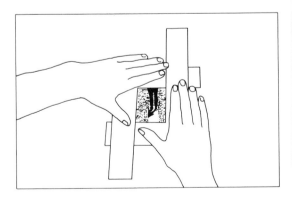

Cropping "L's," two L-shaped pieces of cardboard, laid over a print will let you try out possible croppings. You can evaluate cropping to some extent on the contact sheet, but the full-size print is easier to judge.

Cropping performed major surgery on this picture, which started out as a grab shot by photographer Bill Byers. He saw the diver poised on the board, raised his camera, and shot almost at once. When printing, he realized it was the swirl of the diver's shadow and the swirls in the water that had caught his eye, and cropped the picture down to that.

Spotting

Spotting is almost always needed to finish a print. No matter how careful you have been during film development and printing, there are likely to be a few specks on a print that shouldn't be there. A bit of dust on a negative in the enlarger will be enlarged, along with the negative image, and make a visible white spot on the print. Dust on the film during exposure or development can result in a clear spot on the film and cause a black spot on the print.

Spotting is done after the print is dry. Practice before you work on a good print; it takes some experience to learn how to blend a tone into the surrounding area. Do the minimum amount of spotting needed to make the blemish inconspicuous; too much spotting can look worse than not enough.

Use dyes to remove white spots. Liquid photographic dyes, like Spotone, sink into the emulsion and match the surface gloss of the print. They are available in three (sometimes more) tones to match paper tones: neutral-black, brown-black, and blue-black. In addition to the dye, you will need a very fine brush, such as an artist's size 000 or smaller. Place a drop of neutral-black dye on a small dish. Test the color of the dye on the margin of a scrap print. Add a bit of brown-black or blue-black dye if needed to match the image color of your print.

Spot the darkest areas first. Pick up a bit of undiluted dye on the tip of the brush and spot out any specks visible in the darkest parts of the print. Then mix water into part of the dye on the dish to dilute it for lighter areas. The dye makes a permanent change in the print, so start with a slightly lighter tone than you think you need and darken it if necessary. Test the darkness of the dye on the margin of a scrap print. Use a dotting or stippling motion with an almost dry brush; too much liquid on the brush will make an unsightly blob.

Small black specks or scratches can be etched off. Use the tip of a new mat knife blade or single-edge razor blade to gently stroke the spot until enough of the emulsion density has been etched away to match the surrounding area. Etching is easier to do with fiber-base papers than with resin-coated (RC) papers, and with matte papers than with glossy papers.

Before spotting

After spotting

Spotting corrects small imperfections in a print by adding dyes to cover up white specks or by etching off dark ones. Left, a section of an unspotted print. Right, the same print after spotting.

Barbara London

Solving Printing Problems

Check below if your prints have technical problems. See also Solving Camera and Lens Problems, page 39; Exposure Problems, page 66; Negative Development Problems, page 86; Flash Problems, page 132; and Evaluating Your Print for Density and Contrast, page 102.

Uneven, mottled, or mealy appearance

Cause: Too little time or not enough agitation in developer. Exhausted developer.

Prevention: Develop prints with constant agitation in fresh developer for no less than the recommended time. Do not pull a print out of the developer early if it develops too fast; remake with less exposure.

Fingerprints

Cause: Touching film or paper with greasy or chemical-laden fingers. Fixer is the usual chemical culprit.

Prevention: Rinse and dry hands before handling film or paper, especially after handling fixer. Handle film and paper by edges.

Prints fade

Cause: Prints that fade immediately were bleached by too much time in fixer or an overly strong fixer. Later fading is due to inadequate fixing or washing.

Prevention: Review and follow fixing and washing procedure, pages 95–96.

Yellowish stains

Cause: Processing faults of numerous kinds, such as too much time in developer, exhausted developer, exposing developing print to air by lifting it out of the developer for too long to look at it, delay in placing print in stop bath or fixer, exhausted stop bath or fixer, inadequate agitation in fixer, too little fixing, inadequate washing. Inadequate fixing also causes brownish-purple stains.

Prevention: Review and follow processing procedure, pages 94–96.

Fogging (gray cast in highlights or paper margins)

Cause: Usually due to exposure of paper to unwanted light before fixing, such as from light leaking into darkroom from outside, light from safelight too strong or too close, paper stored in package that is not light-tight, turning on room light too soon after print is placed in fixer. May be caused by too much time in developer, by old paper, or by paper stored near heat.

Prevention: Check all the above.

Entire print out of focus, negative is sharp

Cause: Vibration of enlarger during exposure. Enlarger never focused properly. Buckling of negative during exposure due to heat from enlarger lamp can cause all or part of the print to go out of focus.

Prevention: Avoid jostling the enlarger or its base just before or during the exposure; push the timer button gently. Focus carefully. Avoid extremely long exposures.

White specks

Cause: Most likely, dust on negative. Possibly, dust on printing paper during exposure.

Prevention: Blow or brush dust off negative and negative carrier before printing. Keep the enlarger area as free of dust and dirt as possible.

Dark specks or spots. See *pinholes* and *airbells*, page 87.

Mounting a Print

Why mount a print? Besides the fact that mounting protects a print from creases and tears, you'll find that you (and your viewers) are likely to give more serious attention to and spend more time looking at a finished and mounted print than at an unmounted workprint.

There are several ways to mount a print. Dry mounting is the most common. A sheet of dry-mount tissue bonds the print firmly to a piece of mount board when the sandwich of board, tissue, and print is heated in a mounting press. You can dry mount a print with a border (pages 112–113) or without one (page 114). Overmatting (pages 114–115), with or without dry mounting, provides a raised border that helps protect the surface of the print. If you frame a print, the overmat will keep the print surface from touching and possibly sticking to the glass.

You have quality choices in the materials you use. Archival mounting stock (also called museum board) is the most expensive. It is free of the acids that in time can cause a print to deteriorate, and is preferred by museums, collectors, and others concerned with long-term preservation. Most prints, however, can be happily mounted on less-expensive but good-quality stock available in most art supply stores. If you want a print to last for even a few years, avoid long-term contact with materials such as brown paper, ordinary cardboard, and most cheap papers, including glassine. Don't use directly on the print any kind of pressure-sensitive tape, such as masking tape or cellophane tape, brown paper tape, rubber cement, animal glues, or spray adhesives.

Barbara London

What should you photograph? The answer is—anything you like. Photographs are waiting in unexpected places, so don't limit your pictures to landscapes, portraits, and other predictable subject matter. Here, chemicals in the bottom of a black plastic processing tray had crystallized into an abstract pattern.

Mounting a Print: Equipment and materials you'll need

Mounting equipment

Utility knife with sharp blade trims the mounting stock and other materials to size. A paper cutter can be used for lightweight materials, but make sure the blade is aligned squarely and cuts smoothly.

Optional: **Mat cutter** holds a knife blade that can be rotated to cut either a perpendicular edge or a beveled (angled) one. Some people find it easier to use than an ordinary knife.

Metal ruler measures the print and board, and acts as a guide for the knife or mat cutter. A wooden or plastic ruler is not as good because the knife can cut into it.

Miscellaneous: pencil, soft eraser, fine sandpaper (optional) for smoothing inside edges of overmat window.

Mounting press heats and applies pressure to the print, dry-mount tissue, and mounting board to bond the print to the board. It can also flatten unmounted fiber-base prints, which tend to curl. You can use an ordinary household iron to mount one or two prints if no press is available, but the press does a much better job.

Tacking iron bonds the dry-mount tissue to the back of the print and the front of the mounting board to keep the print in position until it is put in the press. Again, you can use a household iron, but the tacking iron works better.

Mounting materials

Mount board (also called mat board) is available in numerous colors, thicknesses, and surface finishes.

Color. The most frequent choice is a neutral white, because it does not distract attention away from the print. However, some photographers prefer a gray or black mount.

Thickness. The thickness or weight of the board is stated in plys: 2-ply board is light-weight and best for smaller prints; more expensive 4-ply board is better for larger prints.

Surface finish. Finishes range from glossy to highly textured. A matte, not overly textured surface is neutral and unobtrusive.

Size. Boards are available precut in standard sizes or an art supply store can cut them for you, but it is often less expensive to buy a large piece of board and cut it down yourself.

Quality. See information opposite about quality choices. Archival quality is best, but not a necessity for most prints.

Dry-mount tissue is a thin sheet of paper coated with a waxy adhesive that becomes sticky when heated. Placed between the print and the mount board, the tissue bonds the print firmly to the board. Several types are available, including one for fiber-base papers, and one used at lower temperatures for either RC or fiber-base papers.

Cold-mount tissues are also available that do not require a heated mounting press. Some adhere on contact, others do not adhere until pressure is applied, so that, if necessary, they can be repositioned.

A cover sheet protects the print or mount from surface damage. Use a heavy piece of paper or piece of mount board as a cover sheet over the surface of the print when in the mounting press. Use a light-weight piece of paper as a cover sheet between each print in a stack of mounted prints to prevent surface abrasion if one print slides across another.

Tape hinges a print or an overmat to a backing board. Gummed linen tape (Holland tape) is best and should always be used for hinge mounting a print. Ideally, use linen tape to hinge an overmat to a backing board, but less expensive tape is also usable.

Dry Mounting a Print Step by Step

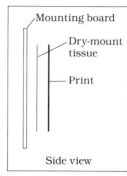

Mounting board

Dry-mount tissue

Print

Side view

Dry mounting provides a good-looking, stable support for a print. Shown here is a mount with a wide border around the print. Bleed mounting, a borderless mounting, is shown on page 114. The mounting materials, the print, and the inner surfaces of the press should be clean; even a small particle of dirt can create a bump when the print is put under pressure in the press. When cutting, use a piece of cardboard underneath to protect the surface on which you are working. Several light cuts often work better than just one cut, especially with thick mounting board. The blade must be sharp, so be careful of your fingers.

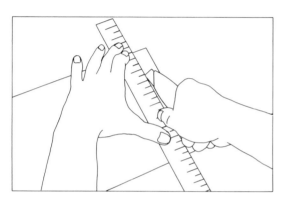

1. Cut the mounting board to size using the knife or mat cutter and the metal ruler as a guide. Press firmly on the ruler to keep it from slipping.

Standardizing the size of your mount boards makes a stack of mounted prints somewhat neater to handle, and makes it easier to switch prints in a frame. 8 x 10-inch prints are often mounted on 11 x 14-inch to 14 x 17-inch boards. Generally, the board is positioned vertically for a vertical print, horizontally for a horizontal print. Some like the same size border all around; others prefer the same size border on sides and top, with a slightly larger border on the bottom.

2. Heat the press and dry the materials. If you are mounting a fiber-base print, heat the dry-mount press to 180°-210°F (82°-99°C) or to the temperature recommended by the dry-mount tissue manufacturer. Put the board and print (not the dry-mount tissue), with a protective cover sheet on top, in the heated press for a minute to drive out any moisture. The heating will also take any curl out of the print, making it easier to handle.

For a resin-coated (RC) print, the press must be no hotter than 210°F (99°C) or the print may melt. Temperature control is inaccurate on many presses, so 200°F (93°C) is safer. There is no need to heat the print, just the board and cover sheet.

3. Tack the dry-mounting tissue to the print. Heat the tacking iron (be sure to use a low setting for RC prints). Put the print face down on a clean, smooth surface, such as another piece of mounting board. Cover the back of the print with a piece of dry-mount tissue. Tack the tissue to the print by moving the hot iron smoothly from the center of the tissue toward the sides. Do not tack at the corners. Do not wrinkle the tissue or it will show as a crease on the front of the mounted print.

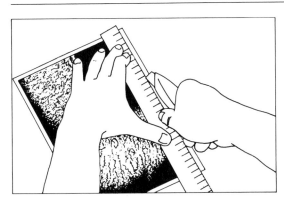

4. Trim the print and dry-mount tissue. Place the print and dry-mount tissue face up. Use the knife or mat cutter to trim off the white print borders, along with the tissue underneath them. Cut straight down so that the edges of print and tissue are even. Press firmly on the ruler when making the cut, and watch your fingers.

5. Position the print on the mount board. First, position the print so that the side margins of the board are even. Then adjust the print top to bottom. Finally, remeasure the side margins to make sure that they are even. Measure each side two times, from the corners of the print to the edge of the board. If the print is slightly tilted, it will show up at the corners even though the print measures evenly at the middle.

To keep the print from slipping out of place, put a piece of paper on the print and a weight on top of that.

6. Tack the dry-mount tissue and print to the board. Slightly raise one corner of the print and tack that corner of the tissue to the board by making a short stroke toward the corner with the hot tacking iron. Keep the tissue flat against the board to prevent wrinkles, and be careful not to move the print out of place on the board. Repeat at the diagonally opposite corner.

7. Mount the print. Put the sandwich of board, tissue, and print in the heated press with the protective cover sheet on top. Clamp the press shut for about 30 sec. or until the print is bonded firmly to the board. You can test the bond by flexing the board slightly after it has cooled.

Both time and temperature in the press affect the bonding. If the print does not bond, first try more time in the press. If the print still does not bond, increase the press temperature slightly.

Bleed Mounting/Overmatting

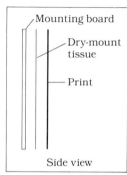

Mounting board

Dry-mount tissue

Print

Side view

A bleed mounted print is even with the edges of the mount.

1. Prepare the print and mount board. Cut the mount board, dry the materials, and tack the mounting tissue to the print (steps 1, 2, and 3 on page 112). In step 1, the board can be the same size or slightly larger than the print.

Turn the print face down and trim off any excess dry-mount tissue so that the edges of the tissue are even with the edges of the print. Then tack the dry-mount tissue and print to the board, and heat in the press (steps 6 and 7, page 113).

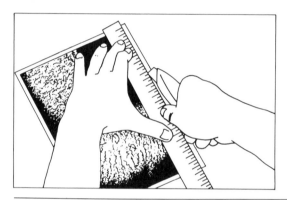

2. Trim the mounted print. Place the mounted print face up and trim off the white print borders, along with the mount board underneath, using the ruler as a guide. Hold the knife blade vertically so that it makes an edge that is perpendicular to the surface of the print. Press firmly on the ruler, and watch your fingers.

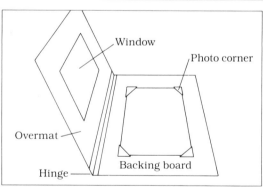

Window

Photo corner

Overmat

Hinge

Backing board

An overmatted print has a raised border around the print.

It consists of an overmat, a piece of mount board with a hole cut in it placed over a print that is attached to another piece of mount board, the backing board. The overmat helps protect the print, and can be easily replaced if it becomes soiled or damaged. After overmatting, the print can be framed or displayed as is.

Overmatting is the preferred means of mounting a print if you are interested in archival preservation.

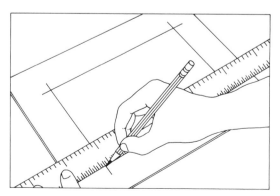

1. Mark the window on the mount board. First, measure the dimensions of the image to show through the window.

Cut two pieces of mount board. To find the size of the boards, add the dimensions of the window to that of the borders. A 7 x 9-inch window, with a 2-inch border on sides and top and a 3-inch border on the bottom, will require a 11 x 14-inch mount (7 + 2 + 2 = 11; 9 + 2 + 3 = 14).

Mark the back of one board for the inner cut. Be sure the window aligns squarely to the edges of the board. A T-square, if you have one, will help.

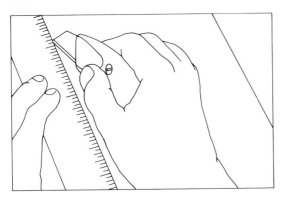

2. Cut the window. It takes practice to cut the inner edges of the overmat, especially at the corners, so practice with some scraps before you cut into good board. Press firmly on the metal ruler so it does not slip, and take care to keep the cutting blade at the same angle for each cut. You can tilt the blade to make a beveled cut or hold it straight. Cut each side of the window just to the corner, not past it. Some people stop very slightly short of the corner, then finish the cut with a separate, very sharp blade. If the cut edges of the window are a bit rough, you can smooth them with very fine sandpaper.

3. Hinge the two boards together by running a strip of tape along a back edge of the overmat and a front edge of the backing board (see illustration opposite, second from bottom). You may not need to hinge the boards together if you intend to frame the print.

Position and attach the print. Slip the print between the backing board and the overmat. Align the print with the window. The print can be dry mounted to the backing board or attached with photo corners or hinges (see below).

Second fold

Cut

First fold

4. Photo corners, like the ones used to mount pictures in photo albums, are an easy way to attach a print to a backing board. The print can be taken out of the corners and off the mount at any time. The corners are hidden by the overmat.

You can buy corners or make your own and attach them to the board with a piece of tape.

Print

Folded hinge

Pendant hinge

Backing board

5. Hinges hold the print in place with strips of tape attached to the upper back edge of the print and to the backing board.

A folded hinge (left) is hidden when the print is in place. Use a piece of tape to reinforce the part of the hinge that attaches to the mounting board.

A pendant hinge (right) is hidden by the overmat.

7 Lighting

Lois Bernstein

Changes in lighting will change your picture. Outdoors, if clouds darken the sky, or you change position so that your subject is lit from behind, or you move from a bright area to the shade, your pictures will change as a result. Light changes indoors, too: your subject may move closer to a sunny window or you may turn on overhead lights or decide to use flash lighting.

Light can affect the feeling of the photograph so that a subject appears, for example, brilliant and crisp, hazy and soft, stark or romantic. If you make a point of observing the light on your subject, you will soon learn to predict how it will look in your photographs, and you will find it easier to use existing light or to arrange the lighting yourself to get just the effect you want.

Lois Bernstein

Look at the light on your subject. Light can be as important a part of the picture as the subject itself. At left, bright light spilling into a shaded area highlighted the woman's face and added a strong diagonal line. Opposite, lights themselves add interest to the picture. Stage lighting is often very contrasty, with spotlit areas surrounded by a black background.

Qualities of Light: From direct to diffused

Whether indoors or out, light can range from direct and contrasty to diffused and soft. Here's how to identify these different qualities of light and predict how they will look in your photograph.

Direct light is high in contrast. It creates bright highlights and dark shadows with sharp edges. Photographic materials, particularly color slides, cannot record details in very light and very dark areas at the same time, so directly lit areas may appear brilliant and bold, with shadowed ones almost black. If you are photographing in direct light, you may want to add fill light (pages 124–125) to lighten shadows. Because direct light is often quite bright, you can use a small aperture to give plenty of depth of field, a fast shutter speed to stop motion, or both, if the light is strong enough.

The sun on a clear day is a common source of direct light. Indoors, a flash or photolamp pointed directly at your subject (that is, not bounced off another surface) also provides direct light.

Diffused light is low in contrast. It bathes subjects in light from all sides so that shadows are weak or even absent. Colors are less brilliant than they are in direct light and are likely to be pastel or muted in tone. Because diffused light is likely to be dimmer than direct light, you might not be able to use a small aperture with a fast shutter speed.

The sun on a heavily overcast day casts diffused light because the light is coming from the whole dome of the sky rather than just from the small disc of the sun. Indoors, diffused light can be created with a very broad source of light used close to the subject (such as light bounced into a large umbrella reflector) plus additional fill light. (Page 127 shows an umbrella reflector used in a lighting setup.)

Direct light

Lois Bernstein

Compare the qualities of light in these pictures. Direct light—hard edged and contrasty. Diffused light—indirect and soft. Directional/diffused light—shadows are softer-edged.

Charles O'Rear

Directional/diffused light

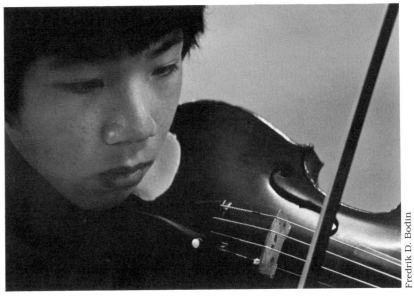

Directional/diffused light is intermediate in contrast. It is partly direct and partly diffused. Shadows are present, but they are softer and not as dark as those cast by direct light.

You will encounter directional/diffused light on a hazy day when the sun's rays are somewhat scattered so that light comes from the surrounding sky as well as from the sun. A shaded area, such as under trees or along the shady side of a building, can have directional/diffused light if the light is bouncing onto the scene primarily from one direction. Indoors, a skylight or other large window can give this type of light if the sun is not shining directly on the subject. Light from a flash or photolamp can also be directional/diffused if it is softened by a translucent diffusing material placed in front of the light or if it is bounced off another surface like a wall or an umbrella reflector.

Fredrik D. Bodin

Lighting **119**

Existing Light: Use what's available

Don't wait for a bright, sunny day to go photographing. You can take pictures indoors, even if the light is dim; in the rain or snow; at dawn or at dusk. If you see a scene that appeals to you, you can find a way to photograph it.

A fast film, one with an ISO rating of about 400, is useful when light is dim. It will help you to shoot at a fast enough shutter speed to stop motion, or a small enough aperture to give adequate depth of field. A tripod can steady a camera for long exposures.

It's difficult to photograph rain as it is actually falling, but you have other options, such as people in the rain, reflections in rain puddles, or rain dripping from leaves and other objects. Michele McDonald, a photojournalist, was on assignment looking for a "rain picture" for her newspaper when she saw a little girl and her mother. She photographed them as they ran down the sidewalk to their car, then took this last — and best — picture through the car window.

Michele McDonald

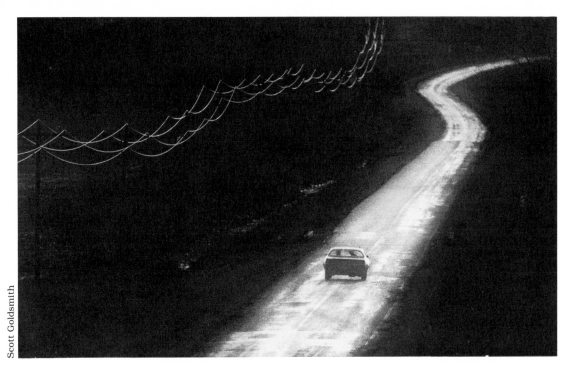

At dusk, look for objects that are still reflecting light. This picture was made late in the evening after a rain. The road and wires were still wet and reflected the last of the day's light, making them stand out against the dark surrounding area.

In extremely dim light, here a single light bulb, try an ultra-fast film, like Kodak T-Max P3200, which has a film speed of 3200. Bracketing is always a good idea in marginal lighting situations. Make several extra shots, increasing the exposure, then decreasing it.

The Main Light: The strongest source of light

The most realistic and usually the most pleasing lighting resembles daylight, the light we see most often: one main source of light from above creating a single set of shadows. Lighting seems unrealistic (though there may be times when you will want that) if it comes from below or if it comes from two or more equally strong sources that produce shadows going in different directions.

Shadows create the lighting. Although photographers talk about the quality of light coming from a particular source, it is actually the shadows created by the light that can make an image harsh or soft, menacing or appealing. To a great extent the shadows determine the solidity or volume that shapes appear to have, the degree to which texture is shown, and sometimes the mood or emotion of the picture.

The main light, the brightest light shining on a subject, creates the strongest shadows. If you are trying to set up a lighting arrangement, look at the subject from camera position. Notice the way the shadows shape or model the subject as you move the main light around or as you change the position of the subject in relation to a fixed main light.

Direct light from a 500-watt photolamp in a reflector was used for these photographs, producing shadows that are hard-edged and dark. Direct sunlight or direct flash can produce the same effects. The light would be softer if bounced onto the subject from another surface, like an umbrella reflector (shown on page 127), or if it was diffused. Fill light (see next pages) would lighten the shadows.

Front lighting. Here the main light is placed close to the lens, as when a flash unit attached to the camera is pointed directly at the subject. Fewer shadows are visible from camera position with this type of lighting than with others, and as a result forms seem flattened and textures less pronounced. Many news photos and snapshots are front-lit because it is simple and quick to shoot with the flash on the camera.

High 45° lighting. If the main light is moved high and to the side of the camera, not precisely at 45° but somewhere in that vicinity, shadows model the face to a rounded shape and emphasize textures more than with front lighting. This is often the main light position used in commercial portrait studios; fill light would then be added to lighten the shadows.

Side lighting. A main light at about a 90° angle to the camera will light the subject brightly on one side and cast shadows across the other side. When the sun is low on the horizon at sunset or sunrise, it can create side lighting that adds interest to landscapes and other outdoor scenes. Side lighting is sometimes used to dramatize a portrait.

Top lighting. With the light directly overhead, long dark shadows are cast into eye sockets and under nose and chin, producing an effect that is seldom appealing for portraits. Unfortunately, top lighting is not uncommon—outdoors at noon when the sun is overhead or indoors when the main light is coming from ceiling fixtures. Fill light added to lighten the shadows can help (see next page).

Fredrik D. Bodin

Back lighting. Here the light is moved around farther to the back of the subject than it is for side lighting. If the light was directly behind the subject, the entire face would be in shadow with just the hair outlined by a rim of light. Back lighting, also called edge or rim lighting, is used in multiple-light setups to bring out texture or to separate the subject from the background.

Bottom lighting. Lighting that comes from below looks distinctly odd in a portrait. This is because light on people outdoors or indoors almost never comes from below. This type of light casts unnatural shadows that often create a menacing effect. Some products, however, like glassware, are effectively lit from below; such lighting is often seen in commercial photographs.

The Fill Light: To lighten shadows

Fill light makes shadows less dark by adding light to them. Photographic materials can record detail and texture in either brightly lit areas or in deeply shadowed ones, but generally not in both at the same time. So if important shadow areas are much darker than lit areas—for example, the shaded side of a person's face in a sunlit portrait—consider whether adding fill light will improve your picture. The fill light should not overpower the main light but simply raise the light level of shadow areas so that you can see clear detail in the final print.

When do you need fill light? Color transparencies need fill light more than prints do. As little as 2 stops difference between lit and shaded areas can make shadows very dark, even black, in a color slide. The film in the camera is the final product when shooting slides, so corrections can't be made later during printing.

Black-and-white prints tolerate more contrast between highlights and shadows than color slides do. In a black-and-white portrait of a partly shaded subject, shadows that are 2 stops darker than the lit side of the face will be dark but still show full texture and detail. But when shadows get to be 3 or more stops darker than lit areas, fill light becomes useful and sometimes essential. You can also control contrast between highlights and shadows in black-and-white prints in other ways. You can, for example, print on a paper of a lower contrast grade (see pages 104–105). However, results are often better if you control the contrast by adding fill light, rather than trying to lighten a too-dark shadow when printing.

Fill light indoors. Light from a single photoflood or flash can produce a very contrasty light in which the shaded side of the face will be very dark if the lit side of the face is exposed and printed nor-

mally. Notice how dark the shaded areas are in the single-light portraits on pages 122–123. You might want such contrasty lighting for certain photographs, but ordinarily fill light would be added to make the shadows lighter.

Fill light outdoors. It is easier to get a pleasant expression on a person's face in a sunlit outdoor portrait if the subject is lit from the side or from behind and is not squinting directly into the sun. These positions, however, can make the shadowed side of the face too dark. In such cases, you can add fill light to decrease the contrast between the lit and shadowed sides of the face (see right). You can also use fill light outdoors for close-ups of flowers or other relatively small objects in which the shadows would otherwise be too dark.

Sources of fill light. A reflector is an easy way to add fill light indoors or out. Holding a large white card or cloth at the correct angle, usually on the opposite side of the subject from the main light, will reflect some of the light from the main light into the shadows.

A flash can be used for fill light indoors or outdoors. A unit in which the brightness of the flash can be adjusted is much easier to use than one with a fixed output. Some flash units designed for use with automatic cameras provide fill flash automatically.

In indoor setups, light from a photoflood can be used for fill light. To keep the fill light from overpowering the main light, the fill can be farther from the subject than the main light, of lesser intensity, bounced, or diffused. See illustrations opposite.

Front light. The man's face is lit by sunlight shining directly on it. Facing into the sun caused an awkward squint against the bright light.

Back light. Here he faces away from the sun and has a more relaxed expression. Increasing the exposure would lighten the shadowed side of his face but make the lit side very light.

Tom Wolfe

Back light plus fill light. Here he still faces away from the sun, but fill light has been added to lighten the shaded side of the face.

Using a reflector for fill light. A large white cloth or card can lighten shadows in backlit or sidelit portraits by reflecting onto the shaded side of the subject some of the illumination from the main light. Sometimes nearby objects will act as natural reflectors, for example, sand, snow, water, or a light-colored wall. At left, an assistant holds the reflector for the photographer, but in many cases the reflector could simply be propped up. The closer the reflector is to the subject, the more light it will reflect into the shadows.

For a portrait, try to angle the reflector to add enough fill light so that the shadowed side of the face is 1 to 2 stops darker than the sunlit side. Here's how to count the number of stops' difference. Meter only the lit side and note the shutter speed and aperture settings. Meter only the shadowed side and note the shutter speed and aperture. The number of f-stops (or shutter speed settings) between the two exposures equals the number of stops' difference.

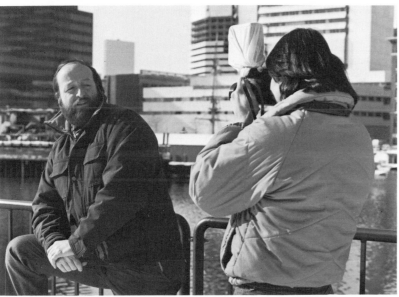

Using flash for fill light. To lighten the shadows on the man's face, the photographer attached a flash unit to her camera. If the flash light is too bright, it can overpower the main light and create an unnatural effect. To prevent this, the photographer set the flash for manual operation and draped a handkerchief over the flash head to decrease the intensity of the light. She could also have stepped back from the subject (although this would have changed the framing of the scene), or, with some flash units, decreased the light output of the flash.

See your owner's manual for instructions on how to set your camera and flash for fill lighting. In general, for a subject that is partly lit and partly shaded, decrease the brightness of the flash on the subject until it is 1 to 2 stops less than the basic exposure from the sun.

Using a photoflood for fill light. The photographer placed the main light at about a 45° angle to the left, then positioned a second photoflood on the right side of the camera so that it increased the brightness of the shadows. This fill light was placed close to the camera's lens so that it did not create secondary shadows that would be visible from camera position. The main light was placed closer to the subject so that it would be stronger than the fill light.

Meter the lit side of the scene and the shaded side, then adjust the lights until the shaded side is 1 to 2 stops darker than the lit side. To get an accurate reading, you must meter each area separately without including the background or other areas of different brightness. If you are photographing very small objects, you may have to use a spot meter or make substitution readings from a photographic gray card positioned first on the lit side, then on the shadowed side.

Alan Oransky

Tom Wolfe

Simple Portrait Lighting

Many fine portraits have been made using simple lighting setups. You don't need a complicated arrangement of lights to make a portrait. In fact, the simpler the setup, the more comfortable and relaxed your subject is likely to be. (See pages 156–159 for more about photographing people.)

Outdoors, open shade or an overcast sky surrounds a subject in soft, even lighting (photograph this page). In open shade, the person is out of direct sunlight, perhaps under a tree or in the shade of a building. Illumination comes from light reflected from the ground, a nearby wall, or other surfaces. If the sun is hidden by an overcast or cloudy sky, light is scattered over the subject from the entire sky. Indirect sunlight is relatively bluish, compared with direct sunlight. If you are shooting color film, a 1A (skylight) or 81A (light yellow) filter on the camera will help remove excess blue.

Indoors, window light is a convenient source of light during the day (see opposite, top). The closer your subject is to the window, the brighter the light will be. If direct sunlight is shining through the window and falls on the subject, contrast will be very high: lit areas very light, unlit areas very dark. Unless you want extreme contrast, it's best to have the subject lit by indirect light bouncing off other surfaces first. A reflector opposite the window can lighten shadows by adding fill light to the side of the person facing away from the window.

A main light—photoflood or flash—plus reflector fill is a simple setup when available light is inadequate (see opposite bottom). Bouncing the light into an umbrella reflector provides a softer light than shining it directly onto the subject.

Fredrik D. Bodin

In open shade outdoors, a subject is lit by soft, indirect light because a building, tree, or other object blocks the direct rays of the sun.

Window light is bright on parts of the scene that face the window, but usually dark in areas that face away from the window. Here the light was indirect, bouncing into the room from nearby areas outside. Contrast between light and dark tones would have been even greater if direct rays of light from the sun had been shining through the window.

Cynthia Dresser

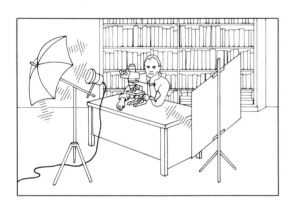

A main light plus reflector fill is the simplest setup when you want to arrange the lighting yourself. The main source of light is from a photoflood or flash pointed into an umbrella reflector that is then pointed at the subject. A reflector on the other side of the subject bounces some of the light back to lighten the shadows.

Scott Goldsmith

Using Artificial Light: Photolamp or flash

Artificial light sources let you bring your own light with you when the sun goes down, or you move inside into a darkened room, or you need just a little more light than is available naturally. Artificial sources are consistent and never go behind a cloud just when you're ready to take a picture. You can manipulate them to produce any effect you want—from light that looks like natural sunlight to underlighting that is seldom found in nature. Different sources produce light of different color balances, an important factor if you are using color films.

Continuously burning lamps such as photolamps and quartz lamps plug into an AC electrical outlet. Because they let you see how the light affects the subject, they are excellent for portraits, still lifes, and other stationary subjects that give you time to adjust the light exactly. Determining the exposure is easy: you meter the brightness of the light just as you do outdoors.

Flashbulbs are conveniently portable, powered by small battery units. Each bulb puts out one powerful, brief flash and then must be replaced. Not so many years ago, press photographers could be followed by the trail of spent flashbulbs they left as they discarded a bulb after each shot. Today, flashbulbs are still in use for some special purposes, but are mainly used with snapshot cameras that accept flashcube or flipflash units.

Electronic flash or strobe is now the most popular source of portable light. Though initially more expensive than flashbulbs, it is ultimately more economical because it offers many repeated flashes without the need of replacing the bulb. Power can come from either battery packs or an AC outlet. Some units are

built into cameras, but the more powerful ones, which can light objects at a greater distance, are a separate accessory. Because electronic flash is fast enough to freeze most motion, it is a good choice when you need to light unposed shots.

Flash must be synchronized with the camera's shutter so that the flash of light occurs when the shutter is fully open. With a 35mm single-lens reflex or other camera with a focal-plane shutter, shutter speeds of 1/60 sec. or slower will synchronize with electronic flash; some models have shutters that synchronize at speeds up to 1/250 sec. At shutter speeds faster than that, the camera's shutter curtains are open only part of the way at any time so only part of the film would be exposed. Cameras with leaf shutters synchronize with flash at any shutter speed. See your owner's manual for details on how to set the camera and connect the flash to it.

Automatic flash units have a sensor that measures the amount of light reflected by the subject during the flash; the unit terminates the flash when the exposure is adequate. Even if you have an automatic unit, sometimes you will want to calculate and set the flash exposure manually, such as when the subject is very close to the flash or very far from it and not within the automatic flash range.

Automatic electronic flash is a standard accessory for an automatic exposure 35mm camera. The flash has a light-sensitive cell and electronic circuitry that sets the duration of the flash by metering the amount of light reflected by the subject during the exposure.

Nikon, Inc.

Determining your own exposure with flash is different from doing so with other light sources. The flash of light is too short to measure with an ordinary light meter. Professionals use a special flash meter, but you can calculate your own flash exposure without one. You determine the intensity of the light by the output of the flash (its guide number)

and the flash's distance from the subject, then you set the aperture accordingly (see below). The farther the subject is from the flash, the dimmer the light that it receives and so the larger the aperture opening needed to maintain the same exposure. Changing the shutter speed (within the acceptable range for synchronization) does not affect the exposure.

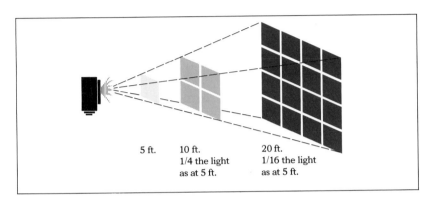

5 ft.

10 ft.
1/4 the light
as at 5 ft.

20 ft.
1/16 the light
as at 5 ft.

The inverse square law is the basis for flash exposure calculations. The farther that light travels, the more the light rays spread out and the dimmer the resulting illumination. The law states that at twice a given distance, an object receives only one fourth the light (intensity of illumination is inversely proportional to the square of the distance from light to subject). In the illustration here, only one fourth the amount of light falls on an object at 10 ft. from a light source as on an object at 5 ft. from the source.

Manually calculating a direct flash exposure

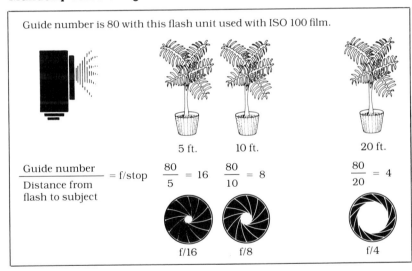

Guide number is 80 with this flash unit used with ISO 100 film.

5 ft.　　10 ft.　　　　20 ft.

$$\frac{\text{Guide number}}{\text{Distance from flash to subject}} = \text{f/stop}$$

$\frac{80}{5} = 16$　$\frac{80}{10} = 8$　$\frac{80}{20} = 4$

f/16　　f/8　　　　f/4

To calculate your own flash exposure, you need to know two things: the distance that the flash travels to the subject and the guide number (a rating given by the manufacturer for the flash when used with a specific film speed). Divide the distance that the light travels from flash unit to subject into the guide number. The result is the lens f-stop that should be used.

Some flash units have a calculator dial that will do the division for you. Dial in the film speed and the flash-to-subject distance and the dial will show the correct f-stop.

Manually calculating a bounce flash exposure

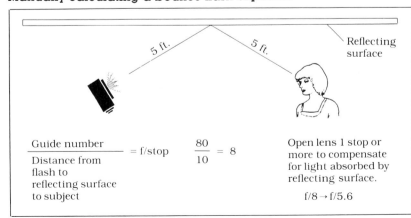

5 ft.　　5 ft.　　Reflecting surface

$$\frac{\text{Guide number}}{\text{Distance from flash to reflecting surface to subject}} = \text{f/stop}$$

$\frac{80}{10} = 8$

Open lens 1 stop or more to compensate for light absorbed by reflecting surface.

f/8 → f/5.6

Bounce flash travels an extra distance. If you are calculating a bounce flash exposure, measure the distance not just from flash to subject, but from flash to reflecting surface to subject. In addition, open the lens aperture an extra one-half stop or full stop to allow for light absorbed by the reflecting surface. Open even more if the reflecting surface is not white or very light in tone.

Some automatic flash units have a head that can be swiveled to the side or above for bounce flash while the flash sensor remains pointed at the subject. This type of unit can automatically calculate a bounce flash exposure because no matter where the head is pointed, the sensor will read the light reflected by the subject. Some cameras can measure flash light through the lens; these also can be used automatically with bounce flash.

More About Flash: How to position it

Light gets dimmer the farther it travels. Light from any source—a window, a continuously burning lamp, a flash—follows the same general rule: The light falls off (gets dimmer) the farther the light source is from an object. You can see and measure that effect if, for example, you meter objects that are near a bright lamp compared to those that are farther away. But light from a flash comes and goes so fast that you can't see the effect of the flash on a scene at the time you are making the picture. (Special exposure meters are designed for use with flash, but if you don't have access to one, you can't use an ordinary exposure meter to compare the tone of one flash-lit object to another.)

A flash-lit scene may not be evenly illuminated. Because light from a flash gets dimmer the farther it travels, you have to use a smaller lens aperture for subjects close to the flash, a wider aperture for subjects farther away. But what do you do if different parts of the same scene are at different distances from the flash?

Sometimes you can rearrange the subject, such as the people in a group por-

trait, so that all are more or less at the same distance from the flash. Sometimes you can change your own position so that the flash more evenly reaches various parts of the scene, such as by bouncing the light onto the subject or bringing in extra lights. If this isn't possible, you simply have to work with the fact that those parts of the scene that are farther from the flash will be darker than those that are closer. If you know that the light falls off and gets dimmer the farther it travels, you can at least predict how the flash will illuminate a scene.

Flash portraits. In one way, flash is easy to use for portraits: the flash of light is so fast that you don't have to worry about the subject moving during the exposure. But the light from the flash is so quick (1/1000 sec. or shorter) that you can't really see what the subject looks like when lit. However, with some practice you can predict the qualities of light that are typical of different flash positions. Shown on the opposite page are some simple lighting setups for portraiture.

Tom Wolfe

When objects are at different distances from a flash, those that are closer will be lighter than those that are farther away. Notice how dark the people in the background are compared to the driver. Try to position the most important parts of a scene (or position the flash) so that they are more or less at the same distance from the flash.

If this were your photograph, would you crop out the people in the background or leave them there?

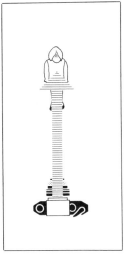

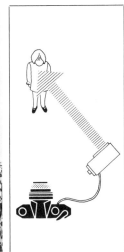

Direct flash on camera is simple and easy to use because the flash is attached to the camera. The light shining straight at the subject from camera position, however, tends to flatten out roundness and gives a rather harsh look.

Direct flash off camera—usually raised and to one side—gives more roundness and modeling than does flash on camera. A synchronization (or sync) cord lets you move the flash away from the camera. To avoid a shadow on the wall, move the subject away from it or raise the flash more.

Alan Oransky

Flash bounced from above onto the subject gives a softer, more natural light than direct flash. Light can also be directed into a large piece of white cardboard or an umbrella reflector and then bounced onto the subject. Bouncing the flash cuts the amount of light that reaches the subject. Some flash units automatically compensate for this, or you can make the exposure adjustment yourself (see page 129).

Flash bounced from the side onto the subject gives a soft, flattering light. You can use a light-colored wall, a large piece of white cardboard, or an umbrella reflector. The closer the subject is to the reflector, the more distinct the shadows on the subject will be. To avoid a shadow on the back wall, move the subject away from it.

Solving Flash Problems

Unwanted reflection

Reflection eliminated

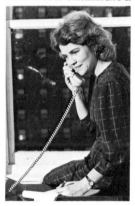

Alan Oransky

Only part of scene exposed

Tom Wolfe

Flash can give some unpredictable results, when you first start to use it, because reflections, shadows, or other effects are almost impossible to see at the time you make the picture. Check below if a flash picture didn't turn out the way you expected. See also Solving Camera and Lens Problems, page 39; Exposure Problems, page 66; Negative Development Problems, page 86; and Printing Problems, page 109.

Unwanted reflection

Cause: Light bouncing back from reflective surfaces like glass, mirror, or shiny walls (see left, top).

Prevention: Position the camera at an angle to highly reflective surfaces or angle the flash at the subject from off camera. The light will be reflected away at an angle (see left, center).

Red eye. A person's or animal's eyes appear red or amber in a color picture.

Cause: Light reflecting from the blood-rich retina inside the eye.

Prevention: Hold the flash away from the camera or have the subject look slightly to one side. If your subject wears eyeglasses, this also prevents bright reflections from them.

Only part of scene exposed

Cause: Shooting at too fast a shutter speed with a camera that has a focal-plane shutter, such as a single-lens reflex camera. The flash fired when the shutter was not fully open (see left, bottom).

Prevention: Check manufacturer's instructions for the correct shutter speed for flash, and set the shutter speed dial accordingly. For most cameras, 1/60 sec. is safe; faster speeds are usable with some cameras. The fastest usable flash shutter speed may appear on your camera's shutter speed dial in a different color from the other shutter speeds.

Part of scene exposed correctly, part too light or too dark

Cause: Objects in the scene were at different distances from the flash, so were exposed to different amounts of light.

Prevention: Try to group important parts of the scene at about the same distance from the flash (see page 130).

Entire scene too dark, or entire scene too light

Cause: Too dark—not enough light reached the film. Too light—too much light reached the film.

Prevention: An occasional frame that is too dark or too light probably results from calculating the lens aperture based on the wrong film speed, or a similar error. If flash pictures are consistently too dark, try setting the flash unit's film speed dial to one half the speed of the film you are using; the film will then receive 1 additional stop of exposure. When calculating exposures manually using a guide number, divide the guide number by 1.4 to give 1 extra stop of exposure. If pictures are consistently too light, try setting the dial to twice the speed of the film you are using or multiplying the guide number by 1.4; the film will receive 1 less stop of exposure.

Joe Wrinn

Flash stops motion. Suspended animation is easy with flash photography. The duration of the flash is so short, 1/1000 sec. or less, that almost all moving subjects will be sharp.

Notice that the background did not receive enough light from the flash to be seen clearly. The fluorescent lighting fixtures, however, which were themselves emitting light, were bright enough to be recorded.

8 Special Techniques

Lois Bernstein

Many special techniques are possible with photography. This chapter concentrates on two major areas: close-ups and filters.

Close-ups. We are used to seeing and photographing things from viewing distances of several feet or more. But many subjects—a tiny insect, the swirling petals of a flower—have a beauty and intricacy that are seen best from up close. Magnifying a detail of an object can reveal it in a new and unusual way.

A camera that views through the lens, like a single-lens reflex camera or view camera, is excellent for close-up work because you see the exact image that the lens "sees" (cameras without through-the-lens viewing show a slightly different viewfinder angle from the one the lens projects on the film). Depth of field is usually very shallow when you photograph up close, and through-the-lens viewing lets you preview which parts of the close-up will be sharp. Through-the-lens metering, which you often have with a single-lens reflex, helps you calculate exposures accurately when you are using close-up accessories such as extension tubes or bellows that decrease the amount of light reaching the film. The next pages tell more about close-ups and how to make them.

Barbara London

Bigger is better with close-ups. The photographer needed a sharp knife as well as a macro lens for the close-up of kiwi fruit, opposite. She sliced the kiwi thin, then placed them on a sheet of glass. She lit them from beneath the glass to produce a slight translucence, as well as from the front to bring out surface detail.

This page, a tin funnel produced circular reflections of the mushroom inside it.

Close-ups

Close-up equipment. Shown opposite are different types of close-up equipment you can use to produce a larger-than-normal image on your negatives. All of them do the same thing: they let you move in very close to a subject.

Whether or not to use a camera support such as a tripod depends on what and where you are photographing. You will be more mobile without one—ready to photograph an insect that has just alighted on a branch, or to get down very close to a low-growing wildflower. Close-up exposures, however, are often longer than normal, and a tripod helps prevent blur caused by camera motion with a slow shutter speed. Also, a tripod lets you compose pictures precisely, perhaps keeping a subject framed as you want it while you meter it or arrange lighting.

Increased exposures for close-ups. Placing extension tubes or bellows between the lens and the camera body moves the lens farther from the film and lets you focus close to a subject. But the farther the lens is extended, the dimmer the light that reaches the film. Beyond a certain extension you must increase the exposure or the film will be underexposed. A camera that meters through the lens increases the exposure automatically if you use compatible extension tubes or bellows. But if the close-up attachment breaks the automatic coupling between lens and camera or if you are using a hand-held meter, you must increase the exposure manually. To do so, follow the recommendations given by the manufacturer of the tubes or bellows, or use one of the methods opposite, below. Close-up lenses that you attach to a camera lens do not require an exposure increase.

Exposures longer than 1 sec. cause the film to respond less than normal; this is called reciprocity effect or reciprocity failure. To compensate for reciprocity effect, increase the exposure an additional amount: one half to 1 stop for 1-sec. exposures, 1-2 stops for 10-sec. exposures, 2-3 stops for 100-sec. exposures. Any exposure problem with close-ups is likely to be underexposure, so for safety bracket your basic exposure with additional shots at wider apertures or slower shutter speeds.

Life size (1:1) on film, enlarged to 2X life size

Alan Oransky

1/10 life size (1:10) on film, enlarged to 1/4 life size

Close-up terms. The closer your camera is to a subject, the larger the image on the film. A close-up is any picture taken from closer than normal to the subject—specifically, when the image on the film ranges from about 1/10 life size (1:10) to as big as life size (1:1). Macrophotography generally refers to an image on film that is anywhere from life size (1:1) to as big as ten times life size (10:1). Photomicrography, photographing through a microscope, is usually used to get a film image larger than 10:1.

A close-up lens attaches to the front of a camera lens and lets you focus up close without using extension tubes or bellows. Close-up lenses come in different strengths (diopters); the stronger the diopter, the closer you can focus and the larger the image. Close-up lenses are relatively inexpensive, small, and easy to carry along in your camera bag. They do not require additional exposure as do extension tubes or bellows. However, image quality may not be as good as with other close-up methods.

Extension tube

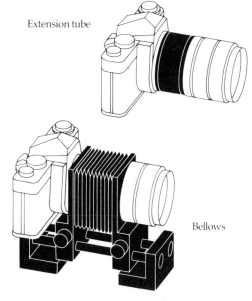

Bellows

A macro lens is your best choice for sharp close-ups. It produces a very sharp image at close focusing distances, whereas an ordinary lens produces its sharpest image at normal distances. A macro lens's mount can be extended more than that of an ordinary lens, which means that even without the use of extension tubes or bellows it can produce an image up to about half life size (1:2).

A macro-zoom lens has the zoom lens's variable focal lengths and will focus relatively close, although not as close as a macro lens of fixed focal length. It produces an image size of about one quarter life size (1:4).

Extension tubes and bellows fit between the lens and the camera. They increase the distance from the lens to the film; the greater this distance, the closer you can bring the lens to the subject. Extension tubes come in graduated sizes that can be used in various combinations to make close-ups of different sizes. A bellows is more adaptable than fixed-length tubes because it can be expanded to any length. Using either tubes or bellows requires increasing the exposure, as explained opposite.

Reversing a lens produces a sharper image when the lens is used very close to the subject. At a short focusing distance an ordinary lens is being used under conditions for which it was not designed and, as a result, image sharpness decreases; reversing the lens improves sharpness. An adapter ring couples the lens to the camera in reversed position.

Exposure increase needed for close-ups

Method 1

If the long side of the area shown in the viewfinder measures:								
in inches	11	5⅛	3¼	2¼	2	1¾	1⅜	1
in cm	28	13	8.5	5.75	5	4.5	3.5	2.5
Open lens aperture this number of f-stops	⅓	⅔	1	1⅓	1½	1⅔	2	2½
Or multiply exposure time by	1.3	1.6	2	2.5	2.8	3.2	4	5.7

Increase applies to a lens of any focal length used with a 35mm camera.

Method 2

$$\frac{\text{indicated f-stop}}{\text{adjusted f-stop}} = \frac{\text{bellows extension}}{\text{focal length of lens}}$$

1. Meter the subject and choose an f-stop and shutter speed combination.

2. Measure the bellows extension (distance from lens diaphragm to film plane) and determine the lens focal length, using the same units of measure—inches, centimeters, or millimeters (1 in. = 2.5 cm = 25 mm).

3. Calculate the new f-stop. If the original f-stop was f/16, the bellows extension 6 inches, and lens focal length 2 inches:

$$\frac{16}{x} = \frac{6}{2} \qquad 6x = 32 \qquad x = 5.3$$

The new f-stop is f/5.3, slightly wider than f/5.6, which is 3 stops wider than f/16 (f/16 to f/11, to f/8, to f/5.6 equals a 3-stop change). You can either open the aperture to f/5.6 or change the shutter speed an equivalent amount. See page 14 if you need to review how to make equivalent exposure settings.

More About Close-ups

Depth of field is shallow in close-ups.
At very close focusing distances, as little as an inch or less of the depth in the scene may be sharp. The closer the lens comes to the subject, the more the background and foreground go out of focus. Accurate focusing is essential or the subject may be out of focus altogether. Small apertures help by increasing the depth of field, but they also increase the exposure time. It may be necessary to use a tripod and, if you are photographing outdoors, to shield your subject from the wind to prevent its moving during the exposure.

Making the subject stand out from the background. Since a close-up is usually one small object or part of an object, rather than an entire scene, it is important to have some way of making the ob-ject you are photographing stand out clearly from its background. If you move your camera around to view the subject from several different angles, you may find that from some positions the subject will blend into the background, whereas from others it becomes much more dominant. You can choose your shooting standpoint accordingly.

Shallow depth of field can be an asset in composing your picture. You can use it to make a sharp subject stand out distinctly from an out-of-focus background. Tonal contrast of light against dark, the contrast of one color against another, or the contrast of a coarse or dull surface against a smooth or shiny one can also make your close-up subject more distinct.

Fred Ward

Depth of field is very shallow when a photograph is made close to a subject. Only the insect's head and upper body are in focus; the front and rear legs and even the tips of the antennae are not sharp. The shallow depth of field can be useful: since the sharply focused parts contrast with the out-of-focus areas, the insect stands out clearly from the foreground and background.

Lighting close-ups outdoors. Direct sunlight shining on a subject will be bright, and you can use smaller apertures for greater depth of field. But direct sunlight is contrasty, with bright highlights and very dark shadowed areas. Fill light helps to lighten the shadows if this is the case (pages 124–125). Light that comes from the back or side of the subject often enhances it by showing texture or by shining through translucent objects so they glow. In the shade or on an overcast day the light is gentle and soft, good for revealing shapes and details.

Lighting close-ups indoors. You have more control over the lighting if you are arranging it yourself indoors, but stop for a moment and think about just what you want the lights to do. For flat subjects, such as a page from a book, the lighting is not critical as long as it is even. Two lights of equal intensity, each at the same distance and angle from the subject, will illuminate it uniformly.

If you want to bring out texture, one light angling across the subject from the side will pick out every ridge, fold, and crease. With a deeply textured object, you may want to put a second light close to the lens to add fill light so that important details are not lost in shadows.

Flash can be used to increase the light level if you want to use a smaller aperture or faster shutter speed. You can also use flash as a fill light. Using the flash very close to the subject may make the light too bright; draping a handkerchief over the flash will soften the light and decrease its intensity. Arrange the handkerchief so it doesn't block the lens.

Stanley Rowin

Cross lighting brought out the texture and volume of this ear of corn. The main light angled across the subject from one side, while a weaker fill light close to the camera lightened the shadows.

At close working distances, you often have to angle the lights carefully to prevent problems such as the camera casting a shadow on the subject. The best way to check the effect of a lighting setup is to look through the camera's viewfinder at the scene.

Using Filters: How to change film's response to light

Filters for black-and-white photography.
Most black-and-white films are panchromatic—sensitive to all colors to about the extent that the human eye is. Blue colors, however, tend to record somewhat lighter than we expect them to in black-and-white photographs, and one of the most common uses of filters is to darken a blue sky so that clouds stand out more distinctly (shown opposite). The chart opposite, top, lists, some of the filters used in black-and-white pictures.

Filters for color photography. Filters are often used in color photography to match the color balance of the light to that of the film so that the resulting picture looks more realistic. Using an FL (fluorescent) filter, for example, decreases the greenish cast of pictures taken under fluorescent light. Various filters for color photography are listed in the chart opposite, bottom.

Increasing exposures when filters are used. Filters work by removing some of the wavelengths of light that pass through them. To compensate for the resulting overall loss of light intensity, the exposure must be increased or the film will be underexposed. If you are using a hand-held meter, simply increase the exposure the number of stops shown in the charts here or as recommended by the filter manufacturer. To review how to change exposure by stops, see page 14.

Some sources list the exposure increase needed not directly as stops, but as a filter factor. The factor tells how many times the exposure should be increased. A factor of 2 means the exposure should be doubled (a 1-stop change). A factor of 4 means the exposure should be increased four times (a 2-stop change). See chart this page.

Increasing exposures with a through-the-lens meter. If you are using a camera with a through-the-lens meter, you may not get a good exposure if you meter the scene with a filter on the lens. The sensor in the camera that reads the amount of light may not respond in the same way that film does. Generally, the sensor gives a good exposure reading with lighter filters, but not always with darker ones that require several stops of exposure change. A deep red filter, for example, requires 4 stops' extra exposure when used in daylight with black-and-white film, but some cameras give only 2½ more stops' exposure if they meter through that filter. The result: 1½ stops' underexposure and a thin, difficult-to-print negative.

Here's how to check your camera's response if you plan to use one of the darker filters. Meter a scene without the filter and note the shutter speed and/or f-stop. Now put the filter on the lens and meter the same scene. Compare the number of stops the camera's settings change with the number of stops they should have changed. Adjust the settings manually, if needed.

Gelatin filters come in 2-inch and larger squares that can be cut to various sizes. They tape onto the front of the lens or fit into a filter holder. They are inexpensive and come in many colors, but can be scratched or damaged relatively easily. Handle them by their edges only.

Glass filters clip onto the front of the lens and are made in sizes to fit various lens diameters. To find the diameter of your lens, look on the ring engraved around the front of the lens. The diameter (in mm) usually follows the symbol Ø. They are convenient and sturdier than gelatin filters, but more expensive.

If filter has a factor of . . .	Increase exposure this many stops
1	0
1.2	⅓
1.5	⅔
2	1
2.5	1⅓
3	1⅔
4	2
5	2⅓
6	2⅔
8	3
10	3⅓
12	3⅔
16	4
32	5

Filter factors. You need to increase the exposure when using most filters. Sometimes this increase is given as a filter factor. If so, see chart for how many stops the exposure should be increased.

A blue sky may appear very light in a black-and-white photograph because film is very sensitive to the blue and ultraviolet light present in the sky.

Fredrik D. Bodin

A deep yellow filter darkened the blue sky and made the clouds stand out. Notice that it also darkened shadow areas, which are bluish in tone.

Filters for black-and-white film

		Type of filter	Increase needed in exposure
To darken blue objects to make clouds stand out against blue sky, reduce bluish haze in distant landscapes, make blue water darker in marine scenes.	Darkens blue objects for a natural effect	8 (yellow)	1 stop
	Makes blue objects darker than normal	15 (deep yellow)	1⅓ stops
	Makes blue objects very dark	25 (red)	3 stops
	Makes blue objects as dark as possible	29 (deep red)	4 stops
To lighten blues to show detail, as in flowers. To increase haze for atmospheric effects in landscapes.		47 (blue)	2⅔ stops
To lighten reds to show detail, as in flowers.		25 (red)	3 stops
To lighten greens to show detail, as in foliage.		58 (green)	2⅔ stops
To make the range of tones on panchromatic black-and-white film appear more like the range of brightness seen by the eye.		8 (yellow) with daylight	1 stop
		11 (yellow-green) with tungsten light	2 stops

Filters for color film

	Type of filter	Increase needed in exposure
To reduce the bluishness of light on overcast days or in the shade. To penetrate haze. Used by some photographers to protect lens.	1A (skylight) or UV (ultraviolet)	No increase
To decrease bluishness more than 1A or UV.	81A (yellow)	⅓ stop
To get a natural color balance with fluorescent light.	Use FL-B with tungsten-balanced film; FL-D with daylight-balanced film	1 stop
To get a natural color balance with daylight-balanced film exposed in tungsten light.	Use 80A (blue) with ordinary tungsten bulbs or 3200K photolamps; 80B (blue) with 3400K photofloods	2 stops (80A) 1⅔ stops (80B)
To get a natural color balance with indoor film exposed in daylight.	Use 85B (amber) with tungsten-balanced film; 85 (amber) with Type A film	⅔ stop
To balance film precisely as recommended by film manufacturer.	CC (color compensating): R (red), G (green), B (blue), Y (yellow), M (magenta), C (cyan)	Varies
To experiment with color changes.	Any color	Varies

Lens Attachments: Polarization and other effects

A polarizing screen can remove reflections. If you have ever tried to photograph through a store window, but wound up with more of the reflections from the street than whatever you wanted to photograph on display inside the store, you know how distracting unwanted reflections can be. Using a polarizing screen is a way to eliminate some of these reflections (see photos opposite). The screen eliminates or decreases reflections from glass, water, or any smooth nonmetallic surface.

Landscapes can be sharper and clearer with a polarizing screen. Light reflected from minute particles of water vapor or dust in the atmosphere can make a distant landscape look hazy and obscured. A polarizing screen will decrease these minute reflections and allow you to see more distant details. It may also help to make colors purer and more vivid by diminishing unwanted coloring such as reflections of blue light from the sky.

A polarizing screen works best at certain angles to your subject (see diagrams this page). The screen attaches like a filter to the front of the camera lens. With a single-lens-reflex or other camera that views through the lens, you can see in the viewfinder the effect of the screen and adjust it until you get the effect you want. An exposure increase of 1⅓ stops is required. A through-the-lens meter will adjust the exposure correctly if you meter with the polarizing screen on the lens.

Neutral-density filters remove a fixed quantity of light from all wavelengths, consequently reducing the overall amount of light that reaches the lens. These filters make it possible to use a slower shutter speed or larger aperture than you otherwise could. For example, if you want to blur action but can't use a slower shutter speed because you are already set to your smallest aperture, an ND filter over the lens has the effect of dimming the light, letting you then set a slower shutter speed. Similarly, if you want to decrease depth of field but are already set to your fastest shutter speed, an ND filter would let you open the aperture wider.

Special effects with lens attachments. In addition to the filters that change tone or color, other lens attachments manipulate or change the image itself. A soft-focus attachment blurs details slightly to make them appear hazy, as if seen through a filmy screen. A cross-screen attachment (star filter) causes streamers of light to radiate from bright light sources, such as light bulbs, reflections, or the sun (opposite, far right). Other lens attachments produce multiple images, vignette the image, or create other special effects.

Best positions for a polarizing screen

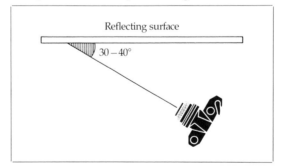

Reflecting surface

30 — 40°

A polarizing screen removes reflections from surfaces such as glass (see illustrations opposite). The screen works best at a 30°-40° angle to the reflecting surface.

90°

When shooting landscapes, using a polarizing screen makes distant objects clearer. The effect is strongest when you are shooting at a 90° angle to the sun.

Alan Oransky

Minolta Corp.

A cross-screen lens attachment, sometimes called a star filter, put the bright stars of light in the photograph above. An eight-ray attachment created the rays around the sun and its reflections from the airplane. Other cross screens produce four, six, or other numbers of rays.

Reflections are a distracting element in the top photograph if the goal is to show the display inside the shop window. A polarizing screen on the camera lens removed most of the reflections in the bottom photograph so that the objects inside can be seen clearly. (The diagram on the opposite page, top, shows the best position to stand when using a polarizing screen to remove reflections.)

You may not always want to remove reflections, however; notice how the people reflected in the top photograph can be seen as an interesting addition to the picture.

9 Seeing Like a Camera

Pictures translate the world you see. If you have ever had a picture turn out to be different from what you expected, you know that the camera does not "see" the way a human sees. For example, in a black-and-white photograph the colors you see in the world are translated into shades of gray. Even color film does not record colors exactly the way the eye sees them, and a color print can alter colors even more.

The way you see contrast between light and dark is also different from the way film responds to it. When you look at a contrasty scene, your eye's pupil continuously adjusts to different levels of brightness by opening up or closing down. In a photograph the contrast between very light and very dark areas is often too great for the film to record them both well in the same picture, so some areas may appear overexposed and too light or underexposed and too dark. Motion, sharpness, and other elements also can be similar to what you see in the original scene, but never exactly the same.

The creative part of photography is that you can choose the way you want the camera and film to translate a scene. Before you shoot, ask yourself what you want in the photograph. What attracted you in the first place? If it is the expression on someone's face, then do you have to move in closer so that you can see it clearly? If it is the odd shape of a tree, then will it be distinctly visible or do you need to change your position so that the shape will not be lost against a busy background?

Once you have the photograph you think you want, stop for a moment to consider some other options. How would it look if you framed the scene vertically instead of horizontally? What if you moved to a very low point of view? What would a slow shutter speed do to the motion of the scene? Try some of the variations, even if you are not sure how they will look in a print—in fact, *especially* if you are not sure, because that is the way to learn how the camera and film will translate them. More about your choices—and how to make them—on the following pages.

David A. Morrison

Choices. During a 15-sec. exposure, lights on moving automobiles blurred into long streaks (photo this page). A shorter exposure would have made the streaks shorter and the roadway even darker. Opposite, the background was much darker than the flowers. With more light on the background or with more exposure, the background would have been more visible but the flowers would not have stood out so strongly.

What's in the Picture: The edges or frame

One of the first choices to make with a photograph is what to include and what to leave out. The image frame, the rectangle you see when you look through the viewfinder, shows only a section of the much wider scene that is in front of you. The frame crops the scene—or, rather, *you* crop it—when you decide where to point the camera, how close to get to your subject, and what angle to shoot at.

Decide before you shoot whether you want to show the whole scene (or as much of it as you can) or whether you want to move in close (or zoom in with a zoom lens) for a detail. You can focus attention on something by framing it tightly or you can step back and have it be just another element in a larger scene.

When you look through the viewfinder, imagine you are viewing the final print or slide. This will help you frame the subject better. The tendency is to "see" only the subject and ignore its surroundings. In the final print, however, the surroundings and the framing are immediately noticeable.

You can also change framing later by cropping the edges of a picture when it is printed. Many photographs can be improved by cropping out distracting elements at the edges of the frame. But if you are making slides, it is best to crop when you take the picture. Although you can duplicate a slide and change its cropping then, it's easier to frame the scene the way you want it when you shoot.

The edges of a picture, the frame, surround and shape the image. Look around the edges at how the frame cuts into some objects or includes them in their entirety. How do the different framings change these pictures?

146

You can frame the central subject of a picture with other parts of the scene. Showing the instruments surrounding the fiddler at center, while cropping out most of the musicians themselves, focuses attention on the fiddler.

What's in the Picture: The background

Seeing the background. When you view a scene, you see most sharply whatever you are looking at directly, and you see less clearly objects in the background or at the periphery of your vision. If you are concentrating on something of interest, you may not even notice other things nearby. But the lens does see them, and it shows unselectively everything within its angle of view. Unwanted or distracting details can be ignored by the eye looking at a scene but in a picture they are much more conspicuous. To reduce the effect of a distracting background, you can shoot so that the background is out of focus (see page 153, top) or change your angle of view as in the photographs below. Interesting juxtapositions that usually go unnoticed—except in a photograph—are one of the pleasures of photography, as in the picture opposite.

A distracting background of a building is an unnecessary element in this portrait. The woman and child also seem rather a small part of the picture.

A plainer and better background resulted when the photographer simply walked around to one side and changed the angle from which he shot the subject. The photographer also moved in closer so that the people would occupy a larger area of the picture.

Fredrik D. Bodin

John White

If you look at the background of a scene as well as the main subject of interest, you may find some good combinations. Here, a baton twirler frames her high school band with her out-stretched arm. The camera records everything within its angle of view and can make the relation between a foreground object and a background one more important than might otherwise be noticed.

Notice how large the person in the foreground appears relative to the band members in the background. She seems very near, while the band appears much farther back. Actually, the two were not very far apart; the camera was simply much closer to one than to the other. Apparent size differences caused by the position of objects relative to the camera can create an exaggerated illusion of depth. Short-focal-length lenses often create this effect because they can be focused very close to an object. More about this type of perspective distortion on the next page.

Depth in a Picture: Three dimensions become two

Photographs can seem to change the depth in a scene. When you translate the three dimensions of a scene that has depth into the two dimensions of a flat photograph, you can expand space so that objects seem very far apart or you can compress space so that objects appear to be crowded close together. For example, compare the two photographs below. You can compress the buildings in a city (opposite) into flat planes to look almost as if they were pasted one on top of the other or you can give them exaggerated height. Pages 36–37 explain more about how to control such perspective effects that can change the way a photograph shows depth.

Two lenses of different focal lengths gave two very different versions of the same scene from the same position: a short-focal-length lens (top) expanded the space; a long-focal-length lens (bottom) compressed it.

Neither of the lenses actually changed anything in the scene. The short-focal-length lens used for the top photo had a wide angle of view; it included nearby objects as well as those that were farther away. The long-focal-length lens used for the bottom photo had a narrow angle of view; it showed only the farthest part of the scene. The part of the scene shown in the bottom photograph is exactly the same within the wider view of the scene shown in the top photograph.

Dan McCoy

Two perspectives of the same city. These sections of buildings seen from the side seem to lie on top of each other (top). Any clues to indicate the actual space that exists between the buildings are excluded from the scene.

Buildings appear to tower to great heights in photographs that look up at them or down on them (bottom). The closer any object is to your eye or to the camera, the bigger it appears to be, so, here, the building looks larger at the top than at the bottom because the camera was closer to its top stories than to its bottom ones.

Depth of Field: Which parts are sharp

When you look at a scene you actually focus your eyes on only one distance at a time, while objects at all other distances are not as sharp. Your eyes automatically adjust their focus as you look from one object to another. If you were at the scene shown opposite, bottom, you might look at the animals and not notice that you were seeing the cage bars much less sharply. But in a photograph, differences in the sharpness of objects at different distances are immediately evident. Such differences can be distracting or they can add interest to the photograph, depending on how you use them.

Controlling the depth of field. In some photographs you have no choice about depth of field (the area from near to far within which all objects will appear acceptably sharp). For example, in dim light or with slow film or under other conditions, the depth of field may have to be very shallow. But usually you can control the depth of field to some extent, as shown on pages 32–33. It is not necessarily better to have everything sharp or the background out of focus or to follow any other rules, but it is important to remember that in the photograph you will notice what is sharp and what isn't.

P. E. Farnes

Landscapes are often photographed so that everything is sharp from foreground to background. The entire landscape is important, not any single part of it. If you had been standing by the camera when this picture was taken, each part of the scene would have looked sharp to you. You wouldn't have noticed that your eyes were actually focusing sharply first on the fence in the foreground, then refocusing on the house in the middle distance, then focusing again on the mountains in the background.

Fredrik D. Bodin

Having the background out of focus is one way to separate a sharp subject from its less important surroundings. The eye tends to look first at the objects in a photograph that are the sharpest. In this photograph, the background still adds some interest, however, as the gargoyle surveys its domain.

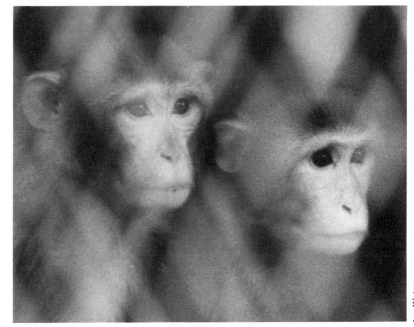

Joe Wrinn

Here, the foreground is out of focus — but still an important element. It lets you know these animals are in a cage. It takes a caption, however, to tell you that the cage is in an animal research center and not in a zoo.

Time and Motion in a Photograph

A photograph is a slice of time. Just as you select the section that you want to photograph out of a larger scene, you can also choose the section of time you want to record. You can think of a photograph as slicing through time, taking a wide slice at a slow shutter speed or a narrow slice at a fast shutter speed. In that slice of time, things are moving, and, depending on the shutter speed, direction of the motion, and other factors discussed earlier (pages 10–11), you can show objects frozen in mid-movement, blurred until they are almost unrecognizable, or blurred to any extent in between. How would you have photographed the rodeo scene (opposite, top)—sharp, as it is, or blurred to show the jolting of the bull? How about the boxers (below)—blurred and streaked or sharp and crisp to show their exact stances? One choice is not better than another. The important thing is to choose and not let the camera always make the choice for you.

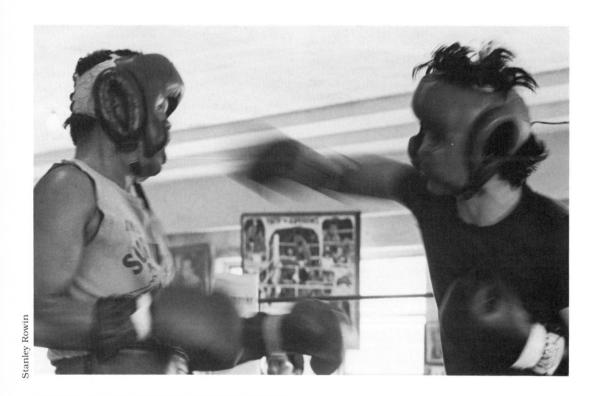

Stanley Rowin

A slow shutter speed blurred the boxers' fists, which were moving, while their torsos, which were relatively still, are sharper.

154

A fast shutter speed froze the motion of the bull, men, hat, and dust. In bright sunlight and using a high film speed, the photographer was also able to use a small aperture so that everything is sharply focused from foreground to background.

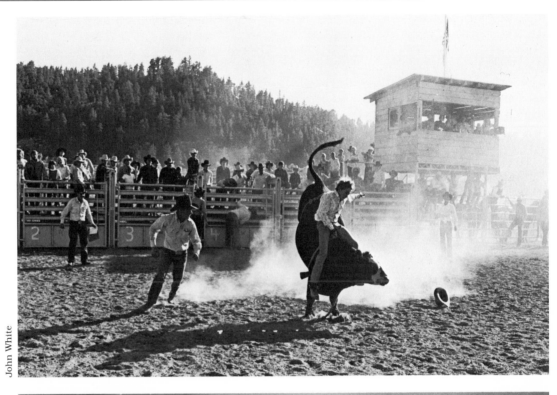

John White

Panning, moving the camera in the direction that the subject is moving, is another way to show motion. In this photograph the moving subject is somewhat blurred, but sharper than the surrounding scene—with a sense of urgency overall.

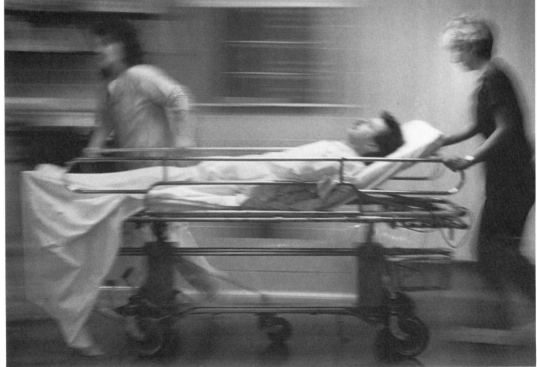

Scott Goldsmith

Seeing Like a Camera **155**

Photographing People: Portraits

A good portrait shows more than merely what someone looks like. It captures an expression, reveals a mood, or tells something about a person. Props or an environmental setting are not essential, but can help show what a person does or what kind of a person he or she is (see photographs opposite).

Put your subject at ease. To do this, you have to be relaxed yourself, or at least look that way. You'll feel better if you are familiar with your equipment and how it works so you don't have to worry about how to set the exposure or make other adjustments.

Don't skimp on film with portraits. Taking three, four, or a dozen shots to warm up can get your subject past the nervousness that many people have at first when being photographed.

Try to use a fast enough shutter speed, 1/60 sec. or faster, if possible, so you can

shoot when your subject looks good, rather than having to ask them to "hold it," which is only likely to produce a wooden expression.

Lighting. See what it is doing to the subject. Soft, relatively diffused light is the easiest to use because it is kind to most faces, and won't change much even if you change your position.

Side lighting adds roundness and a three-dimensional modeling. The more to the side the main light is, particularly if it is not diffused, the more it emphasizes facial texture, including wrinkles and lines. That's fine for many subjects, but bad, for instance, for your Uncle Pete if he wants to see himself as the young adult he used to be. Front lighting produces less modeling than does side lighting (see pages 122–123), but minimizes minor imperfections. Three simple portrait lighting setups are shown on pages 126–127.

John D. Upton

Light was diffused just inside an open doorway, much softer than if the portrait had been made in the direct sun outside. The photographer could have burned in the sunny hillside behind the woman to make it darker, but liked the contrast between its brightness and the shaded, sun-streaked wall.

Scott Goldsmith

An environmental portrait. People shape the space around them and in turn are influenced by their surroundings. Photographing them where they play or work or wherever they have established a space that they inhabit, can tell much more about them and their life than just a straight head-and-shoulders portrait. Here, two city kids are comfortably at ease on the street that doubles as their playground.

Lois Bernstein

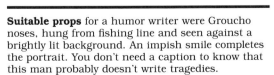
Suitable props for a humor writer were Groucho noses, hung from fishing line and seen against a brightly lit background. An impish smile completes the portrait. You don't need a caption to know that this man probably doesn't write tragedies.

Having someone look into the camera lens creates eye contact with the viewer of a portrait, and often conveys a more intimate feeling than you get when the person is looking away.

Photographing People: Candids

Candids are presumed to be unplanned—pictures of people made either without the subjects knowing they are being photographed or without being posed or directed by the photographer. It isn't always easy to tell if a photograph was posed or not, and most viewers will care more about what the photograph conveys than about exactly how it got that way.

Set your camera's controls beforehand if you want to be relatively inconspicuous at a scene. Prefocus if you can, although that may not be possible with longer-focal-length lenses, which have less depth of field and so require more critical focusing than do shorter lenses. With zone focusing (page 34), you focus in advance by using a lens's depth-of-field and distance scales.

A fast shutter speed is even more important for candids than for portraits, because your subject is likely to be moving and you are likely to be hand holding the camera rather than using a tripod. A fast film (ISO 400 works well in most situations) will be useful.

Joe Wrinn

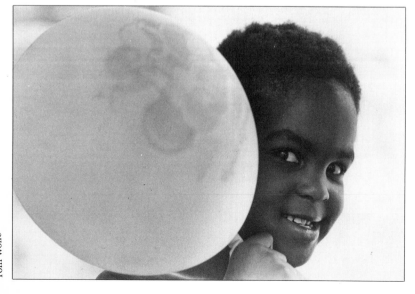

Tom Wolfe

Eye contact may or may not be present in a candid. Above, sports photographer Frank O'Brien was photographed during a game, while his attention was down field. Left, the boy had just turned around and noticed the photographer when this shot was made. Eye contact often involves a viewer more personally with a subject (see also portraits on pages 156–157).

Jonas Dovydenas

A violin maker seems absorbed in trying a violin, but a viewer can't know—and most won't ask themselves— whether the photographer told the man to play. You can create a candid feeling by asking a subject who is aware of your presence to perform some typical action. People are likely to behave more naturally if they have something to do that involves them.

Scott Goldsmith

Take advantage of what is available. Two surgical nurses discussing the day's schedule are joined by their shadows as early morning sunlight streams through a window behind them onto a nearby wall.

Photographing the Landscape/Cityscape

How do you photograph a place? There are as many different ways to view a scene as there are photographers. Most important for you: What do you want to remember? What is the best part of the place for you? Do you want many buildings from a distance or just one structure up close? Is it the landscape as a whole that is interesting or some particular part of it? How does a place speak to you?

After photographing a standard view of New York City as seen from Brooklyn, across the East River (below), photographer Fred Bodin turned his attention to the nearby Brooklyn Bridge, cropping tight to its stone arches and cables to create a shape reminiscent of a Gothic cathedral (right).

Fredrik D. Bodin

Fredrick D. Bodin

Chris Rainier

Depth of field. We often expect a landscape to be sharp from foreground to background. Extremely deep depth of field, as in the photograph above, is easiest to obtain with a view camera, which has a front and back that are adjustable for just such an effect. How to maximize depth of field with any camera is shown on page 33.

Barbara London

Look at a scene from different angles, walking around to view it from different positions. Above, in Ladakh, a remote part of India, Chris Rainier photographed a mound of stones with Buddhist inscriptions against a background of valley and sky. When you are close to an object, even a slight change of position will alter its relationship to the background.

The top of a picture usually identifies the top of a scene, because we are used to seeing things—and photographing them—from a vertical position. Change your point of view and a subject may reveal itself in a new way. Right, a photograph of dried mud taken from directly overhead is slightly disorienting. Not only is the subject matter ambiguous, but it isn't clear which way is up.

Seeing Like a Camera **161**

Responding to Photographs

"It's good." "It's not so good." What else is there to say when you look at a photograph? What is there to see—and to say—when you respond to work in a photography class or workshop? Looking at other people's pictures helps you improve your own, especially if you take some time to examine an image, instead of merely glancing at it and moving on to the next one.

In addition to responding to other people's work, you need to be able to look at and evaluate your own. What did you see when you brought the camera to your eye? How well did what you had in mind translate into a picture? Would you do anything different next time?

Following are some items to consider when you look at a photograph. You don't have to deal with each one every time, but they can give you a place to start. See box opposite for terms that help describe the visual elements in a picture.

Type of photograph. Portrait? Landscape? Advertising photograph? News photo? A caption or title can provide information, but look at the picture first so the caption does not limit your response.

Suppose the picture is a portrait. Is it one that might have been made at the request of the subject? One made for the personal expression of the photographer? Is the sitter simply a body or does he or she contribute some individuality? Does the environment surrounding the sitter add anything?

Emphasis. Is your eye drawn to some part of the picture? What leads your eye there? For example, is depth of field shallow, so that only the main subject is sharp and everything else is out of focus?

Scott Goldsmith

What a viewer sees in a photograph is usually more important than the real situation in which the photograph was made. Harsh, angular light, dark shadows, a bowed head, and "no credit" create a more intense image than the actual scene, which was only a mechanic in an auto shop examining a motor part. Sometimes a caption carries an explanation, but more often it is the evidence in the photograph itself that matters.

Technical considerations. Do they help or hinder? For example, is contrast harsh and gritty, suitable—or unsuitable—to the subject?

Emotional or physical impact. Does the picture make you feel sad, amused, peaceful? Does it make your eyes widen, your muscles tense? What elements might cause these reactions?

What else does the picture tell you besides what is immediately evident? Photographs often have more to say than may appear at first. For example, is a fashion photograph about the design of the clothes, or is it really about the roles of men and women in our culture?

Trust your own responses to a photograph. See how you actually respond to an image and what you actually notice about it.

Visual elements

Focus and depth of field
Sharp overall (page 152), **soft focus overall** (page 120)
Selective focus One part sharp, others not (page 32) See also Shallow depth of field
Shallow depth of field Little distance between nearest and farthest sharp areas (pages 33 left, 138)
Extensive depth of field Considerable distance between nearest and farthest sharp areas (pages 33 right, 68)

Motion
Frozen Sharp even though subject was moving (pages 11 top right, 155 top)
Blurred Moving camera or subject blurred part or all of the image (pages 11 top left, 154)

Light
Frontlit Light comes from camera position, few shadows (pages 122 top, 131 top left)
Backlit Light comes toward camera, front of subject is shaded (page 123 bottom left)
Sidelit Light comes from side, shadows cast to side (pages 123 top left, 42)
Direct light Hard-edged, often dark shadows (page 118)
Directional-diffused light Distinct, but soft-edged shadows (page 119 bottom)
Diffused light No, or almost no, shadows (page 119 top)
Silhouette Subject very dark against light background (pages 57, 65)
Glowing light Subject glows with its own or reflected light (pages 144, 145)

Contrast and Tone
Full scale Many tones of black, gray, and white (page 103 top)
High contrast Very dark and very light tones, few gray tones (pages 46, 110)
Low contrast Mostly gray tones (page 119 top)
High key Mostly light tones (page 64)
Low key Mostly dark tones (page 104)

Texture
Emphasized Usually results from light striking subject from an angle (page 139)
Minimized Usually results from light coming from camera position (page 122 top)

Viewpoint and Framing
Eye-level viewpoint (pages 156, 157 top)
High (page 64), **low** (page 147), or **unusual viewpoint** (page 149)
Framing The way the edges of the photograph meet the shapes in it (pages 146, 24)

Perspective
Compressed perspective (telephoto effect) Objects seem crowded together, closer than they really are (pages 36 bottom, 150 bottom)
Expanded perspective (wide-angle distortion) Parts of the scene seem stretched or positioned unusually far from each other (pages 36 top, 150 top)

Line
Curved (pages 29 bottom, 135), **straight** (page 151)
Horizontal (page 155 bottom), **vertical** (page 151 top), **diagonal** (pages 2, 162)
Position of horizon line (pages 35, 50)

Balance An internal, physical response. Does the image feel balanced or does it tilt or feel heavier in one part than another?

Glossary

Glossary originally prepared by Lista Duren

Aberration Optical defect in a lens (sometimes unavoidable) causing distortion or loss of sharpness in the final image.

Adapter ring A ring used to attach one camera item to another; for example, to attach a lens to a camera in reverse position in order to increase image sharpness when focusing very close to the subject.

Agitate To move a solution over the surface of film or paper during the development process so that fresh liquid comes into contact with the surface.

Angle of view The amount of a scene that can be recorded by a particular lens; determined by the focal length of the lens.

Aperture The lens opening formed by the iris diaphragm inside the lens. The size is variable and is adjusted by the aperture control.

Aperture control The ring on the camera lens (a pushbutton on some models) that, when turned, adjusts the size of the opening in the iris diaphragm and changes the amount of light that reaches the film.

Aperture-priority mode An automatic exposure system in which the photographer sets the aperture (f-stop) and the camera selects a shutter speed for normal exposure.

ASA A film speed rating similar to an ISO rating.

Auto winder See **Motor drive unit.**

Automatic exposure A mode of camera operation in which the camera automatically adjusts either the aperture, the shutter speed, or both for normal exposure.

Automatic flash An electronic flash unit with a light-sensitive cell that determines the length of the flash for normal exposure by measuring the light reflected back from the subject.

Available light A general term implying relatively dim light that already exists where a photograph is to be made.

Averaging meter An exposure meter with a wide angle of view. The indicated exposure is based on an average of all the light values in the scene.

B See **Bulb.**

Base The supporting material that holds a photographic emulsion. For film, it is plastic or acetate. For prints, it is paper.

Bellows An accordion-like section inserted between the lens and the camera body. In close-up photography the bellows allows closer-than-normal focusing resulting in a larger image.

Bleed mount To mount a print so that there is no border between the edges of the print and the edges of the mounting surface.

Blotters Sheets of absorbent paper made expressly for photographic use. Wet prints dry when placed between blotters.

Body The light-tight box that contains the camera mechanisms and protects the film from light until you are ready to make an exposure.

Bounce light Indirect light produced by pointing the light source at a ceiling or other surface to reflect the light back toward the subject. Softer and less harsh than direct light.

Bracketing Taking several photographs of the same scene at different exposure settings, some greater than and some less than the setting indicated by the meter, to ensure a well-exposed photograph.

Built-in meter An exposure meter in the camera that takes a light reading (usually through the camera lens) and relays exposure information to the electronic controls in an automatic camera or to the photographer if the camera is being operated manually.

Bulb A shutter-speed setting (marked B) at which the shutter stays open as long as the shutter release is held down.

Burn in To darken a specific area of a print by giving it additional printing exposure.

Cable release An encased wire which attaches at one end to the shutter release on the camera and has a plunger on the other end that the photographer depresses to activate the shutter. Used to avoid camera movement or to activate the shutter from a distance.

Carrier A frame that holds a negative flat in an enlarger.

Cassette A light-tight metal or plastic container in which 35mm film is packaged.

Center-weighted meter A through-the-lens exposure meter that measures light values from the entire scene but gives greater emphasis to those in the center of the image area.

Changing bag A light-tight bag into which a photographer can insert his or her hands to handle film when a darkroom is not available.

Chromagenic film Film in which the final image is composed of chemical dyes rather than silver.

Close-up A larger-than-normal image obtained by using a lens closer than normal to the subject.

Close-up lens An attachment placed in front of an ordinary lens to allow focusing at a shorter distance in order to increase image size.

Color balance The overall accuracy with which the colors in a color photograph match or are capable of matching those in the original scene. Color films are balanced for use with specific light sources.

Color temperature Description of the color of a light source. Measured on a scale of degrees Kelvin.

Compound lens A lens made up of several lens elements.

Condenser enlarger An enlarger that illuminates the negative with light that has been concentrated and directed by condenser lenses placed between the light source and the negative.

Contact printing The process of placing a negative in contact with sensitized material, usually paper, and then passing light through the negative onto the material. The resulting image is the same size as the negative.

Contamination Traces of chemicals that are present where they don't belong, causing loss of chemical activity, staining, or other problems.

Contrast The difference between the light and dark parts of a scene or photograph.

Contrast grade The contrast that a printing paper produces. Systems of grading contrast are not uniform, but in general grades 0 and 1 have low or soft contrast; grades 2 and 3 have normal or medium contrast; grades 4 and 5 have high or hard contrast.

Contrasty Having greater-than-normal differences between light and dark areas. The opposite of flat.

Crop To trim the edges of an image, often to improve the composition. Cropping can be done by moving the camera position while viewing a scene, by adjusting the enlarger or easel during printing, or by trimming the finished print.

Darkroom A room where photographs are developed and printed, sufficiently dark to handle light-sensitive materials without causing unwanted exposure.

Daylight film Color film that has been balanced to produce natural-looking color when exposed in daylight.

Dense Describes a negative or an area of a negative in which a large amount of silver has been deposited. A dense negative transmits relatively little light. The opposite of thin.

Density The relative amount of silver present in various areas of film or paper after exposure and development. Therefore, the darkness of a photographic print or the light-stopping ability of a negative or transparency.

Depth of field The distance between the nearest and farthest points that appear in acceptably sharp focus in a photograph. Depth of field varies with lens aperture, focal length, and camera-to-subject distance.

Developer a chemical solution that changes the invisible, latent image produced during exposure into a visible one.

Development 1. the entire process by which exposed film or paper is treated with various chemicals to make an image that is visible and permanent. 2. Specifically, the step in which film or paper is immersed in developer.

Diaphragm (iris diaphragm) The mechanism controlling the size of the lens opening and therefore the amount of light that reaches the film. It consists of several overlapping metal leaves inside the lens that form a circular opening of variable sizes. (You can see it as you look into the front of the lens.) The size of the opening is referred to as the f-stop or aperture.

Dichroic head An enlarger head that contains yellow, magenta, and cyan filters that can be moved in calibrated stages into or out of the light beam to change the color balance of the enlarging light.

Diffused light Light that has been scattered by reflection or by passing through a translucent material. An even, often shadowless, light.

Diffusion enlarger An enlarger that illuminates the negative by scattering light from many angles evenly over the surface of the negative.

DIN A numerical rating used in Europe that indicates the speed of a film. The rating increases by 3 each time the sensitivity of the film doubles.

Diopter Unit of measurement that indicates the magnifying power of a close-up lens.

Direct light Light shining directly on the subject and producing strong highlights and deep shadows.

Directional/diffused light Light that is partly direct and partly scattered. Softer and less harsh than direct light.

Dodge To lighten an area of a print by shading it during part of the printing exposure.

Dry down To become very slightly darker and less contrasty, as most photographic printing papers do while they dry after processing.

Dry mount To attach a print to another surface, usually a heavier mat board, by placing a sheet of adhesive dry-mount tissue between the print and the mounting surface. Generally, this sandwich is placed in a heated mounting press to melt the adhesive in the tissue. Some tissues are pressure-sensitive and do not need to be heated.

Easel A holder to keep sensitized material, normally paper, flat and in position on the baseboard of an enlarger during projection printing. It may have adjustable borders to frame the image to various sizes.

EI See **Exposure index.**

Electronic flash (strobe) A camera accessory that provides a brief but powerful flash of light. A battery-powered unit requires occasional recharging or battery replacement, but, unlike a flashbulb, can be used repeatedly.

Emulsion A thin coating of gelatin, containing a light-sensitive material such as silver-halide crystals plus other chemicals, spread on film or paper to record an image.

Enlargement An image, usually a print, that is larger than the negative. Made by projecting an enlarged image of the negative onto sensitized paper.

Enlarger An optical instrument ordinarily used to project an image of a negative onto sensitized paper. More accurately called a projection printer because it can project an image that is either larger or smaller than the negative.

Environmental portrait A photograph in which the subject's surroundings are important to the portrait.

Etch To remove a small, dark imperfection in a print or negative by scraping away part of the emulsion.

Exposure 1. The act of allowing light to strike a light-sensitive surface. 2. The amount of light reaching the film, controlled by the combination of aperture and shutter speed.

Exposure index A film speed rating similar to an ISO rating. Abbreviated EI.

Exposure meter (light meter) An instrument that measures the amount of light and provides aperture and shutter speed combinations for correct exposure. Exposure meters may be built into the camera or they may be separate instruments.

Exposure mode The type of camera operation (such as manual, shutter-priority, aperture-priority) that determines which controls you set and which ones the camera sets automatically. Some cameras operate in only one mode. Others may be used in a variety of modes.

Extension tubes Metal rings attached between the camera lens and the body to allow closer-than-normal focusing in order to increase the image size.

Fast Describes 1) a film or paper that is very sensitive to light; 2) a lens that opens to a very wide aperture; 3) a short shutter speed. The opposite of slow.

Fiber-base paper Formerly the standard type of paper available; now being replaced to a certain extent by resin-coated papers.

Fill light a light source or reflector used to lighten shadow areas so that contrast is decreased.

Film A roll or sheet of a flexible material coated on one side with a light-sensitive emulsion and used in the camera to record an image.

Film advance lever A device, usually on the top of the camera, that winds the film forward a measured distance so that an unexposed segment moves into place behind the shutter.

Film plane See **Focal plane.**

Film speed The relative sensitivity to light of photographic film. Measured by ISO (or ASA or DIN) rating. Faster film (higher number) is more sensitive to light and requires less exposure than slower film. See also **Speed.**

Filter 1. A piece of colored glass or plastic placed in front of the camera lens to alter the quality of the light reaching the film. 2. To use such a filter.

Filter factor A number, provided by the filter manufacturer, that tells you how much to increase exposure to compensate for the light absorbed by the filter.

Fisheye lens An extreme wide angle lens covering a 180° angle of view. Straight lines appear curved at the edge of the photograph, and the image itself may be circular.

Fixer A chemical solution (sodium thiosulfate or ammonium thiosulfate) that makes a photographic image insensitive to light. It dissolves unexposed silver halide crystals while leaving the developed silver image. Also called hypo.

Flare Non-image-forming light that reaches the film, resulting in a loss of contrast or an overall grayness in the final image. Caused by stray light reflecting between the surfaces of the lens.

Flash 1. A short burst of light emitted by a flashbulb or electronic flash unit at the same time the film is exposed. 2. The equipment used to produce this light.

Flashbulb A battery-powered bulb that emits one bright flash of light and then must be replaced.

Flat Having less-than-normal differences between light and dark areas. The opposite of contrast.

Focal length The distance from an internal part of a lens (the rear nodal plane) to the film plane when the lens is focused on infinity. The focal length is usually expressed in millimeters (mm) and determines the angle of view (how much of the scene can be included in the picture) and the size of objects in the image. A 100mm lens, for example, has a narrower angle of view and magnifies objects more than a lens of shorter focal length.

Focal plane The surface inside the camera on which a focused lens forms a sharp image.

Focal-plane shutter A camera mechanism that admits light to expose film by opening a slit just in front of the film (focal) plane.

Focus 1. The point at which the rays of light coming through the lens converge to form a sharp image. The picture is "in

focus" or sharpest when this point coincides with the film plane. 2. To change the lens-to-film distance (or the camera-to-subject distance) until the image is sharp.

Focusing ring The band on the camera lens that, when turned, moves the lens in relation to the film plane, focusing the camera for specific distances.

Focusing screen See **Viewing screen.**

Fog An overall density in the photographic image caused by unintentional exposure to light, unwanted chemical activity, or excess heat or age.

Frame 1. A single image in a roll of film. 2. The edges of an image.

Fresnel An optical surface with concentric circular steps. Used in a viewing screen to equalize the brightness of the image.

F-stop (f-number) A numerical designation (f/2, f/2.8, etc.) indicating the size of the aperture (lens opening).

Full-scale Describes a print having a wide range of tonal values from deep, rich black through many shades of gray to brilliant white.

Ghosting 1. A kind of flare caused by reflections between lens surfaces. It appears as bright spots the same shape as the aperture (lens opening). 2. A combined blurred and sharp image that occurs when flash is used with bright existing light. The flash creates a sharp image; the existing light adds a blurred image if the subject is moving.

Glossy Describes a printing paper with a great deal of surface sheen. The opposite of matte.

Graded-contrast paper A printing paper that produces a single level of contrast. To produce less or more contrast, a change has to be made to another grade of paper. See **Variable-contrast paper.**

Grain The particles of silver that make up a photographic image.

Grainy Describes an image that has a speckled look due to particles of silver clumping together.

Gray card A card that reflects a known percentage of the light falling on it. Often has a gray side reflecting 18 percent and a white side reflecting 90 percent of the light. Used to take accurate exposure meter readings (meters base their exposures on a gray tone of 18 percent reflectance).

Ground glass 1) A piece of glass roughened on one side so that an image focused on it can be seen on the other side. 2) The viewing screen in a reflex or view camera.

Guide number A number rating for a flash unit that can be used to calculate the correct aperture for a particular film speed and flash-to-subject distance.

Hand-held meter An exposure meter that is separate from the camera.

Hand hold To support the camera with the hands rather than with a tripod or other fixed support.

Hard 1. Describes a scene, negative, or print of high contrast. The opposite of soft or low contrast. 2. Describes a printing paper emulsion of high contrast such as grades 4 and 5.

High-contrast film Film that records light tones lighter and dark tones darker than normal, thereby increasing the difference between tones.

Highlight A very light area in a scene, print, or transparency; a very dense, dark area in a negative. Also called a high value.

Hot shoe A clip on the top of the camera that attaches a flash unit and provides an electrical link to synchronize the flash with the camera shutter, eliminating the need for a sync cord.

Hyperfocal distance The distance to the nearest object in focus when the lens is focused on infinity. Setting the lens to focus on this distance instead of on infinity will keep the farthest objects in focus as well as extend the depth of field to include objects closer to the camera.

Hypo A common name for any fixer; taken from the abbreviation for sodium hyposulfite, the previous name for sodium thiosulfate (the active ingredient in most fixers).

Hypo clearing bath A chemical solution used between fixing and washing film or paper. It shortens the washing time by converting residues from the fixer into forms more easily dissolved by water. Also called hypo neutralizer or washing aid.

Incident-light meter A hand-held exposure meter that measures the amount of light falling on the subject. See also **Reflected-light meter.**

Indoor film See **Tungsten film.**

Infinity Designated ∞. The farthest distance marked on the focusing ring of the lens, generally about 50 feet. When the camera is focused on infinity, all objects at that distance or farther away will be sharp.

Infrared film Film that is sensitive to wavelengths slightly longer than those in the visible spectrum as well as to some wavelengths within the visible spectrum.

Interchangeable lens A lens that can be removed from the camera and replaced by another lens.

Iris diaphragm See **Diaphragm.**

ISO A numerical rating that indicates the speed of a film. The rating doubles each time the sensitivity of the film doubles.

Latent image An image formed by the changes to the silver halide grains in photographic emulsion upon exposure to light. The image is not visible until chemical development takes place.

Latitude The amount of over- or underexposure possible without a significant change in the quality of the image.

Leaf shutter A camera mechanism that admits light to expose film by opening and shutting a circle of overlapping metal leaves.

LED See **Light-emitting diode.**

Lens One or more pieces of optical glass used to gather and focus light rays to form an image.

Lens cleaning fluid A liquid made for cleaning lenses without damaging the delicate coating on the lens surface.

Lens coating A thin transparent coating on the surface of the lens that reduces light reflections.

Lens element A single piece of optical glass that acts as a lens or as part of a lens.

Lens hood (lens shade) A shield that fits around the lens to prevent unwanted light from entering the lens and causing flare.

Lens tissue A soft lint-free tissue made specifically for cleaning camera lenses. Not the same as eyeglass cleaning tissue.

Light-emitting diode (LED) A display in the viewfinder of some cameras that gives you information about aperture and shutter speed settings or other exposure data.

Light meter See **Exposure meter.**

Long-focal-length lens A lens that provides a narrow angle of view of a scene, including less of a scene than a lens of normal focal length and therefore magnifying objects in the image. Often called telephoto lens.

Macro lens A lens specifically designed for close-up photography and capable of good optical performance when used very close to a subject.

Macrophotography Production of images on film that are life-size or larger.

Macro-zoom lens A lens that has close-focusing capability plus variable focal length.

Magnification The size of an object as it appears in an image. Magnification of an image on film is determined by the lens focal length. A long-focal-length lens makes an object appear larger (provides greater magnification) than a short-focal-length lens.

Main light The primary source of illumination, casting the dominant shadows.

Manual exposure A nonautomatic mode of camera operation in which the photographer sets both the aperture and the shutter speed.

Manual flash A nonautomatic mode of flash operation in which the photogra-

pher controls the exposure by adjusting the size of the lens aperture.

Mat A cardboard rectangle with an opening cut in it that is placed over a print to frame it. Also called an overmat.

Mat cutter A short knife blade (usually replaceable) set in a large, easy-to-hold handle. Used for cutting cardboard mounts for prints.

Matte Describes a printing paper with a relatively dull, nonreflective surface. The opposite of glossy.

Meter 1. See **Exposure meter.** 2. To take a light reading with a meter.

Middle gray A standard average gray tone of 18 percent reflectance. See **Gray card.**

Midtone An area of medium brightness, neither a very dark shadow nor a very bright highlight. A medium gray tone in a print.

Mirror A polished metallic reflector set inside the camera body at a 45° angle to the lens to reflect the image up onto the focusing screen. When a picture is taken, the mirror moves so that light can reach the film.

Motor drive unit (auto winder) A camera device that automatically advances the film once it has been exposed.

Mottle A mealy gray area of uneven development in a print or negative. Usually caused by too little agitation or too short a time in the developer.

Negative 1. An image with colors or dark and light tones that are the opposite of those in the original scene. 2. Film that was exposed in the camera and processed to form a negative image.

Negative film Photographic film that produces a negative image upon exposure and development.

Neutral-density filter A piece of dark glass or plastic placed in front of the camera lens to decrease the intensity of light entering the lens. It affects exposure, but not color.

Normal-focal-length lens (standard lens) A lens that provides about the same angle of view of a scene as the human eye and that does not unduly magnify or diminish the relative size of objects in the image.

One-shot developer A developer used once and then discarded.

Open up To increase the size of the lens aperture. The opposite of stop down.

Orthochromatic film Film that is sensitive to blue and green light but not red light.

Overdevelop To give more than the normal amount of development.

Overexpose To expose film or paper to too much light. Overexposing film produces a negative that is too dark (dense) or a transparency that is too light. Overexposing paper produces a print that is too dark.

Oxidation Loss of chemical activity due to contact with oxygen in the air.

Pan To move the camera during the exposure in the same direction as a moving subject. The effect is that the subject stays relatively sharp and the background becomes blurred.

Panchromatic film Film that is sensitive to the wavelengths of the visible spectrum.

Parallax The difference in point of view that occurs when the lens (or other device) through which the eye views a scene is separate from the lens that exposes the film.

Pentaprism A five-sided optical device used in an eye-level viewfinder to correct the image from the focusing screen so that it appears right side up and correct left to right.

Perspective The illusion in a two-dimensional image of a three-dimensional space suggested primarily by converging lines and the decrease in size of objects farther from the camera.

Photoflood A tungsten lamp designed especially for use in photographic studios. It emits light at 3400 K color temperature.

Photomicrography Photographing through a microscope.

Pinhole A small clear spot on a negative usually caused by dust on the film during exposure or development or by a small air bubble that keeps developer from the film during development.

Plane of critical focus The part of a scene that is most sharply focused.

Polarizing screen (polarizing filter) A filter placed in front of the camera lens to reduce reflections from nonmetallic surfaces like glass or water.

Positive An image with colors or light and dark tones that are similar to those in the original scene.

Print 1. An image (usually a positive one) on photographic paper, made from a negative or a transparency. 2. To produce such an image.

Printing frame A holder designed to keep sensitized material, usually paper, in full contact with a negative during contact printing.

Programmed automatic A mode of automatic exposure in which the camera sets both the shutter speed and the aperture for a normal exposure.

Proof A test print made for the purpose of evaluating density, contrast, color balance, subject composition, and the like.

Push To expose film at a higher film speed rating than normal, then to compensate in part for the resulting underexposure by giving greater development than normal. This permits shooting at a dimmer light level, a faster shutter speed, or a smaller aperture than would otherwise be possible.

Quartz lamp A tungsten lamp which has high intensity, small size, long life, and constant color temperature.

RC paper See **Resin-coated paper.**

Reciprocity effect (reciprocity failure) A shift in the color balance or the darkness of an image caused by very long or very short exposures.

Reducing agent The active ingredient in a developer. It changes exposed silver halide crystals into dark metallic silver. Also called the developing agent.

Reel A metal or plastic reel with spiral grooves into which roll film is loaded for development.

Reflected-light meter An exposure meter (hand held or built into the camera) that reads the amount of light reflected from the subject. See also **Incident-light meter.**

Reflector Any surface—a ceiling, a card, an umbrella, etc.—used to bounce light onto a subject.

Reflex camera A camera with a built-in mirror that reflects the scene being photographed onto a ground-glass viewing screen. See **Single-lens reflex, Twin-lens reflex.**

Replenisher A substance added to some types of developers after use to replace exhausted chemicals so that the developer can be used again.

Resin-coated paper Printing paper with a water-resistant coating that absorbs less moisture than a fiber-base paper, consequently reducing some processing times. Abbreviated RC paper.

Reticulation A crinkling of the gelatin emulsion on film that can be caused by extreme temperature changes during processing.

Reversal film Photographic film that produces a positive image (a transparency) upon exposure and development.

Reversal processing A procedure for producing a positive image on film (a transparency) from the film exposed in the camera or a positive print from a transparency with no negative involved.

Rewind crank A device, usually on the top of the camera, for winding film back into a cassette once it has been exposed.

Roll film Film that comes in a roll, protected from light by a length of paper wound around the film. Loosely applies to any film packaged in a roll rather than in flat sheets.

Safelight A light used in the darkroom during printing to provide general illumination without giving unwanted exposure.

Sharp Describes an image or part of an image that shows crisp, precise texture and detail. The opposite of blurred or soft.

Shoe A clip on a camera for attaching a flash unit. See also **Hot shoe.**

Short-focal-length lens (wide-angle lens) A lens that provides a wide angle of view of a scene, including more of the subject area than a lens of normal focal length.

Shutter A device in the camera that opens and closes to expose the film to light for a measured length of time.

Shutter-priority mode An automatic exposure system in which the photographer sets the shutter speed and the camera selects the aperture (f-stop) for normal exposure.

Shutter release The mechanism, usually a button on the top of the camera, that activates the shutter to expose the film.

Shutter speed control The camera control that selects the length of time the film is exposed to light.

Silhouette A dark shape with little or no detail appearing against a light background.

Silver halide The light-sensitive part of common photographic emulsions; the compounds silver chloride, silver bromide, and silver iodide.

Single-lens-reflex (SLR) A type of camera with one lens which is used both for viewing and for taking the picture. A mirror inside the camera reflects the image up into the viewfinder. When the picture is taken, this mirror moves out of the way, allowing the light entering the lens to travel directly to the film.

Slide See **Transparency.**

Slow The opposite of fast.

SLR See **Single-lens-reflex.**

Sodium thiosulfate The active ingredient in most fixers.

Soft 1. Describes an image that is blurred or out of focus. The opposite of sharp. 2. Describes a scene, negative, or print of low contrast. The opposite of hard or high contrast. 3. Describes a printing paper emulsion of low contrast, such as grade 0 or 1.

Spectrum The range of radiant energy from extremely short wavelengths to extremely long ones. The visible spectrum includes only the wavelengths to which the human eye is sensitive.

Speed 1. The relative ability of a lens to transmit light. Measured by the largest aperture at which the lens can be used. A fast lens has a larger maximum aperture and can transmit more light than a slow one. 2. The relative sensitivity to light of photographic film. See **Film speed.**

Spot To remove small imperfections in a print caused by dust specks, small scratches, or the like. Specifically, to paint a dye over small white blemishes.

Spot meter An exposure meter with a narrow angle of view, used to measure the amount of light reading from a small portion of the scene being photographed.

Stock solution A concentrated chemical solution that must be diluted before use.

Stop 1. An aperture setting that indicates the size of the lens opening. 2. A change in exposure by a factor of two. Changing the aperture from one setting to the next doubles or halves the amount of light reaching the film. Changing the shutter speed from one setting to the next does the same thing. Either changes the exposure one stop.

Stop bath An acid solution used between the developer and the fixer to stop the action of the developer and to preserve the effectiveness of the fixer. Generally a dilute solution of acetic acid; plain water is sometimes used as a stop bath for film development.

Stop down To decrease the size of the lens aperture. The opposite of open up.

Strobe See **Electronic flash.**

Substitution reading An exposure meter reading taken from something other than the subject, such as a gray card of a standard tone or the photographer's hand.

Sync (or synchronization) cord An electrical wire that links a flash unit to a camera's shutter release mechanism.

Synchronize To cause a flash unit to fire while the camera shutter is open.

Tacking iron A small, electrically heated tool used to melt the adhesive in dry-mount tissue, attaching it partially to the back of the print and to the mounting surface. This keeps the print in place during the mounting procedure.

Telephoto effect A change in perspective caused by using a long-focal-length lens very far from all parts of a scene. Objects appear closer together than they really are.

Telephoto lens See **Long-focal-length lens.**

Thin Describes a negative or an area of a negative where relatively little silver has been deposited. A thin negative transmits a large amount of light. The opposite of dense.

Through-the-lens meter (TTL meter) An exposure meter built into the camera that takes light readings through the lens.

Transparency (slide) A positive image on a clear film base viewed by passing light through from behind with a projector or light box. Usually in color.

Tripod A three-legged support for the camera.

TTL Abbreviation for through the lens, as in through-the-lens viewing or metering.

Tungsten film Color film that has been balanced to produce colors that look natural when exposed in tungsten light, specifically light of 3200 K color temperature. *Type A tungsten film* has a slightly different balance for use with photoflood bulbs of 3400 K color temperature.

Twin-lens reflex A camera in which two lenses are mounted above one another. The bottom (taking) lens forms an image to expose the film. The top (viewing) lens forms an image that reflects upward onto a ground-glass viewing screen. Abbreviated TLR.

Umbrella reflector An apparatus constructed like a parasol with a reflective surface on the inside. Used to bounce diffused light onto a subject.

Underdevelop To give less development than normal.

Underexpose To expose film or paper to too little light. Underexposing film produces a negative that is too light (thin) or a transparency that is too dark. Underexposing paper produces a print that is too light.

Variable-contrast paper A printing paper in which varying grades of print contrast can be obtained by changing the color of the enlarging light source, as by the use of filters. See **Graded-contrast paper.**

View camera A camera in which the taking lens forms an image directly on a ground-glass viewing screen. A film holder is inserted in front of the viewing screen before exposure. The front and back of the camera can be set at various angles to change the plane of focus and the perspective.

Viewfinder eyepiece An opening in the camera through which the photographer can see the scene to be photographed.

Viewing screen The surface on which the image in the camera appears for viewing. This image appears upside down and reversed left to right unless the camera contains a pentaprism to correct it.

Vignette To shade the edges of an image so they are underexposed. A lens hood that is too long for the lens will cut into the angle of view and cause vignetting.

Visible spectrum See **Spectrum.**

Washing aid See **Hypo clearing bath.**

Wetting agent A chemical solution, such as Kodak Photo-Flo, used after washing film. By reducing the surface tension of the water remaining on the film, it speeds drying and prevents water spots.

Wide-angle distortion A change in perspective caused by using a wide-angle (short-focal-length) lens very close to a subject. Objects appear stretched out or farther apart than they really are.

Wide-angle lens See **Short-focal-length lens.**

Working solution A chemical solution diluted to the correct strength for use.

Zone focusing Presetting the focus to photograph action so that the entire area in which the action may take place will be sharp.

Zoom lens A lens with several moving elements which can be used to produce a continuous range of focal lengths.

Bibliography

A vast number of books on photography are available, whether your interest is in technique, history of photography, photojournalism, photography as an art form, or any other area. Look for them in your local library, book store, or camera store.

Eastman Kodak Company publishes more than 800 books and pamphlets ranging from highly technical subjects to basic picture making. All are listed in their *Index to Kodak Information* (publication L-5); a free copy is available from Eastman Kodak Company, Rochester, New York 14650. Two useful basic references include *Kodak Complete Darkroom Dataguide* (R-18) and *Kodak Professional Black-and-White Films* (F-5).

Light Impressions, P.O. Box 940, Rochester, New York 14603 is an excellent source of photographic materials and publications. Photographers Place, 133 Mercer Street, New York, NY 10012 offers many in-print and out-of-print books on photography. Catalogs are free.

Technical references

Adams, Ansel. *The New Ansel Adams Photography Series*, with Robert Baker. *The Camera*, 1980; *The Negative*, 1981; *The Print*, 1983; *Polaroid Land Photography*, 1978. Boston: New York Graphic Society. Also, from the earlier *Basic Photo Series: Natural-Light Photography*, 1971; *Artificial-Light Photography*, 1968. Boston: New York Graphic Society. Stresses full technical control of the photographic process as an aid to creative expression.

Horenstein, Henry. *Beyond Basic Photography*. Boston: Little, Brown, 1977. An excellent next step after learning the basics.

Kobre, Kenneth. *Photojournalism: The Professionals' Approach*, 2nd ed. Stoneham, MA: Focal Press, 1991. Complete coverage of equipment, techniques, and approaches used by photojournalists.

London, Barbara, (Barbara London Upton with John Upton.) *Photography*, 4th ed. New York: HarperCollins, 1989. Widely used as a comprehensive textbook.

Stone, Jim, ed. *Darkroom Dynamics: A Guide to Creative Darkroom Techniques*. Stoneham, MA: Focal Press, 1979. Illustrated instructions on how to expand your imagery with multiple printing, toning, hand coloring, high contrast, and other techniques.

History of photography, collections

The Family of Man. New York: The Museum of Modern Art, 1955. Edward Steichen organized this show, which was probably the most publicized and widely seen photographic exhibition ever mounted.

Lyons, Nathan, ed. *Photographers on Photography: A Critical Anthology*. Englewood Cliffs, NJ: Prentice-Hall, 1966. Twenty-three well-known photographers (1880s to 1960s) discuss their own work and photography in general.

Newhall, Beaumont. *The History of Photography from 1839 to the Present*, rev. ed. New York: Museum of Modern Art, and Boston: New York Graphic Society, 1982. The most widely used basic text on the history of photography.

Szarkowski, John. *Looking at Photographs*. New York: The Museum of Modern Art, 1973. Szarkowski discusses 100 pictures from the museum's collection. An insightful, very readable, and highly recommended book.

Periodicals

Afterimage, 31 Prince Street, Rochester, NY 14607. A tabloid-format monthly from the Visual Studies Workshop. Includes scholarly articles on photography, film, and video; listings of shows, events, publications, and opportunities nationwide.

American Photo, 1633 Broadway, New York, NY. Formerly *American Photographer*. Photography in all its forms, including the fashionable and the famous.

Aperture, 20 East 23 Street, New York, NY 10011. A superbly printed quarterly dealing with photography as an art form.

News Photographer, National Press Photographers Association, P.O. Box 1146, Durham, NC 27702. For working and student photojournalists.

Photo Communique, P.O. Box 129, Station M, Toronto, Ontario, Canada M6S 4T2. Canadian, but not exclusively so.

Photo District News, 49 East 21 Street, New York, NY 10010. Directed toward professionals, but has considerable material of general interest on individual photographers, equipment, and other topics.

Popular Photography, 1515 Broadway, New York, NY 10036. Mainly a magazine for hobbyists, mixing information about equipment and materials with portfolios and how-to articles.

Shutterbug, Box 1209, Titusville, FL 32781. New, used, and vintage equipment for sale via hundreds of classified ads.

Untitled, Friends of Photography, 101 The Embarcadero, San Francisco, CA 94105. A four-times-yearly publication, it is more often a beautifully printed monograph than a magazine, and is always of exceptional quality.

Index

Cut out and assemble the light meter dials on page 175 to see how film exposure is related to light intensity, film speed, shutter speed, and aperture.

Assembling the dials

1. Cut out the 3 dials and the 2 windows in the dials.

2. Connect the 3 dials by putting a pin first through the center point of the smallest dial, then the medium-size dial, and finally the largest dial. (A pushpin, with a piece of cardboard underneath the largest dial, works best.)

3. Line up the 2 windows so you can read the film speeds through them.

Using the dials

1. To calibrate your meter to your film, you set the arrow ▲ marked ISO to the speed of your film. For a trial, set it to ISO 100.

2. With a real light meter, you point its light-sensitive cell at a subject to get a reading of the brightness of the light. In one type of meter, a needle on a gauge (not shown here) indicates the brightness of the light. Suppose this light measurement reading was 17. Keep the film-speed arrow pointing to 100 while you set the other arrow ▲, which points to the light measurement, to 17.

3. Now you can see, lined up opposite each other, combinations of shutter speed and aperture that will produce a correct exposure for this film speed and this amount of light: 1/250 sec. shutter speed at f/8 aperture, 1/125 sec. at f/11, and so on. All these combinations of shutter speed and aperture let in the same amount of light.

4. Try increasing (or decreasing) the film speed to see how this affects the shutter speed and aperture combinations. For example, keep the light-measurement arrow at 17 while you move the film-speed arrow to 200. Now the combinations show a 1-stop change: 1/250 sec. of f/11, 1/125 sec. at f/16, and so on.

5. If the light gets brighter (or dimmer), how would this affect the shutter speed and aperture combinations? Suppose the light is dimmer, and you only get a light reading of 16. Set the light-measurement arrow to 16, while you keep the film-speed arrow at 200. What are the combinations?

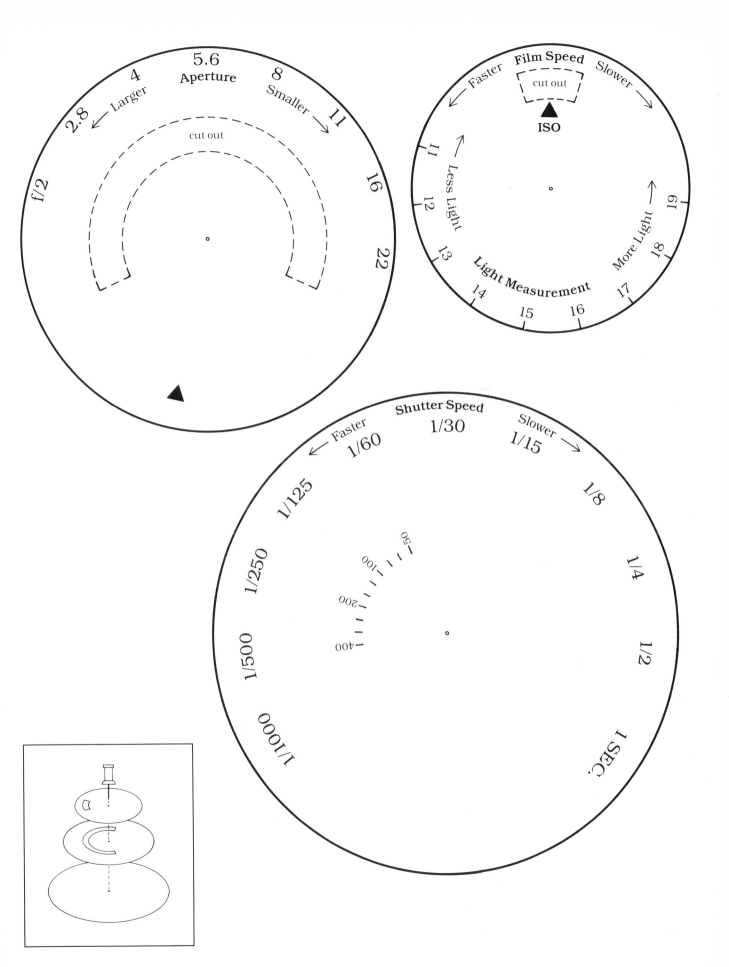

Opposite: A "gray card," a tone of approximately 18 percent reflectance that can be used for substitution meter readings. See page 63.